AWAKENING YOUR
Creative Soul

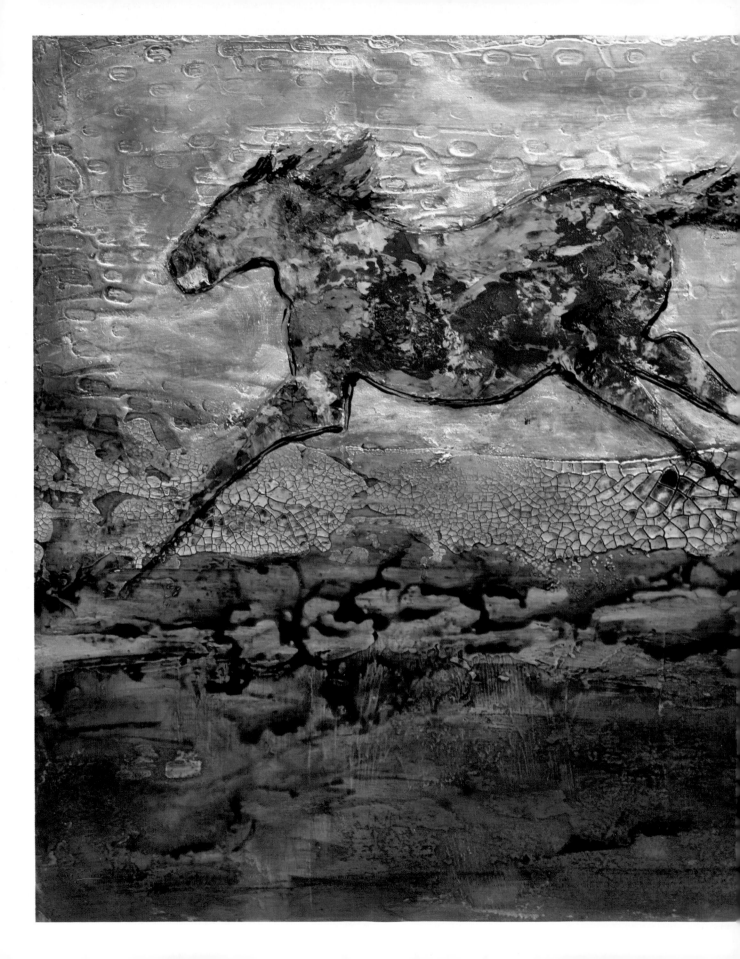

AWAKENING YOUR
Creative Soul

A 52-WEEK JOURNEY TO ARTISTIC DISCOVERY

SANDRA DURAN WILSON

TAKE A LEAP
Sandra Duran Wilson
Mixed media on panel
12" × 12" (30cm × 30cm)

NORTH LIGHT BOOKS

CINCINNATI, OHIO
artistsnetwork.com

CONTENTS

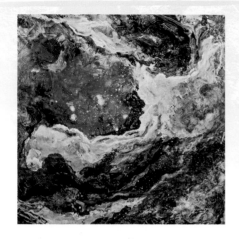
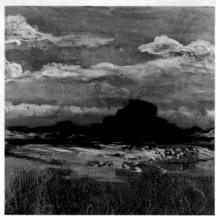

How to Use This Book

We mark our time by the circle. We spin around the sun's axis daily, watching sunrise to sunset, experiencing the seasons going by. We whirl through the years as they go by faster and faster with each passing turn.

The circle is our journey, and this book has been arranged to be used week by week, season by season and onward as we spiral upward. Each direction is associated with a season and time of day—east/spring/dawn; south/summer/midday; west/summer/dusk; north/winter/night. As we follow the seasons, the wheel also walks us around our physical and spiritual development, from birth to wisdom. Use this book to follow your personal circle. You will be awakened.

I usually enter the wheel in the east during the springtime—when everything is new and beginning fresh—then I continue throughout the course of the year. I recommend you enter the season you are in when you pick up the book. If you wish, you can jump around, but the sequence of projects will make more sense if you follow the seasons.

There are 52 chapters that coincide with each week of the year. Each contains either an art, writing or meditation exercise presented with simple step-by-step instructions. Follow along with the steps or use them as a jumping-off point for your own exploration. Either way, when you follow the circle, your creative soul will be refreshed, revived and awakened.

I encourage you to keep a journal for the course of the year while you work through the weekly projects. Decorate it with wild abandon, or not. This is your story and only you can tell it. The journal can be used for writing prompts, insights, hopes, fears, dreams and all that you imagine. Be kind to yourself and learn to listen to your inner critic. In time you will discover how your shadow is one of your greatest teachers, and that it can help you find inspiration even when you fall. Please join me for a spin around the circle.

Peace, love and hugs.

—Sandra

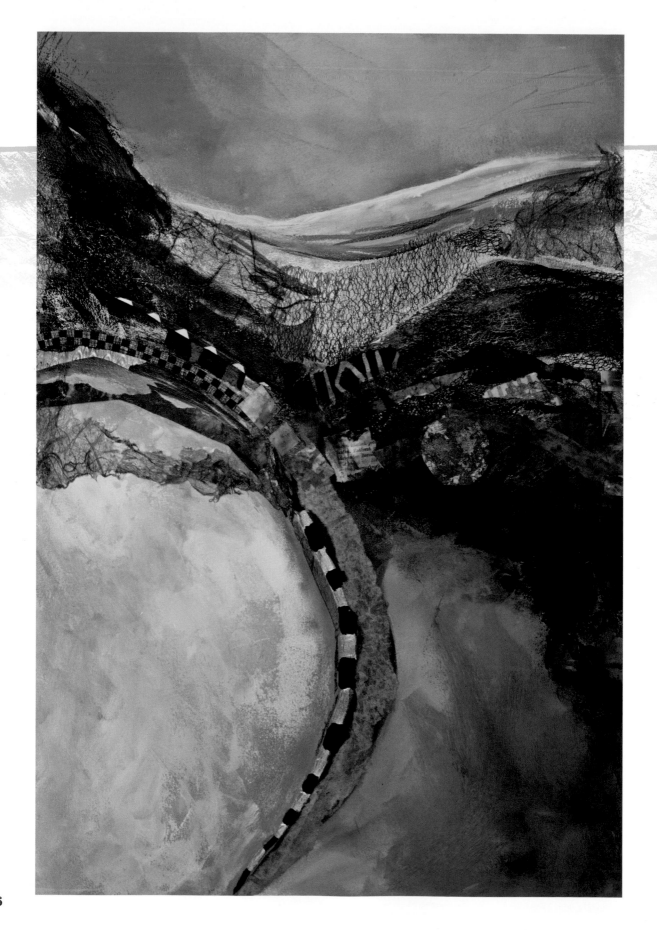

INTRODUCTION

DO EVERYTHING WITH GREAT LOVE, WHETHER IT IS PAINTING, WRITING, dancing, relationships or learning. Sharing your passion is the greatest gift you can give for you will inspire someone else. Listen to the whispers of your soul and the promptings from your heart. This book has been with me for many years. I have written several art technique books before, but this, my sixth book, is the one that has been waiting for me to show up. I feel that my path has come full circle. I was blessed to meet amazing people from all over the world during the decade I held spirituality groups. We shared our experiences, and I was able to feel hope and inspiration with them. We all walked the path together, then I went down a different path. I have been making art, writing and teaching for the past fifteen years, and now I have walked the spiral path and I have returned to this place of inspired spirituality. I return with new eyes and more wisdom, compassion and joy.

There are many voices and teachings out there, so how is my voice different? Everybody must know all this stuff by now. What makes me think that I have something different or more important to say? It is not about what I have to say, it is about your journey. It is about waking up. What will be your song, your rhythm, your story? This book is for the curious soul who is just waiting to find the right spark that will illuminate their creativity. You don't know what might crack open the shell that holds your inspiration. It may be in journal writing, making wisdom cards, exploring meditation, walking a labyrinth or putting on your dancing shoes. I shout out a big invite to join me on this ride into your creative soul. We will explore, experiment, cry, laugh and find others on this journey. The process of doing, making, sharing, searching, falling, getting up and trying all over again is what fills our lives with love. The more you let go, the more you have. Trust your choices. You don't have to know your purpose. Your purpose knows you. It is in your soul.

I write this book for those searching for a new vision. I share in your journey for we are truly all connected.

DOUBLE DIAMOND
Sandra Duran Wilson
Mixed media on paper
30" × 22" (76cm × 56cm)

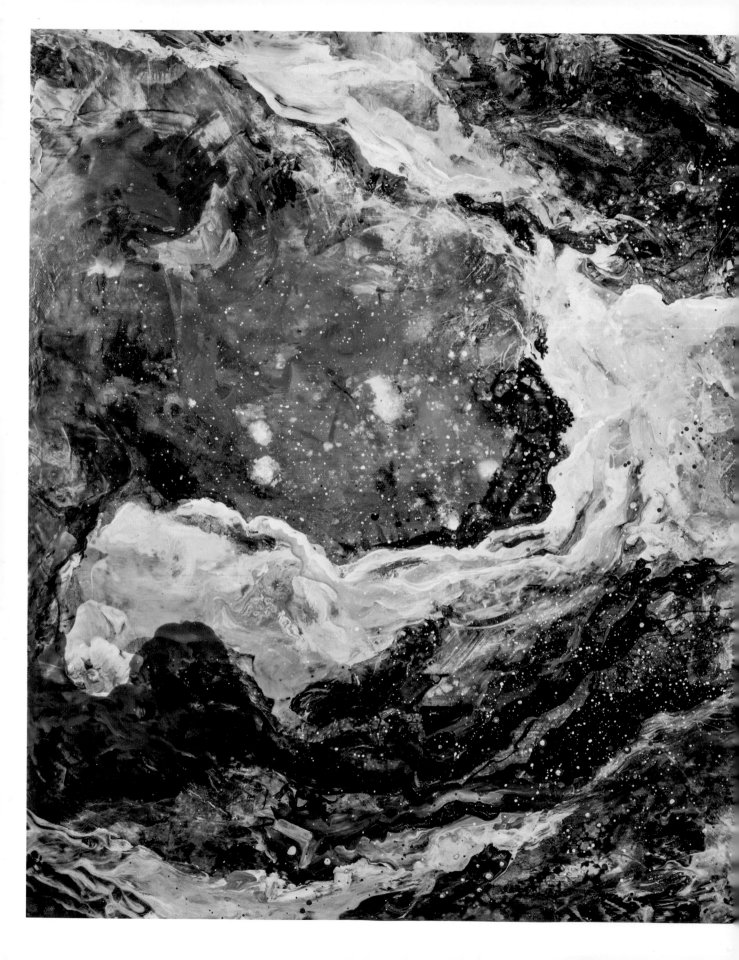

The Eastern Gate

THE EASTERN GATE OF THE WHEEL OPENS AT DAWN ON THE VERNAL EQUINOX.

The east's energies are about becoming new again. Beginning and returning, awakening, new growth, seeing things through fresh eyes, embracing the dawn and springtime. This is the time of early child-hood and learning who you are. Spontaneity, playfulness, wonder, inquisitiveness, truth and creativity are all eastern energies. Question everything with a child's mind and curiosity. This is a magical time when all seems possible.

Face the eastern dawn and awake from the sleep of winter. Feel the rising sun illuminate your mind, body and soul. You are beginning anew, yet you retain the wisdom that you have carried around the wheel of life. The earth is coming alive with new growth and fresh promise. Now is the time to turn outward to greet the day. You have completed the circle of the seasons and been reborn from the darkness of winter, bursting forth with the lively curiosity of the child.

In this season of light emerging from the darkness, we are fueled by the spirit—the part of us that is eternal. This light births creativity, and is manifested in art and writing. Through the exercises in the eastern section, we will peel away the layers of the ego to identify and clarify our soul. We will learn to see with fresh eyes and gain new perspective. We will begin anew and learn to trust our intuitive voices, harness our dreams and jump outside the constraints of time to mani-fest our creativity.

A NEW DAWN
Sandra Duran Wilson
Acrylic on canvas
20" × 20" (51cm × 51cm)

New Eyes

Make the common sights strange and the unusual familiar.

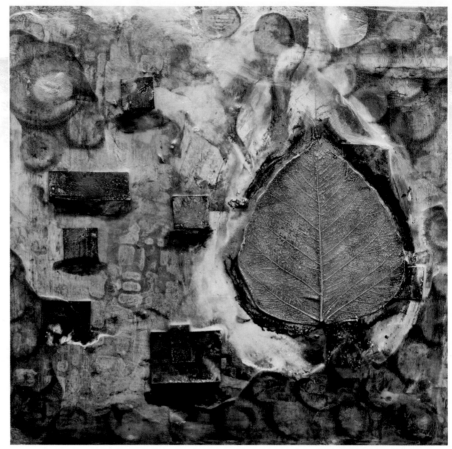

LIFE FORCE
Sandra Duran Wilson
Mixed media on panel
10" × 10" (25cm × 25cm)

I created this painting following my week of noticing water. The painting is made using Venetian plaster on panel. I embedded a leaf skeleton into the plaster, then used water to burnish and remove some of the plaster. I then applied encaustic, which is beeswax with damar resin. These things all contain water.

Your art will be found in the hidden corners and crevices of your soul. It won't hit you over the head, it will whisper your name. Learn to listen and see with fresh eyes. Expand your perceptions and invite your muse to join you in a grand adventure. Think of how when you are traveling to a new place, the time passes slowly compared to the return trip. You see with new eyes on the outward journey, and on the return trip your brain is editing those experiences. Time changes. Our routines can be very helpful for many things, but seeing with new eyes is not one of them.

When we become accustomed to seeing the same things every day, they tend to disappear. Our mind cuts out the familiar. We must train our mind to see again. Take, for example, water. How often do you encounter water in some shape or form during the course of your day? Many times, yet your mind doesn't register these encounters as events to remember.

Look at the page of this book or at a piece of paper. Do you see the cloud in the paper? Thich Nhat Hahn discusses this regarding meditation. The artist can see the cloud floating in the paper or the canvas. The cloud is necessary to produce water. The water is needed for the tree to grow and the paper comes from the tree. This exercise is twofold. First we will make the common sights and experiences memorable, then we will make the strange and unusual concepts more familiar. We are training ourselves to encounter our muse in both the most familiar and the most unlikely places.

Begin today by taking note of every time you encounter water. It is in your coffee or tea in the morning. It is in the shower and the bath. It is in the food you eat. All food requires water. It is used to

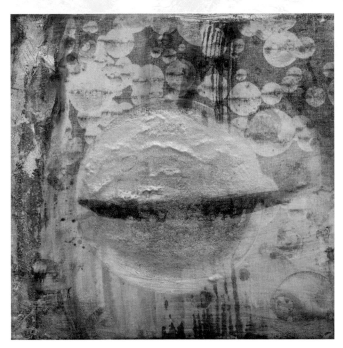

DISTANT PLANET
Sandra Duran Wilson
Mixed media on panel
8" × 8" (20cm × 20cm)

I love astronomy. This is my vision of a planet using fabric and resin. I follow the stories and images from NASA's Voyager missions to inspire my vision of distant planets.

PARTICLES AND WAVES
Sandra Duran Wilson
Mixed media on panel
8" × 8" (20cm × 20cm)

I am a bit of a science geek, and I love to paint what I think particle physics might look like. This piece has cellular images embedded into resin layers and cast acrylic.

grow the fibers to make many of the clothes you wear and to grow food for the cattle that produce the leather for your shoes. It is used in manufacturing plastics. It is everywhere. Notice and think about this for the day. Make yourself aware of the familiar. Think about how you will use this information in creating a work of art.

Now attempt to make the strange familiar by looking at something from a unique perspective. Open your eyes to the minute patterns around you to tell your muse that you are awake and listening. The muse will respond by revealing all kinds of creative ideas and patterns. Let's look from high above. Aerial or topographical maps that indicate elevation changes are a new way of seeing the earth. Think of these like vibrational lines or fractals. Fractals are never-ending patterns that continuously replicate themselves at an increasing scale. These same patterns are repeated over and over until they form larger patterns, but the same form is contained within the larger pattern. They surround us. When you begin to look you will see them everywhere, such as the center of a sunflower, the form of a cauliflower or the veins of a leaf.

Maybe math is strange for you, so begin to look at pictures of coastlines or satellite images of a river delta following its path as it flows into the ocean. This, too, is mathematics. Not as strange now, is it? Science and technology continue to bring new tools to the artist. Drone photography reveals incredible views from a fresh perspective, with artists today creating amazing video art by choreographing and filming illuminated drones at night to create patterns and movement.

Who Are You

Transform a blank canvas into a portrait to get to the heart of your identity.

MATERIALS

Panel or old painting

Creative Paperclay

Ornament or object to shape the clay around or wax paper

Unmounted rubber stamp or flexible texture plate

Light molding paste by Golden

Paper and pencil

Acrylic gel gloss

Paintbrushes

Palette knife

Scissors

Grafix Artist-tac adhesive

Washi tape

Acrylic paints

DecoArt Metallic Lustre cream wax

Water-soluble colored pencils

Who you are is much deeper than the labels we usually give ourselves. What are your labels—woman, friend, mother, artist, healer, man, father or the identity of your career? Think of it like peeling the fine, thin layers off an onion. First there are the dry outer skin layers that come off easily. Next there is a thicker protective layer and then the fine, thin membranes, which are very fragile. These layers are like our labels: easy to identify. Below are the layers of our experiences, followed by the layers of our emotions and, at the innermost center, our soul's core layers.

You can do this exercise with a partner or you can use a mirror to do the exercise by yourself.

To begin, ask the question, *Who am I?* Take a moment to breathe and answer the first thing that comes to you. It will probably be your name. Ask again, who are you? Continue repeating and answering the question like you are peeling off the layers to reveal your inner self. Take time to breathe and let your answers flow. There is no wrong answer.

You may write the words down, or simply stay in the process and write them afterward. If you are doing this with someone, ask them *Who are you?* making sure to look into their eyes when asking and responding. This may feel awkward in the beginning but stay with it. If you are doing this on your own, use a mirror to look deeply into your own eyes.

Write your words in pencil on paper.

When you have finished this exercise, make a self-portrait based on your responses. This is not a traditional self-portrait. It is not based on your outward appearance, but on who you are experientially, emotionally and soulfully.

Here are some of my words: Sandra, wife, friend, daughter, sister, artist, scientist, writer, poet, dreamer, activist, lover of life, sailor of space, light, the wind, the silence between the notes, stillness. The many roles I have throughout my life are the outer layers. My aspirations and dreams are the inner layers, and my soul's core is who I am without all those other roles, like stillness.

I decided to use an old painting I had done back in art school as my background canvas. I like the idea of building layers on top of who I was to create a current self-portrait many years later. All of my past experiences are contained and transformed into who I have become.

To prepare the surface, I covered the entire surface of my old painting with light molding paste, then I added gel gloss onto some areas at random. This created a totally white and somewhat absorbent substrate. If you choose to use an old painting, you can prepare it with gesso or just start with a new blank canvas altogether.

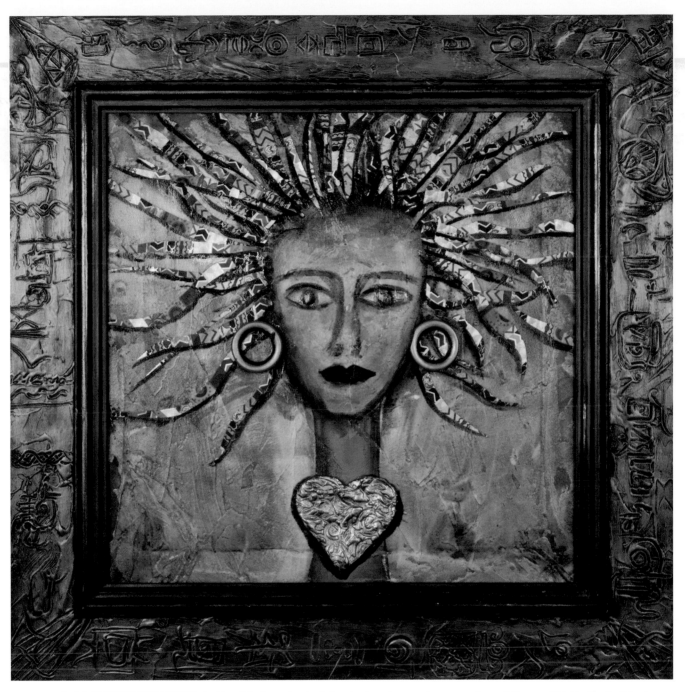

I AM MORE THAN SKIN DEEP
Sandra Duran Wilson
Acrylic on canvas
20" × 20" (51cm × 51cm)

My original art-school painting that I used as my substrate was in an old frame, which I had embellished and painted. I put the updated, finished self-portrait back into the frame and added a layer of gold metallic cream wax. For this exercise you do not have to paint a face for your self-portrait. This is your painting, and it can be completely abstract if you wish. Experiment with different techniques and adapt them to your vision.

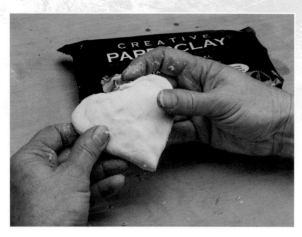

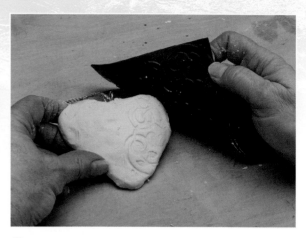

1 Make a heart with paper clay. Roll out the clay to about ¼" (6mm) thickness. I am using a decorative heart ornament as a base to shape the clay around. If you aren't using a base, simply roll the clay flat on top of wax paper and then cut out a heart shape with a knife.

Build up the clay gradually so it has some depth. Dampen your fingers to smooth additional clay and press around the edges to create the heart shape.

2 Using an unmounted rubber stamp or other textured material to emboss, press texture onto the heart. Carefully remove the clay from the heart base or the wax paper and set it aside to dry. It may take a day or two to dry.

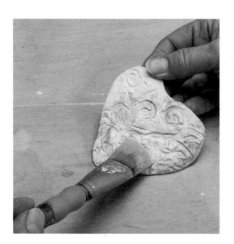

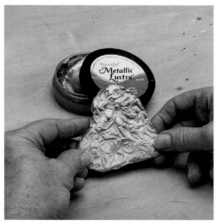

3 Once the clay heart is fully dry, brush on a base of gold acrylic paint and let it dry.

4 When the paint is dry, use your fingers to apply some turquoise metallic cream wax to give the heart a metallic look. Set it aside to dry.

5 Draw the shape of a head and neck on copy paper and cut it out. Place the paper cutouts on your panel surface and use a brown water-soluble colored pencil to outline the shapes. If you like, you can simply draw the shapes freehand.

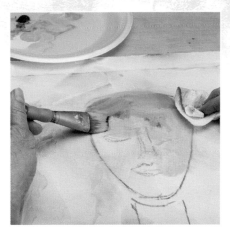

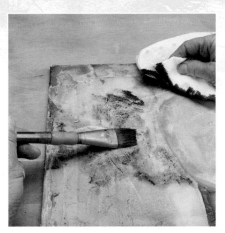

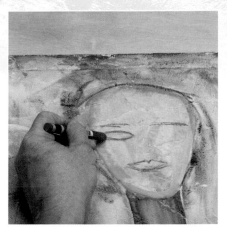

6 Paint the head and neck with mixtures of yellow and red acrylic paints diluted with water.

7 Select the colors for your background. My color palette is green, yellow, white and brown. Dilute the acrylic paints with a lot of water and apply with a large brush. Let it sit for a few minutes, then blot some off. This is a great way to control and build layers.

8 Use the brown water-soluble colored pencil to outline the face on your self-portrait.

9 Write your *Who Am I* words on a piece of copy paper using a pencil. Turn the paper over with the words facedown and apply overlapping strips of washi tape to the paper.

10 Here you see the washi tape, but the words are not visible. The words will be collaged facedown into the finished piece as a meaningful layer, just like the layers of an onion.

11 Cut the washi tape across the layers to create a new pattern: hair that will flow from the head.

12 Pull the protective backing away from a sheet of adhesive film and place the strips onto the sticky side. Reposition the cover paper and rub down to adhere the sticky adhesive to the strips of paper. Remove the cover paper and peel the strips off. The back side of the strips will now have adhesive on them.

13 Position the strips of washi tape where you want them. You can easily reposition them before you rub them down into place. Once everything is arranged as you like, use your hand or a burnishing tool to rub the strips onto the surface.

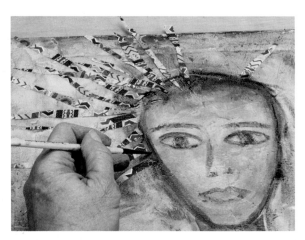

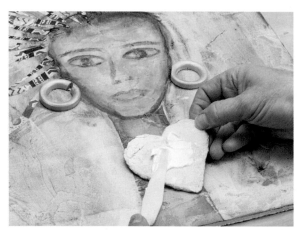

14 Finish painting the face with your acrylics and watercolor pencil, and continue to add the washi strips.

15 I found some wooden rings that I painted gold. You could also use old jewelry or personal symbols to make this your own portrait. Use acrylic gel gloss to attach the heart and your symbols. Apply enough to the objects so that when you press down, some gel oozes out. You can clean off the extra before it dries. Set it aside and let it dry.

A Beginner's Mind

Avoid overthinking your work by abandoning expectations.

Contributed by Seth Apter

LAYER CONVEYOR
Seth Apter
Mixed media on paper
6" × 6" (15cm × 15cm) each panel

MATERIALS

Watercolor paper, 12" × 18" (30cm × 46cm)

Black gesso

Acrylic paints

Brushes

Embossed wallpaper or other textured paper

Rubber stamps

Ink pads

Craft sponges

Stencils

Journaling pens

Scissors

Sometimes starting something new, especially as a beginner, can feel daunting and overwhelming. On the other hand, a beginner does not bring the expectations of immediate success, which can often stifle creativity. In fact, beginners come with excitement, eagerness, passion, hope, curiosity and often a sense of playfulness. Think about creating as a child, the ultimate example of a new beginning.

No matter where you are on your creative path, a complete novice or a seasoned pro, try to think like a beginner. Take risks, be spontaneous, let go of any preconceived outcome, and bring with you the sense that anything is possible. The exercise here, which I call "Layer Conveyor," is all about letting go and having fun. I selected these techniques to help you create without overthinking. So bring your beginner's mind and play!

1 Cut watercolor paper into four 6" × 6" (15cm × 15cm) squares. Brush black gesso loosely on one side of each square. When the gesso is dry, squeeze two colors of acrylic paint onto the surface of each square one at a time and brush it out. Let the colors mix and leave bits of the black surface showing through. Add additional colors of paint as desired.

2 Place your watercolor squares into a pile, overlapping one another. Select one pattern from a variety of pieces of textured paper and brush on acrylic paint. Press the surface of the pattern paper onto the pile of squares, swiping with your hand to apply the pattern from the textured paper to the squares. Shuffle your pile of squares and repeat the process with different colors of paint and different patterns of paper.

3 Once dry, replace your watercolor squares into an overlapping pile. Ink a variety of rubber stamps with background details and press onto the pile. Do this at random with no thought of composition. Shuffle your pile of squares and repeat the process with different colors of ink and different stamps.

4 Select a variety of stencils and create a focal point on each watercolor square by pouncing layers of acrylic paint and ink from the ink pads through the stencil using a craft sponge. Let each layer dry before proceeding to the next. I used 6" × 6" (15cm × 15cm) stencils/masks on each piece, but you can use any number of different stencils to create your own design.

5 Using your choice of journaling pens, outline the stencil words and designs and add your own marks or doodles to make the artwork uniquely yours.

4

Vision Board

Find your vision in the circle by following the Earth's energies.

FUSION VISION
Sandra Duran Wilson
Mixed media and collage on paper
20" (51cm) diameter

MATERIALS

Foamcore or
mat board

Pencil

Craft knife

Cutting board/surface

Ruler or T-square

Shapes for making
circles

Magazine images
or other printouts

Paper and pens
for writing words

Glue stick

I have used visioning to manifest most things in my life. I didn't have the words *vision board* when I was a child, and manifesting didn't mean the same thing back then, but I used pictures. I would write and draw about the things I wanted to do or things I wished for. I would use pictures for my birthday or holiday wish list to present to my parents. I never did get my horse, but I became very adept at drawing them. Later I had posters in my room of places I wanted to go and things I wanted to do. These were my early vision boards. I would stare at the posters and this would become a type of meditation. When I looked out the window and heard the whistle of a distant train, I would imagine where it was going and that I would be on it. I used words, pictures and my imagination to create and manifest.

I now understand that the secret to manifesting relies on feelings. What you focus on expands, so make room for it in your life. Focus on how you want to feel. Create a vision board to hold your desires and dreams in front of you daily so you can focus on them. When you create the vision board, you are defining your desires and dreams. When you put it in front of you every day, you are refining these dreams through short visualizations every time you look at it.

19

at it. Visualization works. It works for improving performance in sports, and it works for imagining the outcome of an activity. It stimulates the same areas in the brain whether you are doing the activity or simply imagining it. It works when you feel the experience like it is happening now.

I have been making simple vision boards with groups for years using a piece of posterboard, a glue stick and a stack of magazines. I remember one person methodically looking through a huge stack of magazines for a very specific image. I suggested that she shut her eyes and visualize the image she wanted using her imagination and to focus on this until it became very clear and she could sense it. I then told her to open her eyes and go grab a magazine from the table. Pick up the first one that speaks to you. She started to give me that are-you-kidding-me look, so I asked her to just act, not think. She trusted and did as I asked. She picked up a magazine and began to flip through it. I returned to the rest of the group, but within a few minutes I heard a squeal. "It's here. It's perfect. It is exactly what I saw!" She added it to her board and proceeded to close her eyes and visualize her next image. She got it. She now understood the power of visualization.

In this project we are going to make a vision board by allowing the Earth's energies to direct and guide us. We will keep an opening in the center of the circle to represent the unknown—the place where all creation is possible. Here are some of the symbolic meanings behind each of the Earth's four directions and a simple objective to contemplate:

EAST—Spring, new beginnings, dawn, awakening, illumination, imagination, play, rebirth, curiosity, wonder and clarity: things I wish to embody.

SOUTH—Summer, growth, learning trust, abundance, paradox, clarity, action, intuition, experimentation, joy: things I wish to learn.

WEST—Autumn, strength, introspection, renewal, gratitude, understanding, acceptance, self-love, maturity, reflection, collaboration: things I wish to share.

NORTH—Winter, wisdom, purity, peace, paradox, serenity, time of reinvention, sitting in the silence, balance transformation, moving from old age to the next level: to simply be.

To get started, gather a stack of magazines, photographs or pen and paper for writing words of inspiration. You can often get free magazines from the library. Find a quiet space where you can close your eyes and begin to feel the things that you would like to call into your life. Remember how you felt when you have had similar experiences or rewards. Feel how your face lit up with a smile or your body felt after a great workout. Recall as many details as you can and incorporate all of your senses. Now begin to see the things or experiences. Visualize a picture and feel the result. When you are ready you may begin to search through your magazines or photos or even look online for images to print out.

Your vision board will be your map for the year, a tangible representation of where you are going, your goals, hopes and ideal life. Consider including a picture of yourself in your board. If you do, choose one that was taken in a happy moment. You might also consider searching for or creating affirmations, inspirational words and favorite quotes to add to your board.

1 Draw a circle, 20" (51cm) in diameter onto your board. I am using black foamcore board and a large lid from a plastic bin as my template.

Place the board on top of your cutting surface and use a sharp craft knife to cut out the circle. Don't worry about it being perfect; I intentionally made it slightly off since most round objects in nature (e.g., the moon) are slightly oval.

2 Use a ruler to draw lines dividing the circle into quadrants. Use the tape roll as a stencil to draw your center circle. Write the energies of each direction in the corresponding quadrant. Revisit the list on the previous page of the energies and lessons for each of the four directions to help you envision each quadrant's meaning.

3 I used the center circle as a place to hold the spirit and the unknown, where anything is possible. Create a special place to hold this energy. I used an image I made and printed it out.

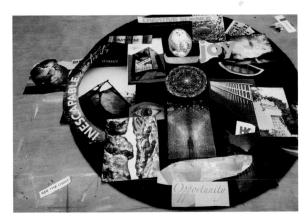

4 Gather the images and words you selected in the beginning of the exercise. Loosely arrange, add and subtract the images, letting your subconscious play. There is no right or wrong way to do this. This is your muse and your spirit's time to play. Try to work in a fluid manner and overlap images and words if you feel inspired to do so. You may even want to leave open spaces on your board for future dreams. When you are satisfied with the placement, use a glue stick to adhere your images.

VISION BOARD TIPS

» You can create a vision board in a shape other than a circle, or one that is more structured and organized.

» Place your vision board where you will see it on a regular basis. Visualization activates your creative subconscious and programs your brain to see things that were always there but escaped your notice.

» Contemplating your vision board is a wonderful way to begin your day, your week or your year.

Attitude Cards

Practice positivity to change your life one day at a time.

MATERIALS

Mixed-media paper,
12" × 9" (30cm × 23cm)

Pencil

Scissors

Recycled plastic
or mat board

Adhesive foam

Stencil

DecoArt Media mister
sprays

Watercolor pencils

Acrylic paints—
Interference Violet

DecoArt Metallic
Lustre cream wax

Permanent pen or
marker

Freezer paper or
wax paper

Spray bottle
of water

Makeup sponge

Cotton swab

Paintbrush

Gloves

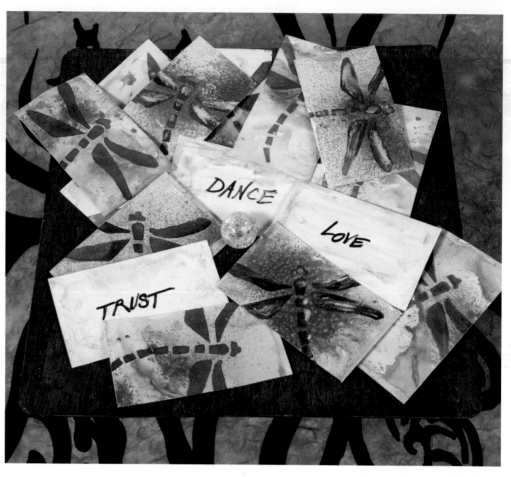

Several of my daily attitude cards

Are you experiencing the kind of day you want? Do you need a little boost or a reminder? Just like the saying "We are what we eat," we are also what we think. Attitude sets our tone for the day. This exercise is one of my go-to rituals for starting my morning: clearing the negativity to begin the day with love and good vibes.

Most of us have experienced getting up on the wrong side of the bed at some point. It has been shown that the attitude you start out with in the morning lingers with you all day because what you focus on expands. Imagine that even before you get out of bed in the morning your mind goes to resistance. You don't want to go to work or you are dreading a task you have to do. Your mind then goes to anger you feel toward someone for letting you down; maybe it moves onto blame. Before your feet have even hit the floor, you have sent 60 to 70 percent of your energy out into the negative void.

Now let's envision a different scenario. If you find your mind going in this direction, Caroline Myss uses a wonderful visual to unplug. She talks about seeing your energy going out from a cord located in your abdomen. Visualize yourself unplugging your energy from the fear, doubt, resentment, anger, whatever. See yourself reaching out and pulling the plug from the socket of negativity. Unplug yourself from that energy. Pull the cord and plug it back into your solar plexus. Begin your day in the present, with all your energy to support you.

Step into your greatness. Keep in mind that what you give yourself, you also may attract from others. If you are disparaging of your own work, pointing out the errors in it, you invite others not only to see those things but also to

see your work in a less than positive light. If you buy into the myth of the starving artist, why would someone want to pay you thousands of dollars for a painting? Pay attention to these self-criticisms to avoid attracting them in others.

Begin your day with joy and inspiration. Leave yourself a note on the mirror that simply says: smile. Another one in your sock drawer: you are loved. One in your car: you are talented. Attitude cards are little reminders of our joy and greatness. You may place these around your home, studio or office. Or you may keep them in a bowl and pull one each morning to set the tone and inspire your day.

To begin, come up with a list of words that you find inspirational or that encourage positivity. Here are some of my words: Laughter, smile, sing, joy, dance, seek, play, you are loved, strength, faith, release, patience, vibrant health, intuition, spontaneity, journey, grace, trust and so on.

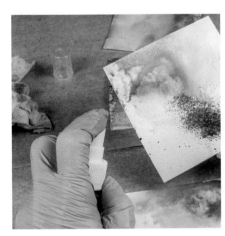

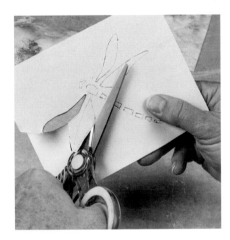

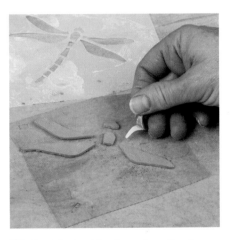

1 Cut a 12" × 9" (30cm × 23cm) sheet of mixed-media paper into 52 cards. You may make as many as you like and whatever size you wish. Mine are 2" × 4" (5cm × 10cm). Place freezer or wax paper to protect your surface, and wearing gloves, spray each card with blue, teal and yellow mister sprays. Spray a light mist of water and the paints will flow and mix together.

Some of the paint mist will end up on the wax paper. You can place a card facedown in the color and move it around to create a mixed paint look. That is how I got the nice green blend seen here in the corner of the card.

2 Make the stamp. I chose a dragonfly stencil. The shape fits nicely for the size card I am making. Place the stencil onto the paper side of your adhesive foam and trace your shape. I am using a Fun Foam sheet I found in the kids' section of my local craft store. Cut out the shapes.

3 Peel the backing from the adhesive foam and put the shapes on a piece of recycled plastic. The plastic I am using is from packaging material. You could also use mat board for your stamp base. I just eyed the placement because I wanted to enlarge the dragonfly's size a bit. If you want it exactly like the stencil, draw the same shape onto your stamp base, either the plastic or mat board. Press the shapes down to ensure good adhesion.

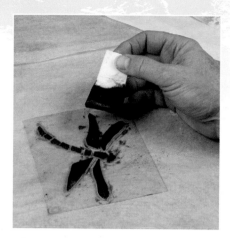

4 Mix a purple shimmery paint and use a cosmetic sponge to apply the paint to the stamp.

5 Press your stamp down onto your card. Check to see if you have enough paint; if not, you can add more and apply again. The advantage to using a piece of clear plastic for the stamp base is that you can see through it, which makes it easier to realign if you wish to stamp again. Stamp all your cards and let them dry.

6 When the stamps are dry, enhance them with Interference Violet paint and metallic cream wax. Use a cotton swab to apply these paints.

7 Now for the word side. Scribble watercolor pencils onto the back of the cards and use a brush dipped in water to create interesting backgrounds for your words. Let it dry.

8 Use a permanent marker or pen to write your words onto the cards.

6

Life Force

Change any energy, any time by becoming aware of your body and breathing.

MATERIALS

Spray bottle of alcohol

Two panels of Plexiglas, Lexan, Optix or any brand of cast acrylic, 8"× 10" (20cm × 25cm)

Gessobord panel, 8"× 10" (20cm × 25cm)

Grafix Dura-Lar frisket film

Picture frame, 8"× 10" (20cm × 25cm)

Acrylic paints and paint pens

Marbleizing spray, gold

Brushes, markers and mark-making tools

StazOn ink pad and stamp

Wooden skewers

Foam stamp

Stencil

Scissors

Sponge

Paper plate

Pencil

Wood graining tool

Towel

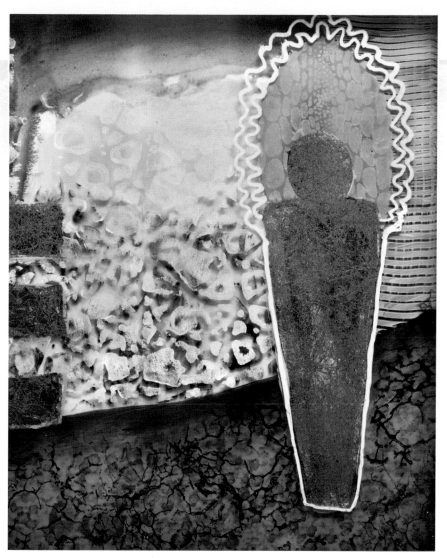

LIFE FORCE
Sandra Duran Wilson
Mixed media on panel and Plexiglas
10" × 8" (25cm × 20cm) framed

Everything holds a life force, energy or frequency. The ripples in the water are movement and energy. The patterns in the sand from the blowing wind. The textures of erosion when water moves over land. There are also energy lines that we don't see with our eyes, but they are there. Music has energy that you feel. I see the colors of music because I have synesthesia, a crossing of the senses. Music looks like wave patterns with colors to me. This painting project will give you a sense of what it is like to feel the waves of sound.

Another good example of energy line paintings are topographical maps that indicate elevation changes. Think of these like energy lines. We are surrounded by these energy lines. When you begin to look, you will see them everywhere. Opening your eyes to the patterns around you will tell your muse that you are awake and listening. She will respond by showing you all kinds of creative ideas and patterns. Imagine these lines depicting the life force of your subject and the surroundings. Listening to music may inspire you and help you envision the lines of the life force. We are going to supercharge our muse and really get our ideas rolling by creating on multiple layers.

25

1 Cut a frisket sheet the same size as your acrylic
panel. My panel is an 8" × 10" (20cm × 25cm) sheet of
Plexiglas. We are going to be painting on both sides of the
Plexiglas, so remove the protective covering from both
sides before beginning. On the paper side of the frisket,
sketch and cut out a figure shape and three rectangles.

2 The frisket film has an adhesive backing. After
you have cut out your shapes, carefully remove
the backing and apply it to your Plexiglas. This is a little
tricky. I remove the backing from one end, carefully put
the edge down and then peel the backing off. It doesn't
have to be perfect.

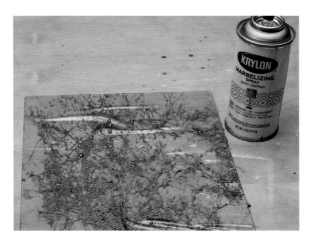

3 Spray the frisket side with gold marbleizing spray
to create a web-like pattern. Let it dry for about 20
minutes and then remove the frisket film. You see that
my frisket sheet had ripples in it, but it turned out okay.
The frisket will act like a stencil and protect the Plexi-
glas from the marbleizing spray, allowing the spray to
go only into the openings.

4 Now that the frisket film stencil has been removed,
turn your Plexiglas over and paint the back side over
the gold figure with Phthalo Turquoise acrylic paint. Let it
dry. The textured gold marbleizing is on the other side of
the Plexiglas, which we will paint in the next step.

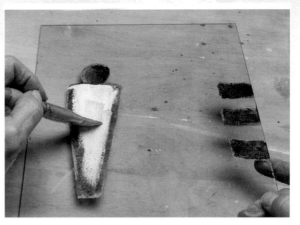

5 Turn the Plexiglas over and set it on top of a white plate so you can see how the paint looks behind the marbleizing spray. Paint the underside of the Plexiglas with three rectangles of Quinacridone Gold acrylic.

6 Turn the Plexiglas over again, and paint white on top of the Phthalo Turquoise side of the figure to create opacity.

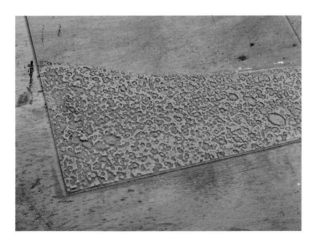

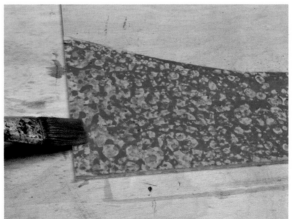

7 Begin the second piece of Plexiglas. Place it behind the first piece using skewers to separate the pieces so they don't touch, then check where you want to place the horizon line. Paint the back side with a watered-down Diarylide Yellow, and, while it is still wet, spritz with alcohol. The alcohol will cause the paint to move away from the alcohol drops, creating an interesting pattern. Let it dry.

8 Turn the second piece of Plexiglas over and repeat the same process using orange. Apply the diluted orange and spray with alcohol. Let it dry. We are working on multiple levels. It can get confusing flipping back and forth, and sometimes you end up with shapes or colors where you didn't intend them. Let go and enjoy the ride.

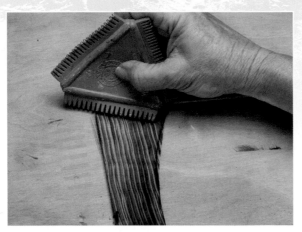

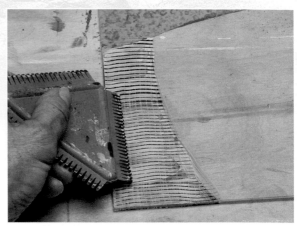

9 Hold the two pieces of Plexiglas together, using skewers to keep them from touching. Decide where to place your next shape and make a line with a permanent marker on the opposite side where the boundaries will be. Paint a Phthalo Green area. While wet, use a wood graining tool to make lines in the paint. Let it dry and then use alcohol on a towel to remove the marker from the opposite side.

10 Flip the piece over and paint the area behind the Phthalo Green with a bright Lemon Yellow and make marks using the wood grain tool going in a direction perpendicular to the green lines. Let it dry.

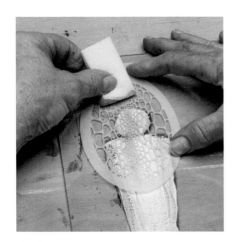

11 Switch back to the Plexiglas with the figure. Place a stencil behind the figure on the side with the white opaque paint and use a sponge loaded with some of the same Lemon Yellow to apply paint through the stencil. I also added some of the yellow to the back side of the orange rectangles. Let it dry.

12 Using wood skewers to keep the Plexiglas panels from touching, place one on top of the other so you can evaluate your composition and values. I decided to add Cobalt Teal behind the stencilled aura around the figure's head. Think about what colors you want on your wood panel background.

13 Brush red and yellow acrylic paint diluted with water onto an 8" × 10" (20cm × 25cm) Gessobord panel. I wanted a simple, loose and watercolor-like background here. Let it dry.

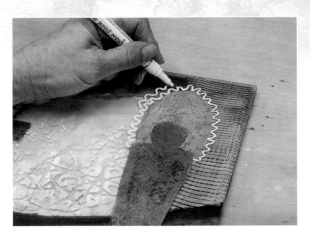

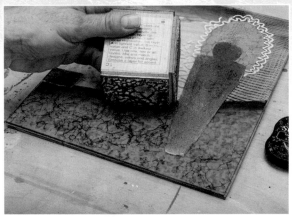

14 Working on the front side of the figure, paint a foam stamp with lots of white paint and press it onto the yellow area of the Plexiglas. Use a white paint pen to add energy lines around the top of the figure.

15 I used dark blue ink and a rubber stamp to add a layer over the orange. Let it dry.

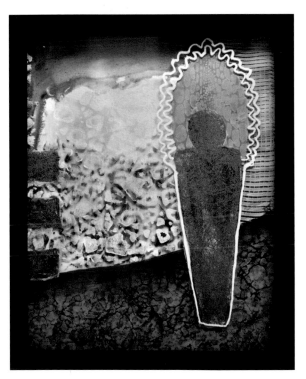

16 Load the foam stamp from step 14 with brown paint, and working on the front side of the second Plexiglas, press a few background shapes into the middle section.

Once dry, assemble the two pieces of Plexiglas and Gessobord together and secure them in an 8" × 10" (20cm × 25cm) frame to complete your layered artwork.

"Your time is limited, so don't waste it living someone else's life. Don't be trapped by dogma, which is living with the results of other people's thinking. Don't let the noise of others' opinions drown out your own inner voice. And most important, have the courage to follow your heart and intuition."
—*Steve Jobs, when he was facing his death from pancreatic cancer*

Stone Meditation

Harness your breathing through meditation to discover newfound inspiration.

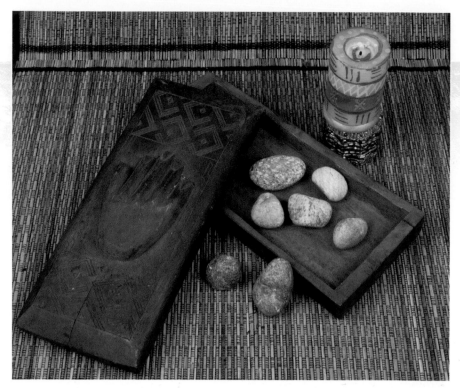

My seven meditation stones

To connect with your deepest inspiration, it is necessary to become still and go to the place of silence between the notes. You can always find this place by following your breath. You are never lost, just remember to breathe. Put your attention on the present moment. Distraction is not in the present, it is either in the past or the future. The breath is always in the present moment. You can be here now in your breath. Put your attention on sensations. Release. Forgiveness, meditation and mindfulness are all in the present moment. Your stories are a part of you, but they hold you in the past or future. Bring yourself into the timeless eternal now. Become a powerful generator of love and breathe.

This meditation is adapted from a practice Thich Nhat Hahn taught to children. I call it seven stone meditation. I chose seven stones because there are seven colors in the rainbow, which are the colors of the seven chakras (the energy systems in our bodies). The word *chakra* means "wheel" in Sanskrit. See exercise 28 for more information on chakras.

Prepare Your Supplies and Space

Gather seven smooth stones that fit into your hand and a timer. I like to use the meditation app Insight Timer on my smartphone. Have your journal and a pen nearby as well.

Find a place where you can sit comfortably. I like to sit on a cushion on the floor. If you sit in a chair or on a sofa you will need to be able to reach your stones on either side of you. Place the seven stones to your right side. Find a place where you may be undisturbed for about ten minutes, or however long you feel comfortable. Silence your phone and open the timer app (or set a standard timer).

Close your eyes and slowly breathe in through your nose and out through your mouth. Feel yourself in your body. Let your mind calm down and slow your breathing. Continue until your breathing is slow and steady and you feel present in your body. Now as you slowly inhale through your nose, pick up a stone with your right hand. Move it to your waist level near your belly button. Hold your breath for a moment and then, as you transfer the stone to your left hand, slowly exhale through your mouth and place it down on your left side.

Continue to inhale slowly through your nose and pick up another stone with your right hand, hold your breath and then transfer the stone to your left hand and exhale slowly. Each time you pick up a stone, keep your awareness on your breath. Hold your breath for a short time and then exhale while placing the stone down. When your mind begins to

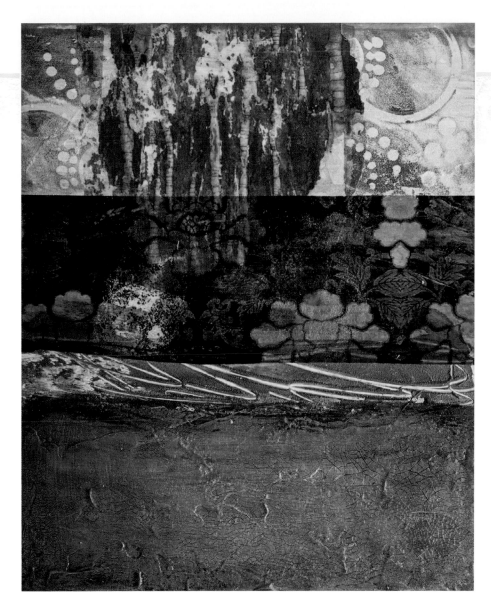

LOTUS
Sandra Duran Wilson
Mixed media on panel
11½" × 9½" (29cm × 24cm)

Lotus was inspired by a meditation I did sitting by the pond outside my studio. The water lilies and lotus were in bloom, the water danced as it tumbled over the stones in the stream, and the birds sang a tranquil melody. The three layers represent the earth at the bottom, the water and plants in the middle, and the air, birds and sun above. I love to meditate outside to connect heaven and earth. I become the conduit between the two, and creativity flows.

roam or chatter, bring your focus back to your breath and the stone, and focus only on this.

Continue picking up the stones and breathing. When you have moved all the stones from your right side to your left side, continue breathing and move them all back from your left to the right side. Focus on your breathing and moving the stones. I continue this for about five to ten minutes. Practice daily and work up to about fifteen minutes.

How to Use This Meditation

After you have practiced this meditation for several days in a row, use the meditation time to prime the well for inspiration. Be mindful and in the present moment. Following your medi-tation practice, try writing your stream-of-consciousness. Keep a journal nearby. When you have completed the meditation and slowly brought your consciousness back into the room, pick up your paper and pen and write whatever flows into your mind. Because you have spent the last several minutes quieting the chatter, you will get clearer thoughts than if you wrote before the meditation. Your writing doesn't have to be about anything and it is for your eyes only. You will be surprised how easily your words, thoughts and ideas flow. Be mindful and let your soul speak. Use your writings to inspire your next painting or creative project. When I have looked back at some of my writings, I have found many wonderful seeds that have sparked new projects and ideas.

8

Freedom

Discover the joy and freedom of creating by turning off your inner critic.

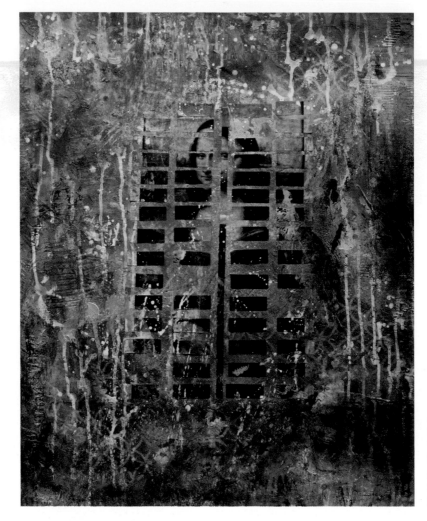

FREE MONA
Sandra Duran Wilson
Mixed media on paper
24" × 18"
(61cm × 46cm)

Finding your freedom is what creating is all about. Yes, there are lessons and it takes practice to learn how to paint, write or play music. Playing scales trains your fingers and ear, just like drawing trains your eye and hand. This exercise is about connecting with the joy of creating. It's about taking your kid (you) to the playground and leaving the critic at home. Today we will follow our wonder. Ever wonder what would happen if you did this or that? Then do it. Sometimes I like to honor my first thought before all the excuses have a chance to pour in.

I once had a thought to paint something big. I mean really big, like on a bedsheet. But the naysayer in me said, Who would buy that? Where would you store it? How would you do

it? You would use a lot of paint. It would be an expensive mistake . . . and on and on. I decided to hit the mute button on this inner critic and instead say to myself, *I am going to play today*. I painted a canvas the size of a bedsheet and I used spray paint and a mop and broom. It was a blast. I then cut it up into pieces and mounted them. In this exercise we will do just that and shut off our inner critic and play on paper.

When I was in my twenties I was a bartender. I worked downtown at a very popular restaurant and bar in the tourist area. My friends would come in for the margaritas and music, and I always had a basket of windup toys like a fire-breathing Godzilla, a bendable Pokey and other little bendy animals and people. It was the adult

toy box and people had a blast playing with the toys. Folks would interact, group projects and games were born and friendships were made. People would return on vacation and they would ask what new toys I had. It was a fun job. Very serious people learned how to play and loosen up, and I hope they took that energy home with them.

The idea here is to use things that you normally wouldn't in your creative practice. You say, wait, but I don't have a practice. Follow along and enjoy the ride then. You may never look back! You are welcome to join me for the whole project, borrow a few ideas or set off on your own adventure. Here is how we get to play today.

1 Wearing gloves, pour some paint on your paper. I am using some turquoise and yellow house paint samples I got at the hardware store along with some decoupage. Spray with water.

2 Remove some of the paper covering from a piece of corrugated cardboard to create a unique mixed-media tool, and spread the paint around.

3 While the paint is still wet, spray the surface with water and then spray gold metallic paint onto the wet surface. Do this outside because the metallic spray paints have heavy fumes. Tilt and move the paper so the water and paint move around and create some fun textures.

4 Place a stencil on the surface and spray with magenta. This paint doesn't have the same fumes, but you may wish to continue outside with the spray paint.

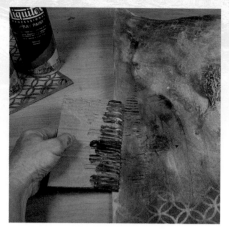

5 Continue to work quickly, not waiting for the paint to dry. Spray the surface with more water and then blue spray paint. Tilt the paper and let the paint run. I decided to spray some alcohol drops simply because I wondered what would happen if I did. Now let it dry.

6 Use a cosmetic sponge to apply orange paint in some areas around the edges.

7 Load up your cardboard with some blue and white paint, and drag it over the painting. Here I am just playing, making marks and applying colors.

8 Mix some white paint with water, then drop and splatter it onto the surface using both the fan brush and the handle of the fan brush to get larger drops.

9 Add some more water to the white paint on your plate and pour it onto your painting. Tilt the paper and let it run. When satisfied, let the piece dry.

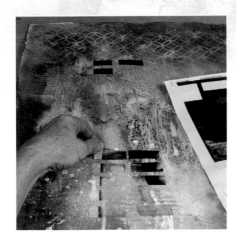

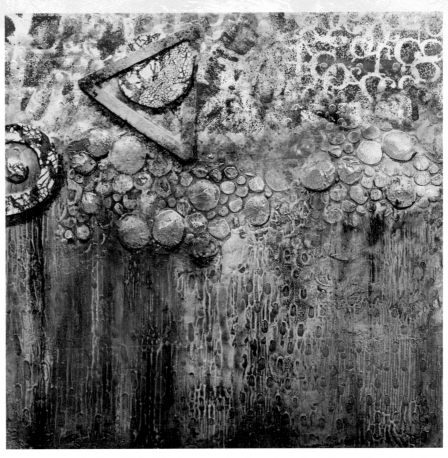

10 When the surface is dry, take the clear address labels with the printed image (I printed the *Mona Lisa*) and begin sticking them lightly onto the painting so you can move them around as needed. I decided to add more space between the labels. You may decide to put them closer together for a different abstract look. Once the labels are arranged as you wish, rub them down so they don't peel off.

Refer to the beginning of the exercise to view the final painting. I added some more details, such as brown paint, along the outer areas and a few white highlights here and there. I also dribbled a little more paint on top of Mona and sealed it up with some of the decoupage.

MOVEMENT
Sandra Duran Wilson
Mixed media on panel
14" × 14" (36cm × 36cm)

This piece was painted on salvaged wood. I used Venetian plaster, stencils and collaged crackle papers as well as textured rollers and altered stencils that I made myself. I found it freeing to use unusual materials without regard for how archival the piece might turn out. I find it liberating to create with whatever materials call to me. Do not let rules get in the way of your creativity.

9

Outside of Time

**Step outside of time by writing
a letter from your future self.**

Time is something that has always fascinated me since hearing about eternity as a child. I kept trying to imagine what it would look like. Even now, eternity is a concept that eludes my physical mind. But is time really fixed? I was seventeen and studying at university in a science medical program that was going to take ten years to complete. One night I went to a café and while in the restroom, I saw a line scribbled on the door that forever changed my life. The graffiti said, "Time is an illusion to keep everything from happening at once." This is all I need to know, I thought. I dropped out of school, went to Mexico and mined fire agates. I learned to cut them and became a jeweler and sculptor. I ended up in Santa Fe, New Mexico.

Time is fluid. When you are little, time moves so slowly, but as you get older it zips by. Think of how time stands still when you are absorbed in the creative process. We are all time travelers and we have the power to make time stand still. When we spend our time lamenting, regretting or letting the inner critic rant, we lose time. When we are in the present moment creating, time stands still. I want to share an exercise that I call *Jump Time*.

I began the practice of writing letters to my future self about twenty years ago. I write the letters in gratitude for the life I am living, the things I am doing and places I am. I base the practice on a very unusual experience I had. I was driving through the desert when I reached a point in the road that had always felt very spiritual to me. I suddenly felt connected to the past, but it wasn't a memory; it was co-consciousness. I was communicating with my teenage self. The message from my present self to my past was, Everything will work out okay. You are going to have some rough times. You will experience great loss and many difficulties in your life. You will come close to losing your life, but don't give up. Keep going, keep believing and never let go. You will survive and come

through this a much richer person. Be fearless and daring. Now this is going to become a very small whisper that you will hear only in your dreams, but it is your future talking.

I call this painting *Jump Time*. I have this painting where I see it every morning when I wake up so I always remember that time is not necessarily linear.

Exercise

Find a stretch of time and space where you may sit quietly for about twenty to thirty minutes. Gather a pen, paper and an envelope. Sit in a comfortable position and begin by breathing in through your nose and out through your mouth. Calm your mind and just feel yourself floating like you are sitting on a cloud. Imagine yourself rising even higher and higher. When you look out through your mind's eye you see yourself in the future. What are you doing? How do you feel? Who are you with? What are you grateful for? Are you traveling, do you have a new job, relationship? Are you centered in your body?

Take your time and visualize as many details as you can. These are your hopes, dreams and aspirations. This is where you wish to be, who you want to be, who you are, your soul self. When you can really feel that you are living this dream, open your eyes and write a letter from this future self to your present self.

Write your letter in present tense: "I am having a beautiful vacation in Barcelona. The architecture, the museums and the food are all fantastic. The love of my life and I are very grateful for our wonderful apartment in the heart of the city. I am thrilled to be exhibiting my work and meeting new friends. We are strolling through ancient gardens, feeling the sun, smelling the flowers and hearing the song of laughter. I am feeling blessed and at peace. Life is joyful. Thank you, spirit."

"The distinction between the past, present and future is only a stubbornly persistent illusion."
—*Albert Einstein*—

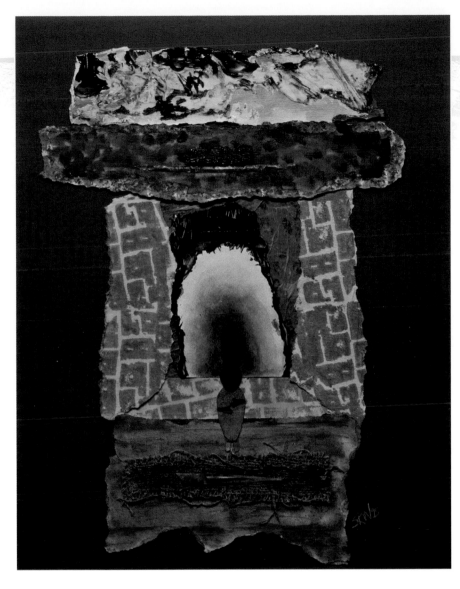

JUMP TIME
Sandra Duran Wilson
Mixed media on paper
25" × 21" (64cm × 53cm)

Now turn the page over and use your nondominant hand to write a reply to your future self. Mine says, "You are so welcome. You are a precious soul that deserves love and joy. All is always here for you. Remember to reach out and be your most amazing self. You are loved."

E-MAIL YOUR FUTURE SELF

For the digital version of this exercise visit futureme .org and myfutureself.com. Instead of using a pen and paper, simply type out your letter, input a future date and the website will e-mail you on that day.

Fold the letter and place it in the envelope. Seal it and address it to yourself and write a date on it. Put it into a folder and keep it where you will remember where it is. I like to date mine about six months in the future. Do this on a regular basis so when you go to put another in the folder you will have a collection of mail from your future self.

I have kept mine over the years and I see so many things, places, events and even people that have manifested in my life. After you have been writing your letters, you may try your own version of creating around the concept of time. Try a collage or a painting. Perhaps a poem, dance or song. Whatever your creative self feels moved to do. Step outside of time and co-create.

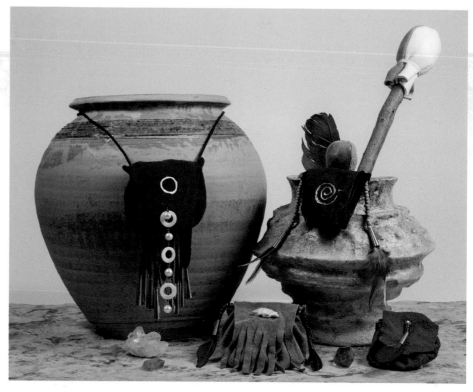

A gathering of my intentions

10

Holding Intentions

Gather tokens to remind you of your strength and wisdom.

MATERIALS

Pattern on paper

Suede or heavy fabric

Scissors

Chalk or pencil

Board

Hammer and nail

Heavy cord or a shoestring

Beads, feathers, cones and any other items for decoration

Time to gather your tokens of intention

A medicine wheel can take many different forms as it symbolizes the four directions as well as Father Sky, Mother Earth and Spirit Tree. All of these symbolize dimensions of health and the cycles of life. A medicine wheel can be represented by an artwork such as a painting, or it can be a physical construction on the land.

We can learn many lessons working within the Wheel of Life. Think of it as a place of balance and restoration. We worked with some of the symbols and intentions of the wheel in the Vision Board exercise. I have been building and working with medicine wheels for about thirty years now, and I am still learning. In this exercise, we are going to make a medicine pouch—a sacred container—for your intentions. The "medicine" in the pouch is a gathering of small tokens that remind us of who we are, why we are here and what we wish to accomplish. The simple version of this pattern may be cut out, strung and decorated in about an hour. More elaborate decorations take longer and gathering your tokens may take weeks.

You may wish to review the symbols of the Earth's directions before proceeding (see page 20). If you are creating a bag to use for your own healing, keep your items personal and do not share or show them to others. The tokens represent your heart, soul and strength. This process is a ceremony. It is done to help ground you in the creativity of the Earth. Dream of your spiritual guides and ancestors, and choose tokens to represent them and the lessons they've imparted. These are the intentions that we carry in our hearts.

The pouches we are creating are a physical reminder of these intentions. They are a reminder of where your muse, heart and soul reside. If you wear your pouch, you will be reminded of the strength that is contained within you. If you keep it in your home, I suggest keeping it near your bed so you may touch it when rising and resting for protection and healing. It is a touchstone—a reminder—of our connection to the Wheel of Life.

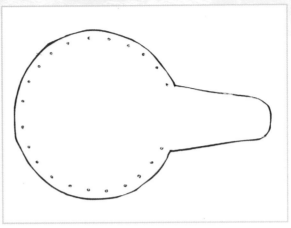

1 Determine which side of the suede you wish to have on the outside. Gather your board, pencil (or chalk) and pattern.

2 Copy and enlarge this medicine bag pattern to create a paper stencil.

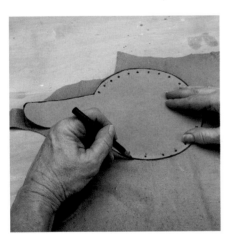

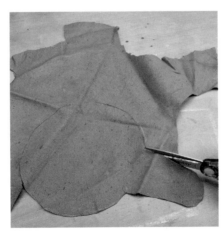

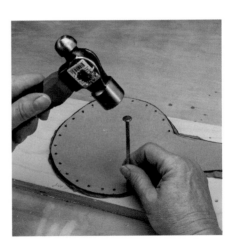

3 Place your stencil on the back side of the suede material and outline it using chalk or a pencil.

4 Cut out the pattern with sharp scissors.

5 Place the suede pattern on top of a wooden board, and the paper stencil on top of the suede. Use a hammer and nail to make the holes. Make sure that you have an even number of holes.

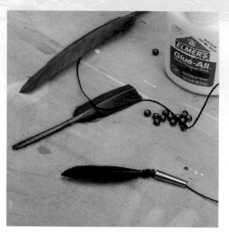

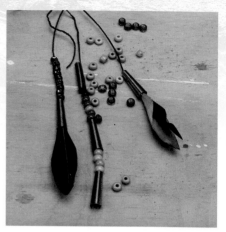

6 Cut an adequate length of cord depending how you will be using or wearing the bag, or use a shoelace. Begin on the outside of the bag and string the cord through the holes. Do not skip any holes or your cord will be off.

7 Make your decorations. Tie a waxed linen cord about 12" (30cm) in length around a feather. Use scissors to snip off the thicker part of the quill. Wrap the cord around the feather and tie a knot. I put a dab of glue on the knot to hold it together. Slip the cord up through a cone and add beads if desired. Tie a knot to hold it all in place.

8 Here are a few different combinations of decorations I've assembled.

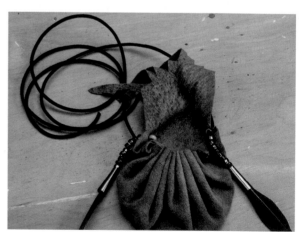

9 Cut fringe and twist if desired. Paint a pattern or decorate to reflect your desires.

10 Tightly cinch the cord, gathering the body of the bag together. Make a hole near top hole where the cord is threaded. Tie your decorative strands of beads to this hole of the pouch. I put a bead on the inside of each hole and tied the knots around the beads so they can't slip out.

How to Use Your Pouch

Take the time to gather your tokens of intention. You may include a stone for healing, such as carnelian for energy or turquoise for protection. Different plants have healing powers like sage, cedar or sweet grass. You may put in a small animal carving or a talisman representing a connection with someone or something. These are your intentions. Take great care to regard and honor your intentions.

Here is a prayer I wrote. You may use it when placing your intentions into the pouch:

I place my heart inside of you.
My love is nestled here.
I place the gifts of wisdom, light and love
To carry me through darkness.
I place my courage here to keep me strong.
I place my memories to keep me company.
I place my dreams and hope.
I place my strength and I feel your power.
I thank you for my wings to fly.

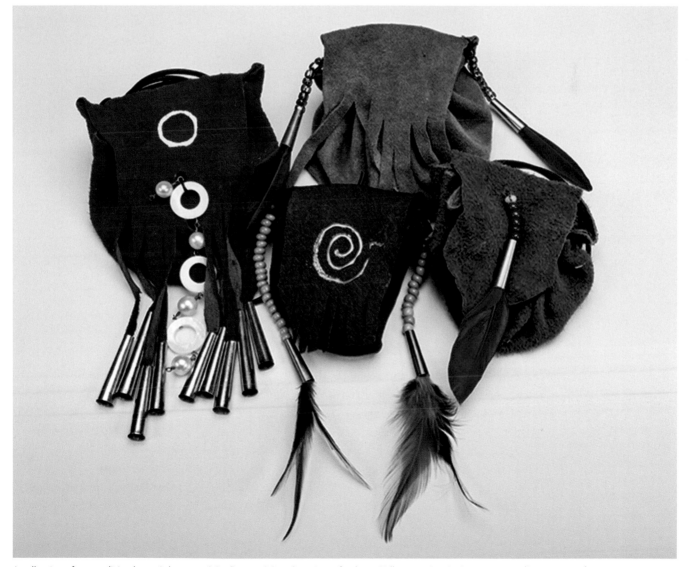

A collection of my medicine bags. I decorated the flaps with beads, paint or feathers. Follow your inspiration to personalize your pouches.

Find Your Tribe

Create a hand map to identify and connect your tribe.

Contributed by Jill M. Berry

Journal page or watercolor paper, 8" × 10" (20cm × 25cm)

Single sheet of computer paper to trace your hand

Pencil and eraser

Scissors

Stencils

Ink pads

Stencil brush or cosmetic sponge

Colored pencils, watercolors or markers

Scraps of maps or collage elements

Decorative tape

Fine-tipped black pen

Letter stamps

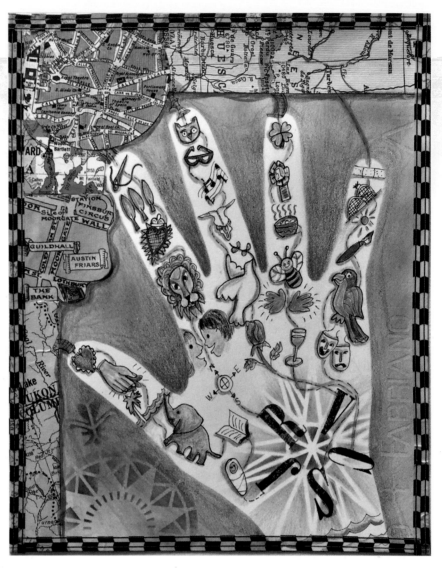

MAP OF MY HAND HOLDERS
Jill M. Berry
Mixed media and collage on paper
10" × 8" (25cm × 20cm)

In the east, the energy is about becoming new again or seeing things with fresh eyes or a child's mind. This exercise is all about discovery, in particular, discovering or finding your tribe. Since I use mapmaking as a tool for exploration and storytelling, and since we all traced our hands to make artful beginnings as children, I decided a hand map was in order. For me, the hand symbolizes creativity and support. Those who have figuratively or literally held our hand on our creative journeys are our tribe.

A number of visual traditions combine to make what we love so much about maps. There is the compass rose, a symmetrical, elaborate geometric design that has at least four points that represent north, south, east and west. There are neat lines, the graphic borders that define the edges of the map. There are routes, streets or borders defining areas of land, and in pictorial maps there are symbols or illustrations of what is seen along the way. We will incorporate some of those traditional map elements in our hand maps.

Start by making a list of five people who are important to your sojourn through life, then assign an animal to each of them that your inner child might want to have along. Each of the animals I selected reminded me of my individual tribe members and offered something to the creative passage. Here are some examples: Owl: wise, quiet strength. Elephant: loyal, smart. Lion: fierce, authoritative. Bumblebee: industrious, flight. Parrot: color, spontaneity. Continue to make notes about your relationship with each tribe member that could be drawn in some symbolic or literal way. You could also use collage for this whole project without drawing a thing.

Make a list of attributes of each tribe member that could be illustrated with a small symbol to add to your map. I came up with the idea of having the palm of my hand be the base of an island off the mainland of life, and each finger a promontory with a path of a tribe member. The promontory is connected to the mainland by a bridge.

1 Outline your hand with pencil on a piece of white paper the size of your final piece. Cut the hand out carefully as you want to use both pieces to mask.

2 Place the hand paper on the page you want to use as your final piece. Load a stencil brush with color from an ink pad. Brush from the center out, holding down the paper hand to use it as a mask.

3 Decorate the wrist area with stencils. Use the background piece of your cutout hand as a mask if you want to keep the color inside the hand. Draw or stencil the initials of your tribe members in a circle. This will look something like a compass rose.

4 Stamp or draw the initials of your tribe members in a circle over the stencils.

5 Collage the mainland area on your map with map scraps.

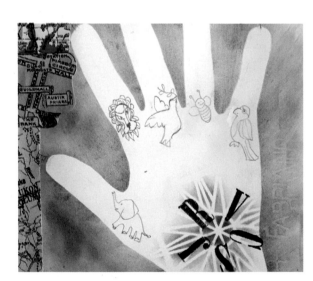

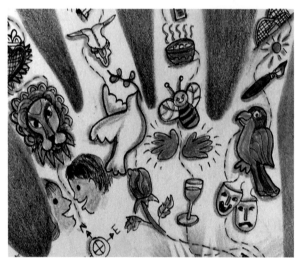

6 Make a list of five members of your tribe. Assign each of them an animal guide that matches your relationship with them. For example, my mother is one member of my tribe, and I assigned her the elephant since it is a smart, patient and funny animal that is very loyal. Make a list of attributes and symbols that remind you of each of your tribe members. Make them very simple. Sketch the animals on the map.

7 Continue adding symbols to each pathway and color them in with watercolors, markers or colored pencils. Connect them with pathways that lead to the initial of the member. Add bridges from the fingertips to the mainland. Decorate as you wish and finish off with decorative tape for neat lines.

Dreams

Catch your dreams.

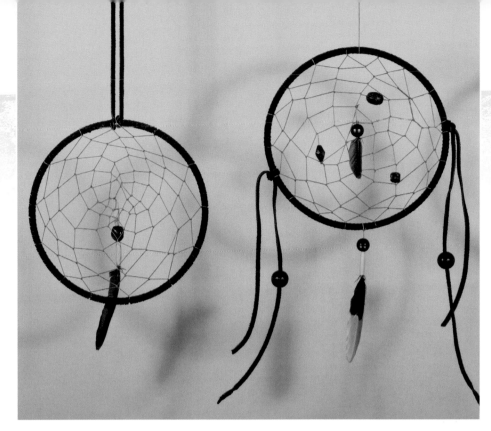

A selection of dream catchers hung on a piece of twine

MATERIALS

Metal or
natural hoop

Leather wrap

Waxed linen cord

Glue

Feathers or beads

Dreams speak to us in a symbolic and personal language. Our dreams may appear quite different from night to night, yet there is usually a connected theme. What is the underlying theme? Have you been stressed out about something or someone? Are you nervous about an upcoming event? Are you tired of being tired? Many things play into our dreams.

Carl Jung believed that dreams are a window into the unconscious mind. He believed that while we sleep, our unconscious mind is working on finding solutions to problems we face in our conscious mind. I have solved many problems in my dreams through lucid dreaming. This is a way to interact within the dream while you are sleeping. It is like the director watching a scene unfold and then saying, "Cut, let's redo that scene." The first way to step into your dreams is to practice recalling them. Always write down specific details and events that occur in the dream including time, dates, places, people, objects, actions and other symbols that

you think are important. By piecing together the various parts of a dream, you will be able to start interpreting the meanings of the dream as a whole.

Do you not recall your dreams, or you feel that you don't dream at all? Maybe you just need to catch them first. Dream catchers come out of Native American traditions. They originated with the Ojibwe people and were traditionally hung above cradles for protection. The dream catcher we will make in this exercise is not like those used by the First People and no disrespect is intended. I adapted the project so you might find the materials at a craft store rather than in nature. The dream catcher is meant to hang near your bed swinging freely. It catches the dreams as they flow by. The good dreams know how to pass through the dream catcher, slipping through the openings in the web and sliding down to the dreamer. The bad dreams, not knowing the way, get tangled in the dream catcher and disappear with the first light of day.

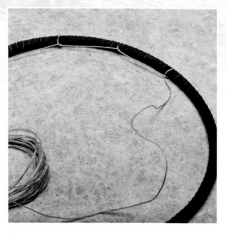

1 Pull enough leather wrap from the spool to tie a knot plus several extra inches; do not cut it from the spool. Squeeze a line of glue along a few inches (several cm) of the metal hoop and let it become tacky. Tightly wrap the leather around the hoop over the tacky glue. Continue all the way around the hoop.

2 When the leather is wrapped all around the hoop, tie a knot at the end and leave a few inches after the knot. I like to put a small amount of glue on the knot to keep it from slipping. Tie the two ends of the leather together to make a hanger.

3 Make the web with waxed linen cord. I used about 6 yards (5.5m) for an 8" (20cm) hoop. Tie one end near the top hanging loop of leather. The web you create will be determined by your first loops. I made my first round about 1½" to 2" (4cm to 5cm). Wrap the cord around the hoop and then loop the cord around in a hitch knot. Keep the cord taut but not too tight. End the first round about 1" (3cm) from the beginning of the first loop.

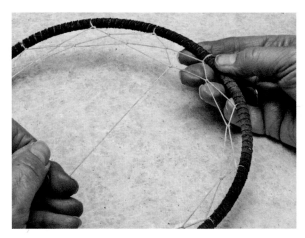
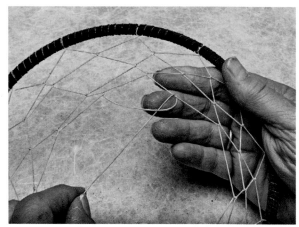

4 As you go around the second time, you will make your hitch knot in the middle of the first loop. Pull the cord tight as you weave your web.

5 Continue weaving inward in the same manner. You can skip some loops to change your pattern. If you like you can add beads as you weave your web.

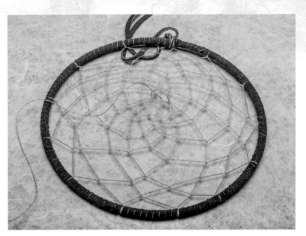

6 When you get to the center, tie your cord off with a double knot. You can also use part of the cord to tie beads or feathers to your dream catcher.

7 Tie a feather with the cord and then slip a bead over the knot. Seal with a dab of glue.

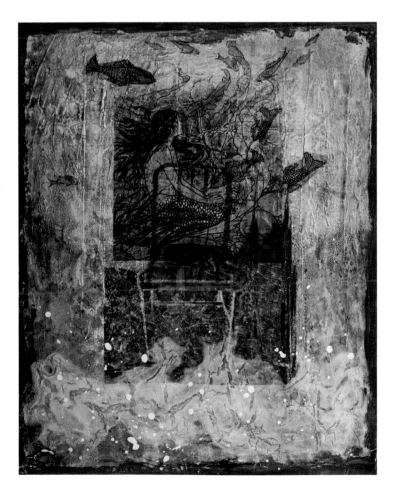

MERMAID DREAMS
Sandra Duran Wilson
Mixed media on panel
12" × 10" (30cm × 25cm)

I like to paint my dreams, but sometimes my dreams paint me. This is my underwater painting, the mermaid in the seat of knowledge with the fish swimming around her. I find myself putting together colors, symbols or imagery that recall a dream. Try painting your dreams awake.

Rebirth

Rework an old finished painting to give it new life.

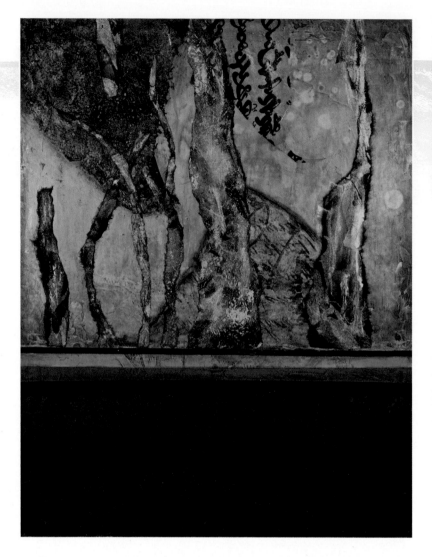

MOUNTAINS AND MESAS
Sandra Duran Wilson
Mixed media on panel
24" × 18" (61cm × 46cm)

Here is a painting that had been way in the back of the closet for six years before I looked at it and thought, *What was I thinking?* So here is what I did.

1) I had previously become attached to some areas of the painting and I was afraid to ruin it. But it never felt right, and after showing it a few times it went into hiding.

I like to reinvent myself every decade. I have learned to do this before the universe does it for me. We are always learning, growing and changing, and as artists, there are so many new resources that connect us. We no longer have to feel isolated in the studio. We can reach out across the world and talk to others who are grappling with the same issues. There are classes online, retreats and workshops galore, not to mention social media. Who will you be next? What will you do? Sometimes the choices may be overwhelming, especially if you are still working other jobs to support your art habit.

We are all doing the best we can with what we have right now. The beauty of reinventing yourself is that you will have new information tomorrow that you didn't have today. Everything we need

has already been given. Our journey is to find those things that we need, to dig deep within and unearth the buried treasure.

I remember thinking when I was a child of seven or eight that by the time I was twenty-one, life wouldn't be very interesting because I would know everything. Wow, I figured out how wrong I was long before I reached twenty-one. That was both the most wonderful discovery and the most terrifying. We will never run out of things to do, to be and to learn. Figuring out life is a big job. When we think we have figured out a small part of it and we have a system for making it through the days, wham, we get knocked off the balance beam!

The first reaction you have when your world is disrupted is to hold on tight to what you know. After all, it has worked for you

"I reinvent myself every decade. I discovered long ago that life would do it anyway.
Planned reinvention keeps me on my toes."
—*Sandra Duran Wilson*—

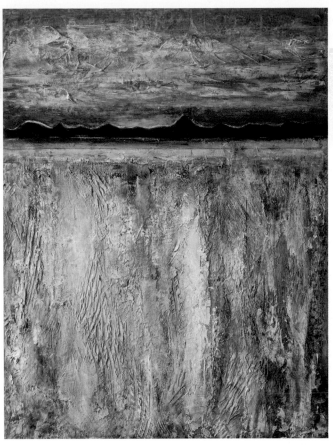

2) I pulled it out and turned it on its head, covering most of it with white paint. I used alcohol drops on the top to create texture and a comb tool on the bottom to add lines.

3) Here is the finished piece. Some of the textures can still be seen, but the color palette is completely different. The only part that survived was the mountains and mesas that used to point the other direction. I completed many paintings in the six years between completing this work. I had a lot more information to work with this time around.

in the past. But when you are grasping and holding on to things, your hand is closed. When you open your hand and release, you are open to receive. This is true for your mind, body, soul and creativity, too. Enter the gap between knowing and asking. This is where you can tap into a place of reawakening, a place to revitalize yourself and your muse. Take a brave leap into the unknown! The future is waiting to support you.

Apply this to your art practice as well. We call many things like art and medicine "a practice." This is because we are always learning and growing. The painting you made years ago would be painted differently today. I recall one of my art teachers telling me that after I had made five hundred paintings I would begin to understand painting. Begin to understand! Wow, it was intimidat-

ing and somewhat discouraging because I thought I would have it all figured out once I got the degree. Life has a way of challenging us. Take the challenge. I understood what she meant when I reached that point. Now that I have exceeded that number, I think I am getting to a point where I can trust my instinct.

All of my paintings are not masterpieces though. In fact, the more you paint, the more you expect of your work. So I have put some paintings away for a while and then brought them out years later when I have learned more. I have learned to give my art a second life.

In this exercise pull out a painting or two that you stored away and give them a second life. Have some fun, be daring, reinvent your work and maybe even your life.

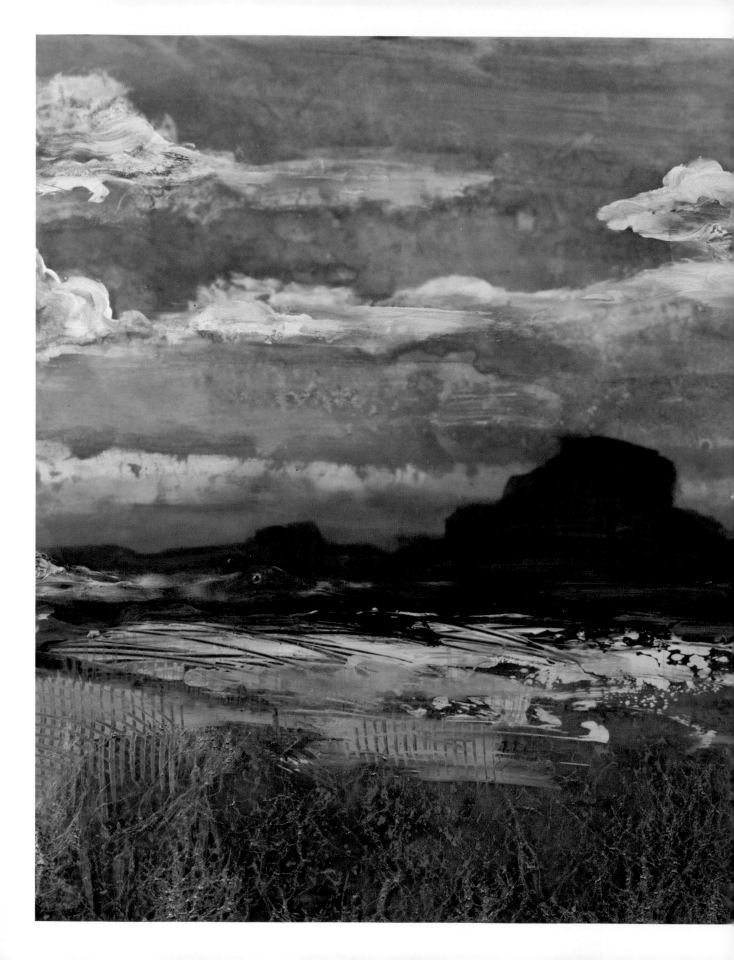

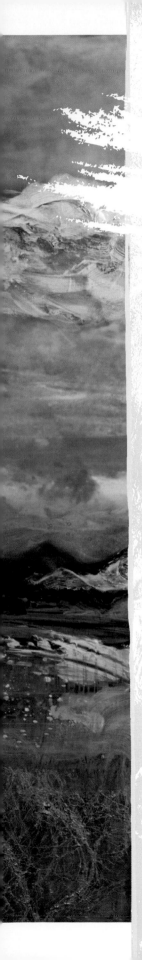

The Southern Gate

THE SOUTH OPENS TO THE SUMMERTIME.

The southern energies are about growth, trust, innocence and faith. Rapid change occurs like the teenager who changes by the minute, growing and maturing seemingly overnight. The heat of the summer and the storms move over the land and help the plants grow quickly. South is a time of childhood wonder and trust. It is a time when you reach out for fulfillment so quickly that you do not have time to question the path. Childhood and young adulthood embody this direction, and the transition must be tempered with patience.

The south is also paradoxical. Seek your vision in the south, follow it quickly. You must trust and be quick to adapt and change. While we are trusting and exploring we must also learn how to take care of ourselves and not burn out. This is the paradox, be both open and within. Maturing our self-love and nurturance. We learn love, and we learn how to let go of all that doesn't serve our highest good.

In this season we will practice testing and searching through our emotions. Try on a new role, test out a new creative medium, push the boundaries. The result is to learn to trust your instincts. Develop the wisdom to listen, even to the trickster. Remember to laugh and not take yourself too seriously. Have some fun.

PEDERNAL
Sandra Duran Wilson
Mixed media on panel
12" × 12" (30cm × 30cm)

Go With the Flow

Embrace the flow to create a poured painting.

Contributed by Kimberly Conrad

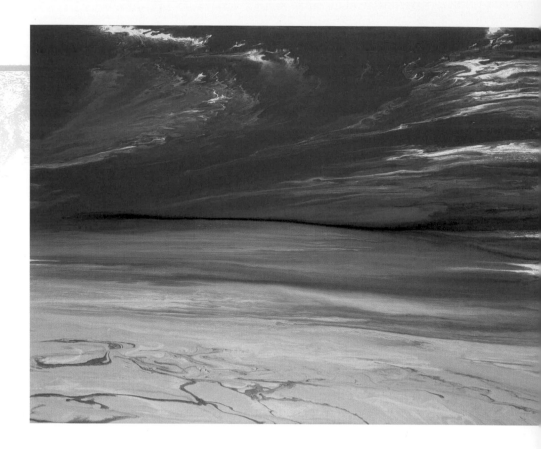

DAYS OF SUMMER
Kimberly Conrad
Poured acrylic
36" × 48" (91cm × 122cm)

MATERIALS

Plastic bin to catch excess paint

Watercolor paper, 140-lb. (300gsm) 11" × 15" (28cm × 38cm)

Piece of glass or Plexiglas, 8" × 10" (20cm × 25cm)

Pencil

Scissors

Fluid acrylic paints

Kitchen strainer

Plastic bottles with spouts

Distilled water

Spray bottle

I believe my true understanding of go with the flow began in March of 2006 when life as I knew it came to a screeching halt. My husband, an airline pilot at the time, suffered sudden cardiac arrest while playing racquetball. His life was saved by a savvy lifeguard at the gym. Though it was touch and go for a bit in the hospital, he received an implanted defibrillator and I'm thrilled to report that he is still here with us alive and well years later.

The things is . . . the FAA has this funny little rule about their pilots having implanted devices, so he lost his job, and thus began a whole new adventure. What's very interesting looking back, is that it was just a few months prior to the event, as we like to call it, that my art journey had begun to take its own turn.

I began as a palette knife oil painter but had recently fallen quite accidentally into pouring paint. Painting suddenly became my teacher, a life coach of sorts. When you pour paint, you have very little control. You not only have to trust the process that every little detour will culminate in the right ending, but you also have to find joy in the process, hold on and allow yourself to feel the excitement of the ride.

It has been such a metaphorical journey . . . this pouring. In life, we spend an exorbitant amount of energy strategizing and planning, often down to the smallest detail, but life has its own ideas and rarely unfolds as we think it will.

I am still a planner by nature, but I am so very conscious of the reality that the less I try and the more I relax and embrace the natural flow of life's moments, messages and events, the happier I am. In fact, I am quite often blissfully surprised! For me, to go with the flow means to trust the process—in life, in art, in relationships and in *all* things.

1 Tear off a sheet of paper from an 11" × 15" (28cm × 38cm) watercolor pad and using an 8" × 10" (20cm × 25cm) piece of glass, cut your paper, leaving about ¼" (6mm) or so of additional edge all the way around the glass. As the painting lies flat to dry, there will be a bit of runback, and we will cut this additional edge off in the final stages.

2 Using a strainer, pour your paint into a new clean bottle. Add distilled water and pop the lid on. In this demonstration I am using fluid acrylics by Golden (Teal, Cerulean, Iridescent White and Gold) in a ratio of three parts paint to one part water.

This is a the most critical step to poured painting because you must avoid clumping paint. Use distilled water because the chemicals in tap water will compromise the integrity of your paint.

Different colors of paint have different viscosities. The amount of water added will vary depending on the type and thickness of paint used. I like my paint to be the consistency of heavy cream so I can alter it as I spray water. Sometimes a bit less water is needed depending on the color; just add a bit at a time to avoid starting out with paint that is too thin.

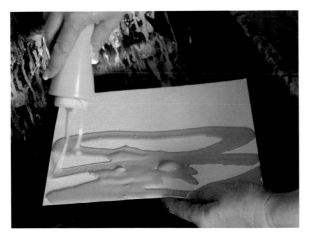

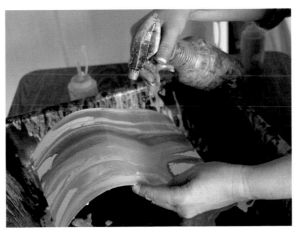

3 Hold your paper over a plastic bin and apply the paint in horizontal sections with your spray bottle.

4 Spray the paint with distilled water.

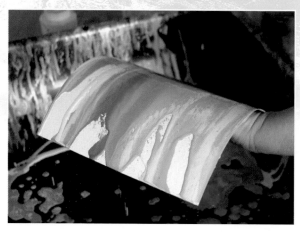

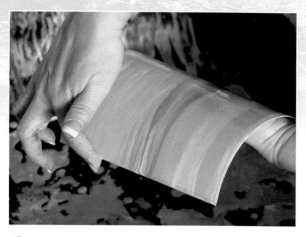

5 Apply additional paint, and spray water multiple times to let it run and create the desired effect. Once you have a composition you like, allow the wet, softened paper to fold over your forearm.

6 Use you finger to quickly wipe the excess paint from the edges of the paper to reduce the amount of run-back when you lay the paper flat to dry.

7 Lay the painting on the waiting piece of glass. Be sure to leave an edge of the paper hanging off the glass, to aid in lifting it later.

Once I laid this piece down, I realized I wanted to add more blue and green, so I quickly picked it up and applied more paint and water, repeating the process. This should be done only in the first 2 to 3 minutes; otherwise the paint will begin to set and reapplying will result in a mess!

8 Let your painting dry overnight. Now it is ready to crop and sign. Place the clean 8" × 10" (20cm × 25cm) piece of glass over the top of your dry painting, and crop to the exact size you want, removing the excess edges of the paper.

Tell a Story

Explore the theme you are living, expand it or change it . . . you are the author.

MY PHOTOGRAPH

A walk in an unfamiliar landscape can be like going to another planet: inspiring. I photographed this image while exploring White Sands National Monument in southern New Mexico.

We tend to create around the same themes because this is our story, but do you always recognize the themes? How many times have you felt like you woke up from a dream and wondered whose life you were in? This has been the plot of many a movie or book. Is it total amnesia, some sinister plot or have we simply lost our way and straggled along for years not being present? It is time to wake up and rewrite the script.

Exercise

We are going to write a story about discovering our muse. Your story can be any genre: science fiction, drama, comedy or even fantasy. Write your story and then illustrate it. It may be figurative, abstract, emotional or whatever your muse gives you. Use it as a springboard to explore a new path or medium. Make a sculpture, stitch a book, write a song, take photographs or dance your story. Or try them all. Here are some prompts to guide you to the next development.

- Where do you find inspiration?
- Is it a place, thing, activity or something else?
- What do your surroundings look like?
- Go somewhere—to the park, a museum, a bus—somewhere you will encounter people. Really look at those around you without staring. Look not only with your eyes but with your heart. Sketch a person or write about a person you see. Don't judge. The person may be anyone you are drawn to, but not someone you know. You will probably have only a few minutes to capture the essence of the character.
- What is a place you daydream about?
- Is it real or in your imagination?
- How do you feel when you are there?
- There is an open space ahead of you; what does it look like?
- What is the weather like?
- Where are you going?
- Whom are you going to meet?
- The character you met earlier is your muse. What does your muse tell you?

MILAGRO
Sandra Duran Wilson
Mixed media on panel
14" × 14" (36cm × 36cm)

My painting _Milagro_, which
means miracle, is where I
found the ladder leading up
to the window to the sky. It
is inspired by a real place in
northern New Mexico.

I have included my photograph, story and two paintings
as examples.

My Story

I awaken to see what appears to be snow all around, yet it
is not cold. It is not sand either. It is a strange material like
dry water. I walk toward the horizon feeling the crisp dry air
on my face. The sky sparkles like turquoise and white fluffy
clouds that look like cotton candy float by. I walk, the scenery
changes and I see a building in the distance. I hear a cry! I can't
tell if it is human or animal. The hairs on my arms go up. A

wind swirls around me, and I sense a presence. That is when
I see him. He is dirty and wearing old clothes. He doesn't look
like he has had a bath in a long time, but his eyes are shining
like beacons behind a shaggy head of hair and a crusty beard.
I ask, "Did you scream?" He does not answer, he just points
toward the horizon, to the structure. He gestures for me to go
to it. I question him, but he doesn't speak, just points.

As I walk toward the building, I sense a presence follow-
ing me. A raven flies overhead and I hear the scream again. It
is the caw of the raven, laughing at me. I continue to struggle
through the gypsum, a dry, sand-like substance. I feel like I

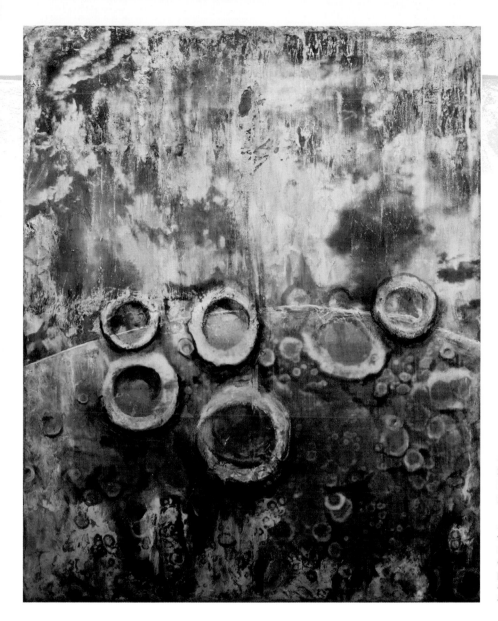

DANCING LIGHT
Sandra Duran Wilson
Mixed media on canvas
20" × 16" (51cm × 41cm)

Dancing Light is my imagined version of looking back to Earth from the upper reaches of space. My imagination is piqued by images of galaxies and outer space, science fiction and theoretical physics.

am sinking down, it is pulling me under. I panic and struggle. The raven flies overhead cawing and laughing. I get angry and struggle more and sink deeper. Then I hear him in my head say, *Stop struggling and let the gypsum carry you to the ladder.* I don't see a ladder, but I talk myself down and begin to breathe. I close my eyes and feel the joy of my creative life growing stronger inside my heart.

When I open my eyes, I see the ladder leading up to the sky window. The gypsum now supports my weight and I move toward the rungs of the ladder. I climb as the raven chases and dives at me, trying to knock me off the ladder. I yell, "What are you doing, I am trying to fly like you." The raven says, "You must climb beyond the sky to find what you are looking for." So I climb until I am beyond the atmosphere of the earth. I am in space looking back at the ground and the sky. I hear the old man saying to me, "You have reached the first level of your creativity. Do not be afraid. Trust that the ground supports you. The raven was not trying to knock you off the ladder or taunting you; she was keeping you aware of your surroundings so you didn't fall or give up. Trust in your path, climb and discover new worlds. Keep climbing to the stars."

Now, whether you write or paint, tell your story.

A New Perspective

Shake things up and break free of constraints.

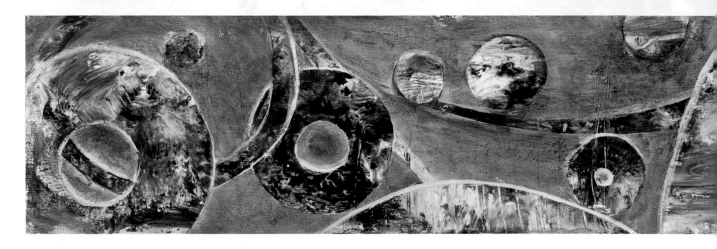

MATERIALS

Spray bottle of water

Watercolor or mixed-media paper

Scissors

Gesso

Foam roller

Frisket film or shelf liner paper

Acrylic paints—
Anthraquinone Blue, Quinacridone Gold, Pyrrole Orange, Diarylide Yellow, Sepia and Titanium White

Brushes—synthetic flats

Liner brush

Pencil

Palette

When I was a kid I used to love to look at the world upside down. I would lean against the wall and stand on my head. I pictured myself walking along the ceiling and jumping to get through the doorways. In my childhood perspective, the furniture all stayed on the floor, now turned upside down, and I could roam through the rooms jumping and climbing. Even as an adult when I was stumped, I would lie on the bed and look at the room upside down. I would be able to get a new perspective and many times find unique solutions.

You don't have to stand on your head to get a new perspective in your artwork, just shift your point of view. When we are young our imaginations are so flexible and agile. As we age, sometimes our expectations and perspectives stiffen and become a bit more predictable. I propose that we mix things up.

Our brains come to expect to see a landscape in a traditional horizontal rectangle, and abstract art tends to be in a vertical orientation. This exercise will help you break free from predictable perspectives. Shift the horizon line in a traditional rectangle format or attempt a tall skinny landscape or a long narrow horizontal abstract. Break free of traditional perspectives and shake up your world.

1) **SLOT CANYON** | Sandra Duran Wilson
Mixed media on paper | 19" × 6" (48cm × 15cm)

2) **SOUNDS OF STRATA** | Sandra Duran Wilson
Mixed media on paper | 19" × 6" (48cm × 15cm)

3) **IN THE DISTANCE** | Sandra Duran Wilson
Mixed media on paper | 12" × 9" (30cm × 23cm)

4) **SKY WINDOW** | Sandra Duran Wilson
Mixed media on paper | 12" × 9" (30cm × 23cm)

5) **LONG DAYS OF SUMMER** | Sandra Duran Wilson
Mixed media on paper | 6" × 19" (15cm × 48cm)

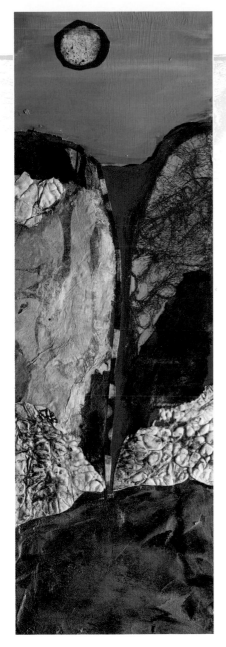

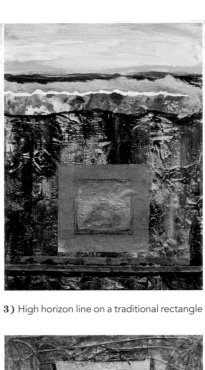

3) High horizon line on a traditional rectangle

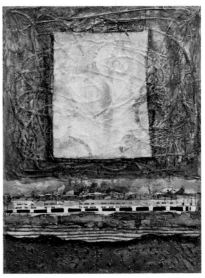

1) Tall skinny landscape

2) Tall skinny abstract

4) Low horizon line

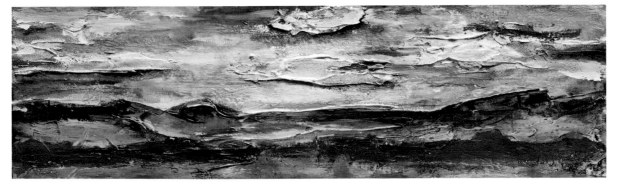

5) Long narrow landscape

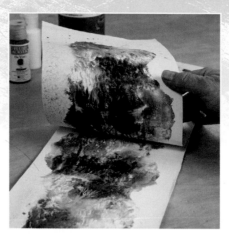

1 Cut a large piece of watercolor paper into two or more long, narrow pieces. Mine are 19" × 6" (48cm × 15cm). Apply two coats of gesso on both sides, letting dry between coats. When the gesso is completely dry, apply a few drops of white, Quinacridone Gold and Anthraquinone Blue over the surface of one of the gessoed papers. Mist lightly with water and place the second gessoed paper on top of the wet paint.

2 Twist and rotate the pressed strips of paper, then carefully pull them apart. Rotate the paper and keep dragging the paint over the surface. You are using the second piece of paper like a brush to move the paint around.

3 Pick up the paper and rotate it to distribute paint in a different area. Be careful not to overmix or it will get muddy. Now you have two backgrounds to choose from.

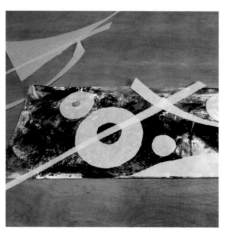

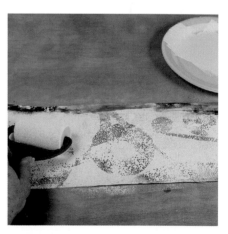

4 Determine the shapes you would like and draw them on the paper side of a sheet of frisket film. Use scissors or a craft knife to cut out the shapes. You can try a shelf liner paper that is removable to get a similar result.

5 After cutting out the shapes, remove the backing paper, put the sticky side down onto your painting and gently press the film onto the painted surface. Make sure to press down firmly on the edges of the shapes.

6 Put Titanium White onto the palette and use a foam roller to paint the entire surface. You can use a brush for a different look. The roller will give it more of a spray-painted look. Let it dry.

7 When dry, carefully remove the frisket film.

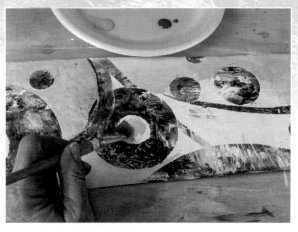

8 Make sure all the film is removed and determine your glazing colors. Apply a diluted layer of yellow over the white. I am using Diarylide Yellow diluted with water to the consistency of cream. Brush it on and blot some off if it is too thick. You want to see some of the underlying texture.

9 When the yellow is dry, repeat the process using Pyrrole Orange diluted in the same manner. Apply and blot some off. Let it dry.

10 When dry, use Sepia to add a bit of dark in certain areas to create depth.

11 Use a liner brush to accentuate the shapes using white paint.

Animal Friends

You are never alone, listen for the whispers of your animal guide.

MATERIALS

Gessobord panel,
12" × 12"
(30cm × 30cm)

Acrylic paints—Cobalt
Teal, Yellow Iron Oxide,
Payne's Gray, Baltic
Green, Permanent
Violet Dark and
Titanium White

Acrylic gel gloss

Venetian plaster

Old credit card

Scouring pad

Paper towels

Spray bottle
of water

Brush

Palette knife

Deli sheet

Decoupage

Collage papers

Painted rice paper

Gel pens

Scissors

Pencil

Stencil

Gloves

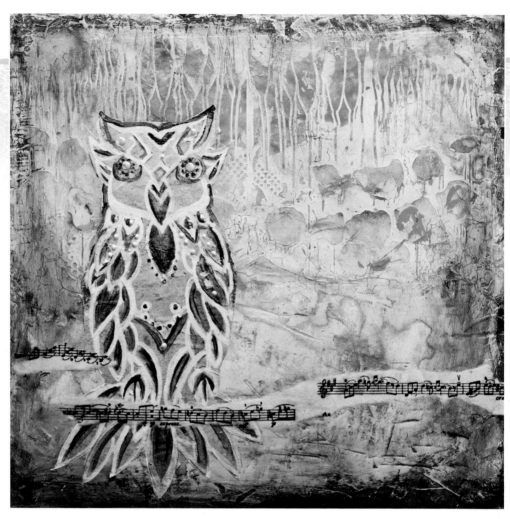

MI TECOLOTE
Sandra Duran Wilson
Mixed media on panel
12" × 12" (30cm × 30cm)

Which animal are you? Are you the courageous mountain lion or do you hold the goddess energy of Earth Mother like the turtle? Animals have always played an important role in human existence. We wouldn't be here without our kin. Learning to live with all creatures connects us and keeps us in balance physically, emotionally and spiritually. Learning about our fellow creatures brings us in harmony with the lessons that each may teach us. When you call upon the energy and traits of a creature, you are asking to be drawn into their strength and harmony. So how do you do this? Let me share the story of how my animal guides found me.

I grew up on the border of Mexico, and the land influenced me and shaped who I am. My two older brothers and I were pretty much free range, as was the norm for the 1960s. Both of my parents worked and Ava came to look after us. She would tell me stories of the *curanderas*— the plants used for healing—and the animals that were safe and the ones to stay away from.

Ava was very fearful of owls for in her native culture they represented witches. She told me a story of how she sent her sons out into the night to chase away a *brujo* that was masquerading as an owl. She said the boys saw it change from an owl to a witch. I had a very different understand-

ing of owls, so I was confused. There had always been an owl that would appear to me in the corner of the room when I was falling asleep. No one else ever saw it, but I wasn't afraid. It always felt like a protector. I was a child, and my world was magical. I would tell my mother about the owl, and she would smile that "That's nice, but it is just your imagination" smile. The owl would whisper lessons to me, very softly, and most of the time I didn't understand. It was like little songs that would put me to sleep. I knew the owl was my friend and protector.

As I grew up, the owl didn't appear as frequently, but I still heard the whispers. I also remembered which plants were for healing and the stories of the *curanderas*. My parents were healers, but they practiced western medicine. I liked their medicine, too, and would spend time looking at slides under my father's microscope. Other animals came to me, but the owl has always been with me.

The owl teaches us to be quiet and listen. The nighttime is when I listen. During the night I process all that has passed through my day and trust the wisdom of knowing. The Greek goddess Athena had an owl as counsel. Owl had the ability to illuminate any deception and speak the truth. Those were the whispers that owl had so long ago been teaching me. Trust in your intuition, do not be led astray, know yourself, be in your truth, trust your insights and stay in your power. This is owl medicine.

For this exercise let your animal guide inspire a painting. But first ask yourself what animal you are drawn to. What qualities does it represent to you? Do you feel a spiritual connection when in its presence? Search your memory and pay attention to which animals are calling to you. There are many wonderful books and resources online to study the characteristics and symbols of animals. In working with animal medicine, you want to pay attention. Ask for guidance and then listen. You may not hear words; perhaps it will be pictures or feelings or simply whispers to your soul. Follow, pay attention and remain open.

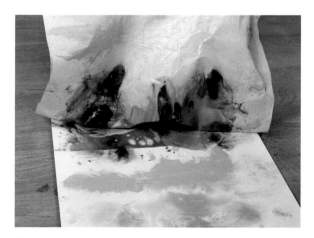

1 I like to do a quick start on my Gessobord background. I put a few drops of Cobalt Teal, Payne's Gray and Titanium White at the top, Baltic Green in the middle and Yellow Iron Oxide in the lower portion. Spray with water and then drop a deli sheet gently onto the surface. Hold onto it and move, drag and rotate it to distribute the paint. Use the deli sheet like a brush. Move the paper to areas that need paint. When satisfied, let your surface and the deli sheet dry. Save it to use as collage paper in a different project.

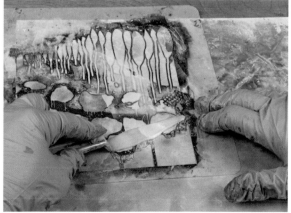

2 When dry, place your stencil down and use a palette knife to spread gel gloss over the stencil. Remove and clean the stencil immediately before the gel dries on it. You can also use your deli sheet to clean off your stencil. Let the gel dry thoroughly. This may be several hours or overnight. It will be clear when dry. Don't rush this step; it is important that the gel be fully dry in order to cure.

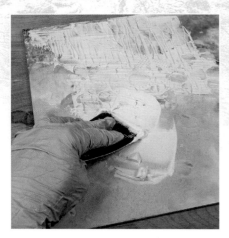

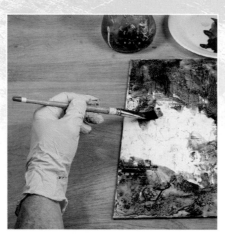

3 When the gel is dry, spread a thin layer of plaster over the painting with an old credit card. You want to use enough plaster to hold paint, but not too much because you will be removing much of it later. Let the plaster dry.

4 Apply a watered-down Permanent Violet Dark over the dry plaster surface and let it dry.

5 I am using gloves because plaster can dry out your skin. Use a scouring pad to remove some of the plaster. I also keep a damp paper towel handy to help remove the plaster. Never put plaster down the sink. Keep a bucket to rinse your scrubber in and dump the plaster outside. It is nontoxic, but it might clog your pipes.

6 As you scrub, aim to reveal the background color while leaving some paint and plaster texture. The area where you stencilled gel gloss will protect the underlying colors. Be gentle in the areas that have no gel to avoid scrubbing all the way back to the panel. Add back color if you have scrubbed away too much.

7 Create your animal guide. I am using a Japanese paper that I painted lavender. Trace your animal design and then use paint to outline your design. I used white and purple to outline my owl. Let it dry.

8 Add dimensional embellishments using gel pens.

9 Adhere your collage to the surface using decoupage.

10 I tore some music sheets to be branches and added them with the decoupage. Let it dry.

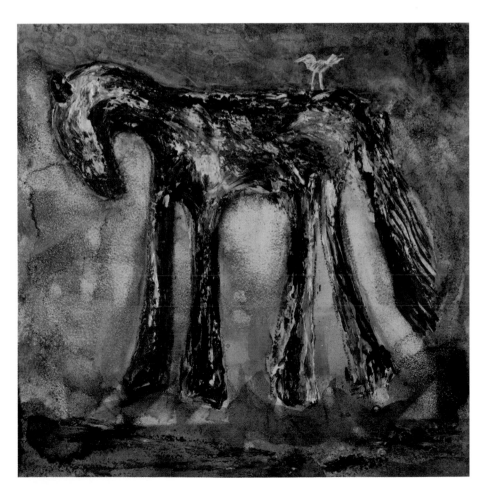

BUDDIES
Sandra Duran Wilson
Mixed media on panel
10" × 10" (25cm × 25cm)

In addition to the owl, I have always had a great affinity for the horse. I climbed aboard my first horse bareback when I was three years old. This painting represents me on Old Blue, the horse that I rode way back then.

Rekindle Passion

Weave your way into a new dimension.

MATERIALS

Paper

Colored markers

Pencil

Why do you create? What motivates you to manifest? When I was young I would make birthday and holiday cards for my family. I was the go-to person for sign-making in my grandparents' ceramic studio. I would enter my paintings in shows or simply make things for fun. I grew up in a small town and the school didn't have art classes, so my great-aunt, Santa Duran, who was a professional artist, taught my brothers and me to paint and draw. We also got to make some fun craft projects with our neighbor, a retired art teacher. I was fortunate to have art guides along the way. If you don't have supportive folks around you, this exercise will help you find the signs you need to point the way to your creativity.

In this project we explore beyond our typical creative routine and everyday commitments to excavate and mine our passions. There is a thread that weaves together our artistic journey, and you can follow it to map out your passion.

The thread that has held my interest and passion over all these years is materials. I love to play with materials like clay, paint, gels, gold leaf, resin and printed images. It was this love of experimentation that led to my first book. I had been teaching alternative printmaking and my coauthor and I hit upon the idea of writing a book on image transfers. The timing was right, and the passion kicked in with experimenting and exploring.

To begin, think about what it is that you are passionate about and begin weaving together your creative interests and goals. Maybe you have been working in collage, but you really want to explore sculpture. Or you are a quilter who has been hearing the call of photography. For me, new digital media is something I am fascinated with. That may be my next reinvention, or filmmaking. Start with a word or phrase and trace your creative passions outward.

1 Take out a piece of paper and begin to make a map of the thread that weaves your passions together. If you have ever done mind mapping, then this will look familiar. Mind mapping is a visual tool that allows you to visualize, link and structure your ideas to see where your creative thread is. I call this technique "Mind Weaving" and we will create it in a circular fashion.

Begin in the middle of your page with a word or phrase inside a circle. This may be *art, creativity, what I love to do*, any of these. From that idea, play with other words or ideas that are linked to this and follow your passion outward. Put these other circles and connect them with other ideas, weaving together your creative passion.

2 My love of materials and experimentation led me to work with cast acrylic. From there, I explored working in glass, but after several classes I decided that my passion was really with acrylic. This is how I began incorporating cast acrylic into my paintings.

Getting back to some of my earlier sculpture days was a big boost for rekindling my passion. I noticed in hindsight how it had been evolving for many years.

MORNING LIGHT
Sandra Duran Wilson
Mixed media on paper
6" × 6" × 3" (15cm × 15cm × 8cm)

3 After many years of combining cast acrylic with painting, I let the cast acrylic stand on its own as a sculpture. This fed the path I had been experimenting with in glass.

ABSTRACT REASONING
Sandra Duran Wilson
Acrylic resin and steel
9" × 36" × 3" (23cm × 91cm × 8cm)

4 Today I continue to work with all these materials, and my sculpture style evolves as I learn more about the nature of the materials. Most recently I discovered some new materials made for fabric that I am incorporating into my paintings. I have a feeling that they will find a way into the cast acrylic sculptures next. The weaving of ideas continues.

EMERGENCE
Sandra Duran Wilson
Mixed media on panel
10" × 30" (25cm × 76cm)

Planting the Seeds

Plant seeds of intention to nurture and manifest your desires.

ASPEN DANCE
Sandra Duran Wilson
Mixed media on paper
23" × 15" (58cm × 38cm)

MATERIALS

Seeds

Paper pulp

Bowl or plastic container

Gloves

Potting soil

Planting pot with drain hole and saucer to catch water

Water

Plastic wrap

Rolling pin, brayer or can

Cookie cutter or lid

Palette knife

Colored pencils

Tissue paper

Scissors

Glue

Fine-tipped pen

What do you want to see show up in your life? When it does, are you ready to nurture and care for it? You must plant and nurture the seeds of your creativity, health, dreams and desires if you want them to show up. First, let go of the negative chatter in your head. When you wake in the morning, greet the day with open arms, hope and excitement. Do you dread going to your job and trudging through another uninspired day? Take baby steps. Plant some seeds and nurture the changes you want to manifest in your life.

The south is the direction of planting and rapid growth. This is the time to grow your desires, tend to them daily and watch them flourish. Try unplugging or muting the negative voices. One of my

students drew a circle on her table and wrote *mute* inside the circle. When she would start to protest that her work wasn't good enough, she would reach over and hit the mute button. There is nothing like strong physical reinforcement to manifest change.

In this exercise we will create a ceremony to honor our intentions. First, gather your journal and begin to describe the life you dream of living. Perhaps you want to devote more of your time to your creative passions, whether painting, writing, cooking, playing music or dancing. Do you wish for more financial security in your life? Rather than focusing on lack, plant the seeds of abundance. Are you always doing for others, but not leaving enough time for yourself? Plant the seeds for self-care and nurture.

Whatever your desires, write them down. Now close your eyes and spend about five minutes imagining that you are living the life with these desires manifested. How do you feel? Engage as many senses as possible. What is your new job? Are you on a retreat, writing your book, composing a song or dancing in the moonlight? Feel it, sense it and engage with this life you seek. Now open your eyes and let's begin.

You will need a sunny window or garden in order to plant your seeds. I am using seeds from a plant called Talinum paniculatum. Every year I harvest its seeds and hold them until the next year. This reminds me of the continuation of life around the wheel of the seasons.

1 Gather your supplies. Place some paper pulp into a bowl or plastic container and slowly add water. Mix with your hands and add a small amount of water at a time. Continue to mix until the paper pulp is like wet clay.

2 When the pulp is workable, place it between plastic wrap and use a rolling pin, can or brayer to roll it flat to about ⅛" (3mm). Use a cookie cutter, lid or palette knife to cut out a shape. I am using a cookie cutter in the shape of a bird. Carefully use a palette knife to remove the excess pulp from around the birds.

3 Gently press your seeds into the pulp while it is still slightly wet and let dry completely. When the paper shapes are completely dry, remove them from the plastic. This may take a day depending on the temperature.

Small seeds that easily germinate work best. Some good ones are marigolds, poppies, pansies, cosmos or most annual flower seeds. I am using talinum seeds.

4 Use a fine-tipped pen to write the desires you came up with on the back of your dried seed shapes. If the paper is too soft, write your intentions on a card and place it next to your pot. Prepare your pot by adding potting soil until the pot is about two-thirds full. Water the soil and make sure you have a drain hole in your pot so your seeds won't get waterlogged. After the water has drained, place your paper with the seeds into the pot.

5 As you cover the seeds with potting soil, make your intention known by creating ceremony and intention. My intention was self-care along with laughter and joy.

When I planted my talinum seeds, this is the ceremony that I used upon planting: *I call on Mother Earth, Father Sun and Sister Moon to hold my seeds in the soil, to nurture and entice my intentions to break free from their seedpods.*

Pay attention and protect the small seeds as they break open and begin to grow. Lightly sprinkle some water on top and place your hand on your heart and feel your intention inside of the seeds. Feel them safe and tucked away. Imagine that in the darkness of the earth they are gathering strength to burst forth into the light.

Every day honor your plants with your presence and attention. Think about your intentions that are gathering energy. Check the soil and when it is dry, water it, make sure your seeds get enough sun and do not get too hot or too cold. These are your intentions that you are nurturing, and they need to be looked after if you want them to grow. Soon you will be rewarded with little green shoots poking their heads above the soil.

6 Continue your nurturing, and when the sprouts are big enough you may need to transplant some to other pots or put them in the garden. In step 5 you can see that I had a lot of sprouts come up. Part of my self-nurturance was to let go of some of the things on my plate so I am not overwhelmed with another to-do. I removed some of the sprouts so others had room to thrive. I looked at this as what I needed to do in my life. I said no to many commitments and stuck with a simple morning routine of walking. No trip to the gym, no exercise regimen, just walking. It was a blessing. My plants grew larger, and when the weather was warmer I transplanted them outside.

7 Here are my seedlings that have grown tall and strong. They made beautiful flowers, and when the first freeze came I harvested the seeds.

This cycle of nature reminds me to continue to cultivate fresh ideas and intentions. Next season when I plant my seeds, my intention may be the same, but it will probably manifest in a new manner. I must make sure I am paying attention. My seeds are currently drying for next season. Maybe next year I will take up biking!

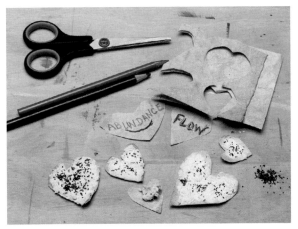

8 Here is an alternate idea for how to incorporate your desires and intentions. Cut some tissue paper about 4" × 6" (10cm × 15cm) and fold in half. Write your words on the tissue paper with colored pencils. Place some seeds into the tissue and use the glue to seal the edges. Let it dry. I plant these in the same manner.

9 You may also try this with some handmade or heavy-weight paper cut into shapes, such as the hearts shown here. Write your words on the paper cutouts and put some of the wet paper pulp onto the cutout shapes. Press some seeds in the wet pulp and let it dry. Proceed with the same intention-setting ceremony when planting.

Angel Art

Create environmentally friendly sculptures to leave in nature.

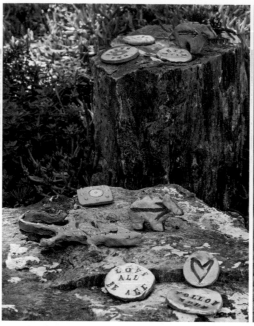

Integrate your animal sculptures in nature where people are likely to find them: on a park bench, a walking trail, bus stop or some other public spot where they may be discovered. I put some in my front garden and it didn't take too long before they returned to the earth, or maybe someone found them.

MATERIALS

Clay

Cookie cutters

DecoArt Metallic Lustre cream wax

Watercolors and brush

Letter stamps

Paper pulp

Plastic wrap

Parchment paper

Brayer

Craft knife

Angel art is my environmental version of guerilla art. The guerilla art movement got its start in the streets of the United Kingdom mainly with graffiti artists. It morphed into a bigger genre and a way for artists to anonymously share their art in public places. I think of angel art as a way to spread some joy and happiness in the most unsuspecting places. The anonymity of it helps the artist to escape from the ego of making art for recognition or money.

There are many ways to spread angel art. My hometown of Santa Fe, New Mexico, is populated with artists of all genres, from actors to painters to writers and musicians. Back in the 1970s, in the infancy of performance art, there was the Rubber Lady. She would appear at gallery exhibitions, museum shows and public events clothed completely in rubber from head to toe. Even her face was covered in a rubber mask. She disappeared from the scene many years ago, but in 2010 a short documentary was made about her.

There are many other examples of guerilla art in Santa Fe: pop-up installations of knitted scarves on fish sculptures, single shoes randomly placed in the median along a certain street, and sculptures attached to road signs. I love living in such a creative community. You too can contribute to the creativity of your community. In this exercise we will create environmentally friendly sculptures made from natural materials designed to return to the earth.

SHARE YOUR CREATIVITY

I like to put sweet love notes or positive affirmations inside library books for others to happen upon. Another favorite is to leave a beautiful journal full of drawings in a public environment asking the finder to add to the art and pass it on to others.

1 Condition the clay by working it in your hands. When it feels pliable, place it between sheets of plastic wrap and use a brayer to roll out to a thickness of about ¼" (6mm). Use cookie cutters to cut out shapes and place them on a piece of parchment paper.

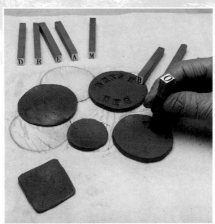

2 While the clay is still pliable, use letter stamps to impress messages or words. I sometimes make sentences by writing each word on a separate shape. Loosely drape plastic wrap over the pieces and let them dry slowly to prevent cracks and warping. Let them dry completely. This can take a few days depending on the temperature and humidity of where you live.

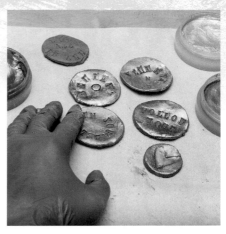

3 When the pieces are dry, paint them using metallic cream wax, which is water-soluble.

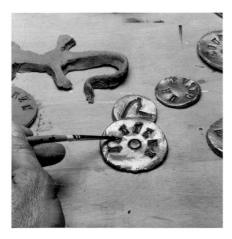

4 Use watercolor to enhance the words and paint your pieces.

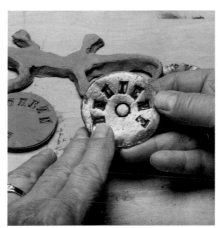

5 Finish with metallic cream wax.

6 Sculpt animal shapes by hand with clay. I used a craft knife to cut around the clay to make a lizard shape. Add water to some paper pulp (sold in packages for papier mâché) and sculpt a bear or two. Let them dry for several days. Paint the animals with watercolors. If you leave them in nature, the elements will eventually help them to disappear, leaving no trace, unless they are found by a lucky stranger.

Collaboration

Exchange reference photographs with a friend for a unique point of view.

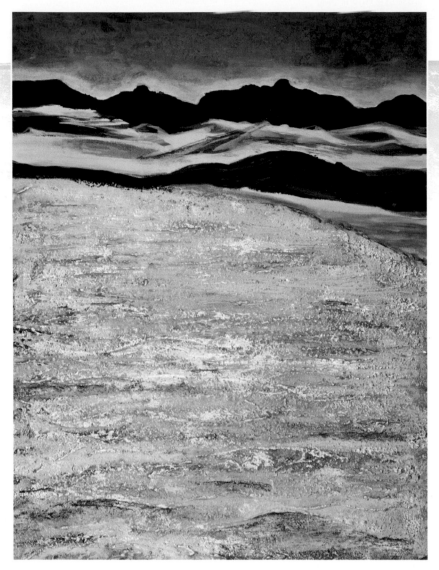

What I see through my eyes is only a slice of reality. When someone else looks at the same thing, they are looking through their filters and not mine. We may look at the same thing and see completely different images. I love to collaborate with others to enhance this experience. This is a beautiful way to connect with others around the planet beyond the artist friends you typically hang out with. It is a wonderful way to see the world through others' eyes. Reach out to a friend across the world and exchange images to create something new from someone else's original point of view.

There are a couple of ways to approach this exercise. You can send a photo of a place you have been. Or you can create and photograph an environmental art piece in nature like a pile of stones or leaves. (Think of Andy Goldsworthy-style environmental art.) Take it a step further and use a photo app to alter the image as I did with the photograph of a rock arrangement I sent to my friend Amy Flowers. Amy is a mixed-media artist in Ohio who creates museum installations around the world. We met in Santa Fe where she regularly teaches art workshops.

WHITE SANDS OF TIME
Sandra Duran Wilson
Mixed-media acrylic on canvas
20" × 16" (51cm × 41cm)

I began my painting with the same perspective as the photograph. Having recently been to White Sands, I knew that this is what most of the terrain looked like. There are tall dunes of gypsum, but not much sand. My piece was about the texture and patterns that the wind makes on the dunes. I built up layers of gel medium, paint and even some of the gypsum that I had collected from my trip. The piece literally sparkles with the gypsum.

This is the photo that my friend Amy sent me of the White Sands National Monument in New Mexico. The perspective of the photograph is from a low point looking up. We originally sent each other three images to choose from. I chose this one as my reference because I had recently been to White Sands. I had collected some of the gypsum dust from the dunes that had ended up in my car, and I wanted to incorporate it into my piece.

I snapped this image with my smartphone at Plaza Blanca in New Mexico, where Georgia O'Keeffe once painted. Hikers passing by this spot would leave a rock, and this spontaneous sculpture emerged.

I altered and cropped my original photograph in the PicsArt Photo Studio app then sent it to Amy. This is the image she used to create *The Frozen Dance of Rocks* below.

In the final piece, Amy used tissue adhered with clear tar gel to create the rock and stone wall textures, and then layered acrylic glazes to build depth of color and texture. This painting exercise inspired many others, such as those on the left.

THE FROZEN DANCE OF ROCKS
Amy Flowers
Mixed media on paper
12" × 18" (30cm × 46cm)

Here are a couple of process shots leading up to another of Amy's paintings inspired by my photos. The images show a gradual layering of tissue paper, acrylic and charcoal in vertical format.

Recognizing Intuition

Quiet the chatter and create fearlessly.

Contributed by Tonia Jenny

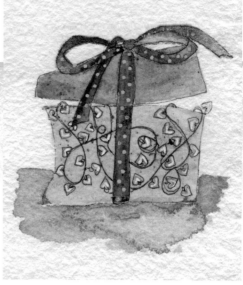

MATERIALS

Acrylic medium

Acrylic paint pens

Fine-point permanent pens

Hemp or watercolor paper

Soft paintbrush

Teabags, emptied and dried

Water brush

Water-based markers

Watercolor paints and pencils

Sometimes it's hard to distinguish if some bit of guidance you're receiving from within is coming from your intuition (also known as the higher self) or from your ego. I've learned that if I'm not in the right headspace, intuition's answer cannot be heard over the domineering "help" from the ego. With practice, this becomes easier to recognize and I've finally learned that if I want to hear what my higher self has to say, I truly need to meditate. If you can learn to quiet the inner chatter of the mind—even just five minutes does wonders—you can get in touch with your intuition.

The ego's guidance is rooted in fear and will always do its best to gain control over any situation in order to keep you alive and as unchanged as possible. (Change is unpredictable, which terrifies the ego.) Intuition on the other hand is always content with your expressing who you truly are, free of fears of rejection. Intuition guides from a space of love and security. It will not seek happiness outside of itself.

The ego will often find the need to prove its logic, formulating a debate with many facts to support its claim. Intuition already knows the truth and will not seek justification.

So what exactly does all of this have to do with making art? There is great value in creating from an intuitive place rather than consulting the ego (i.e., the inner critic, in the case of creativity). By creating what our higher self wants to express rather than what we believe will get us outside recognition and validation, we create in a way that is unique and most likely to resonate with others because of its powerful authentic energy. This is the irony. Let go of what you believe your art needs to be, and chances are it will be stronger and loved by others.

This exercise is a creative challenge designed to help you tap into the process of creating intuitively. This exercise was inspired by one of Elle Luna's 100 day projects (the100dayproject.org) that I participated in through Instagram called #100DaysOfTeaStains. I began with torn bits of brewed teabags, collaged onto hemp paper. Each day I would look at the torn tea-stained shape and let my imagination tell me where to go with it. Sometimes obvious imagery would emerge similar to seeing animals in the clouds in the sky, but other days it was more difficult and I had to force myself to not overthink it and just draw and paint and see where it went. This was a challenge just for me and I allowed myself to take risks and go in previously uncharted directions—such as illustrating pieces of clothing or figures of people—things I had never explored before.

My hope is for you to learn, as I did, that we have so much more inside of us than we can ever realize and that the wellspring is never truly dry; it's only the ego that fears it so.

1 Pick a teabag and tear off a portion of the paper. If it's a larger piece, it may need to be folded to fit the surface paper. Use acrylic medium and a soft brush to adhere the teabag scrap to the surface paper. I used hemp paper, which I love, but watercolor paper would also work well. Let the piece dry thoroughly. I like to do ten to twelve of these at a time, sandwich them between pieces of parchment paper and press them in a bookbinding press.

2 Look at the shape and see if anything emerges for you. Begin adding color to the scrap or anywhere on the paper using a water brush and pan watercolor paints. Here I immediately saw a pair of pants, so I added a waistband, but I also kept the color loose and wasn't worried about creating any particular type of pants. The idea is to plan as little as possible.

3 Add more defined patterns, shapes or details using markers. You can continue to make things up as you go. Continue to look at the variations in the tea stains and the watercolor and see where your intuition tells you to go.

Finally, add intricate details and areas of depth using fine-point pens and paint pens.

Here is a before and after selection from my 100 Days of Tea Stains art challenge. Remember, if no specific imagery emerges in the piece right away, don't worry and don't overthink it. Even if the piece ends up purely abstract, that's great!

Accidental Masterpiece

Trick your inner critic and create with wild abandon.

SEEDS OF INSPIRATION
Sandra Duran Wilson
Mixed media on canvas
24" × 24" (61cm × 61cm)

The finished piece was completed with stamping, bringing forth pattern in some areas and pushing it back in others.

Attachment and perfectionism can stop creativity and innovation in its tracks. When working on a painting, you may become attached to an area you love. I am guilty of this myself. I will work all around it trying to preserve the precious part and not integrate it into the whole. This keeps the painting from becoming cohesive. How do you get over this?

One way I work around this is to have many pieces in process at the same time. I also keep a canvas, panel or paper around to apply leftover paint, clean off stencils, press stamps, apply the last bit of gel, etc. I am not using the canvas to merely apply the leftover products, I am applying them in different areas. This is not the same as painting over an old painting or redefining a not so successful piece. This is what I call the accidental masterpiece and it invites another part of your creativity to come out and play. It is a way to keep the critic at bay and to let your muse experiment without expectations.

These accidental masterpiece panels that I keep around provide me with some new color combinations that I would not have thought of because I may layer paints from several different paintings over the course of weeks. I jump-start a piece when I clean a stencil onto the surface. When the painting reaches a certain point, it begins to speak to me. I listen and follow it where it wants to go. This may only be a background, but perhaps it has a color palette I want to explore or an unusual texture I wish to enhance. Sometimes it just looks crazy and so I keep layering. It will finally speak if I listen and look.

Make a habit of reusing your supplies rather than putting them down the drain or in the trash. I'll use deli papers left over from moving paints, papers used for masks—you get the idea. It is also fun and inspirational to trade papers with others.

Exercise

In this exercise the goal is to let go of the outcome and allow freedom to take the reins. Embrace your inner scientist and experiment with some of your leftover supplies, papers and canvases. When you sense something cohesive, stop and reevaluate. It may be time to look at values, composition and other elements that make a good painting. Remember to work the whole painting, sometimes rotating it as you paint.

It can help to set a meditation timer. I recommend the Emotional Freedom timer by Elliott Treves on the Insight Timer app. It's a great tone for letting go.

A) This first canvas had been hanging around the studio for some time. I was using it to clean off some stamps I'd made, remove paint from a foam roller and dabs of paint, paste and gel. I was feeling rather attached to it after several people remarked how they liked it. Part of me would think, *You can't like that, it is just swipes of paint and messes of stamps!*

B) This accidental masterpiece was calling on me to intentionally work on it. I tried a few things to take it to the next level, though I had some fear about messing it up . . . and I did. It felt overworked and the composition was more of a repeated pattern like wallpaper.

C) So I covered up most of it with white and began to work on varying scale and bringing back the joyful and playful feeling.

D) I added some variation and repetition and covered up some busy areas. See the finished piece on the facing page.

Focus

Take a painting from scribble to structure.

Gesso

Mixed-media paper,
18" × 24" (46cm × 61cm)

Acrylic paints—
Cobalt Teal,
Titanium White,
Green Gold, Pyrrole
Red, Quinacridone Gold,
orange

Gloves

Palette

Markers

Foam rollers

Foam stamps

Ruler

Brayer

Scissors

Pencil

So far we have been working with intention because what we focus on manifests in our art. But sometimes the monkey mind takes over, which is when our thoughts jump all over the place. Taming our monkey mind takes work, but there are tricks we can use to make it easier. A friend of mine uses this trick when she finds herself having negative thoughts. She will say, "Cancel, clear," as if deleting a program on the computer.

How else can we tame the mind and stay focused? By honoring the impulse, rather than pushing it away. When we honor the monkey mind and let it have its way, it will play out and leave room for focus to come in. Focus can then be used to manifest the desires we have.

This technique may be easily adapted in other areas of our lives. That which we focus on is drawn to us. The law of attraction. This is where the cancel-clear comes into play. When you are focusing on your outcome and a negative thought pops up, hit the cancel-clear buttons in your mind and go back to focusing. Don't give yourself a tough time for losing focus, just let go and return to where you were.

So in this exercise just go with it! To get started, grab a selection of your favorite supplies and a large piece of mixed-media paper (18" × 24" [46cm × 61cm]). It's time to scribble and play!

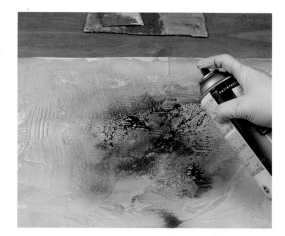

1 Gesso both sides of the paper and let it dry. This will help keep the paper from buckling. Put your gloves on and squirt out some Cobalt Teal, yellow and Titanium White. Use your hands to move the paint around and finger-paint. Engage your restless self and play like you are 5 years old again. Remember that feeling, embrace it.

2 When the base layer is dry, squeeze out some red paint on your palette and load up a foam stamp. Start stamping all over your paper with abandon. Repeat with another stamp and color.

Here are twelve scribble squares that resulted from one of my play sessions. Clockwise from top left: *Swirls of the Sea, Merry-Go-Round, Forest Floor, Balance, Circus Days, Fiesta, Contemplation, New Growth, Calming the Mind, Back and Forth, We Are All Connected* and *Seedpods*.

3 Load a textured foam roller with Green Gold and Titanium White and take it for a spin all over the paper.

4 Apply Quinacridone Gold to a brayer and add touches here and there.

5 Grab a couple of brush-tip markers in one hand or both and begin to scribble. By holding two, you can't get too particular. The point is to engage your monkey mind and let it run wild.

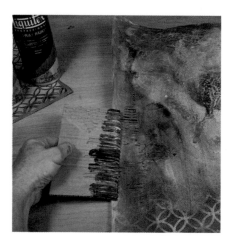

6 Smear on some orange paint using your whole hand in a few sections.

7 Now take a deep breath and let your paint dry. We are going to switch gears and begin to focus.

8 Turn the paper over and map out a grid of twelve 6" × 6" (15cm × 15cm) squares on your 18" × 24" (46cm × 61cm) paper using a pencil and a ruler, then cut the paper into twelve individual pieces.

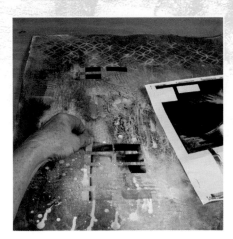 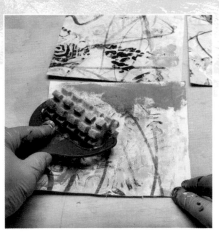 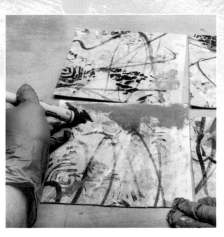

9 Focus on each individual square and look at its shapes, lines, colors and patterns. One at a time, mentally develop each square into a painting unto itself.

10 Use the same tools that you used on your large precut paper and embellish each square.

11 Add more colors and patterns.

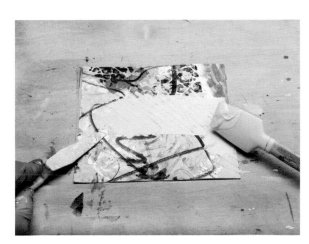 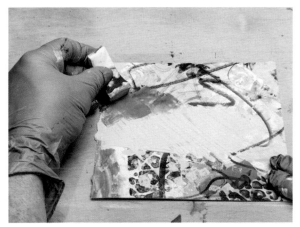

12 Cover up areas and add texture. Here I am using Titanium White with a touch of Pyrrole Red.

13 Continue to develop the compositions and focus on each individual piece. Listen to your inner muse. Rotate, add more paint, cover some areas up, even use a bit of collage. Each piece has a unique voice.

Awareness

Work within a set of limitations to expand your creativity.

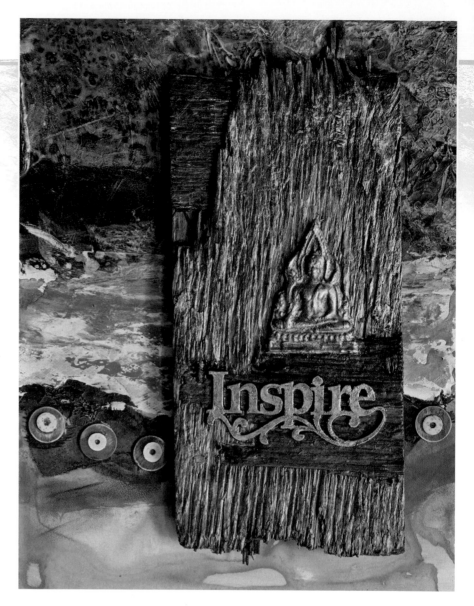

INSPIRE
Sandra Duran Wilson
Mixed media on panel
12" × 9" (30cm × 23cm)

This is a piece I completed using my materials in a limited fashion. I had this piece of delaminated plywood, which I picked up on the side of the road, hanging around in my studio for ages, and it was on the table, so in it went. I already had the painted background from a previous demo out and ready to go, as well as the copper pieces that I was going to use in another project but that didn't make the cut. I used two-part epoxy glue to add those to the panel and I used Aves Apoxie Sculpt, a two-part epoxy clay, to fuse the wood to the surface and the metal figure. The glue was used to attach the wooden ornamental word *Inspire*.

Have you ever felt overwhelmed when thinking about your next project or when confronted with the blank canvas or page? Maybe you have an idea for a project you want to begin, but you feel bogged down by all of the choices. What colors to use? What's my message? Where do I start?

Just as it's important to be aware of our surroundings and intentions, it is also important to be aware of our limitations. When I was younger and had a lot less, I found very creative ways to work around my lack of resources. A trip to the second-hand store would always inspire and great inventions would come out of necessity. When your resources are limited, that creative part of your brain kicks in and goes, "Hmm, I could try this or use that. . . ."

Usually when I am in the throes of creating, things fly, piles are made and stuff is everywhere. When I finish a series of works, part of my creative ritual involves putting everything back in its place. But inevitably I am left with a few things on the table. My challenge here was to use only those things plus a few paint colors. I did not allow myself to pull out my collage papers or use lots of different mediums or tools. In this exercise your challenge is to limit the tools and colors that are in front of you and use just what you have. Limit everything and get creative.

A) These are the limited supplies that I started with. I had a demo panel that had some crackle paste on it and a transfer of circles. I also collected a dryer sheet with crackle paste on it, some fabric, torn paper, a book page, some crackle paste and a wooden ornamentation of the word *Explore*.

B) Here is what I made. I didn't have to use all of the materials but I couldn't pull in any more. I took time working with the composition and layers.

I cut up the dryer sheet with the crackle paste on it and used geometry as my inspiration. The circles were balanced with triangles, and I layered even more circle pieces on top for depth. The book page didn't make it, but the fabric did. I painted the wooden *explore* to fit in with the color scheme. This piece was collected by one of my favorite people for her 90th birthday. She embodies the word *explore*.

EXPLORE
Sandra Duran Wilson
Mixed media on panel
12" × 9" (30cm × 23cm)

26

Road Map

Take a road trip for fresh inspiration.

TAKE THE HIGH ROAD
Sandra Duran Wilson
Mixed media on panel
10" × 8" (25cm × 20cm)

MATERIALS

Road map

Markers or pencils

Panel or canvas

Decoupage

Brushes

Acrylic paints—
Red Iron Oxide,
Cobalt Teal, Diarylide
Yellow, Quinacridone
Burnt Orange,
Payne's Gray and
Titanium White

Collage papers

Palette knife

Crackle glaze

Water

Gloves

Scissors

An idea comes to you because you are meant to manifest it. The idea is for you, but if you don't act on it, someone else will. Ideas and action go hand in hand. Ideas are like physical entities. When you have an idea, you begin to move toward it. This is the sacred first step to creating—to hold your idea close and nurture it just like you might an infant.

At this point don't share your idea. If you put your idea out there, you invite the naysayers to chime in. Just like an infant needs time to develop its immune system before being exposed to a lot of people, your idea needs time to incubate. Let your idea grow. Hush your own inner critic. When there is resistance from your inner critic, you know you are onto something. Persist. Motivational speaker and author Debra Poneman says, "Leave the steam inside the kettle. Nobody became famous by saying what they were going to do." If you put your idea out there and you receive good positive feedback, then you have let the steam out of the kettle.

> "In any moment of decision, the best thing you can do is the right thing,
> the next best thing is the wrong thing, and the worst thing you can do is nothing."
> —*Theodore Roosevelt*—

You have received your boost before you have done anything. You may not have as much motivation to continue.

The next step is to act. Do not wait until everything is right. Begin because you must. Push past the resistance. Take the step from which there is no turning back. Act despite the discouragement you may encounter. Take your leaps over the hurdles. Act even though you are afraid, whether it is the fear of failure or the fear of success.

To take action, you must first identify how to go from point A to B. But how do we find our own personal road map to success? How do we find the right route? Listen to your heart. The heart creates from a different place than the eyes, the mind or the ego. Check in with your heart as you motor along your road. Recalculate your road map as you go. You may have doubts along the way. This is human. Listen to your heart and soul. Yes, you may have a meltdown and feel that you will never succeed, but listen to the whispers in your soul. Keep going. Happiness is being in love with life, no matter what kind of life we get.

In this exercise we are looking for inspiration from maps. I am using a road map to symbolize places I wish to go and places I have been that hold precious memories. By beginning the painting with the map as the background, I am instilling the intention and memories of travel into the piece. You may not see it clearly, but you know it's there. As you work, connect with the feeling and excitement that you get when planning a vacation or trip. This feeling will get transmitted into your art.

This is a fun way to find a road you may wish to journey on. Travel the road map and pencil in your dreams. Paint it, love it, live it and make it so. Open your heart to manifesting. Just like on any grand adventure, the most memorable moments are the unplanned detours. Enjoy the trip.

1 Paint your panel with Red Iron Oxide and let it dry. Tear out a page of a road atlas or other paper map, and roughly tear it so that the edges of the map fit within the panel. I used a map of New Mexico and marked places I had been and adventures I'd had in marker. You can mark places that are significant to you or not mark anything at all.

2 Spread decoupage onto the panel surface with a brush. Place your map page while the decoupage is still wet and use a brush to smooth out the air bubbles. Brush the decoupage over the surface, too. Let it dry.

 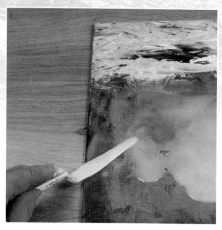

3 Brush a mixture of Diarylide Yellow and Quinacridone Burnt Orange diluted with water over the map page. The paint should be translucent.

4 Mix Titanium White and Cobalt Teal together and use a palette knife to spread over the top portion of the panel. I also applied some Payne's Gray with the knife. Let dry.

5 Spread a layer of clear crackle glaze over the map section of the painting. The size of the cracks will depend on the thickness of the glaze application. Keep it flat and let it slowly dry. This may need four or more hours depending on how thick an application you put on.

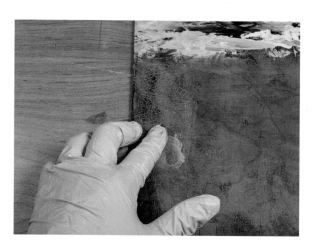 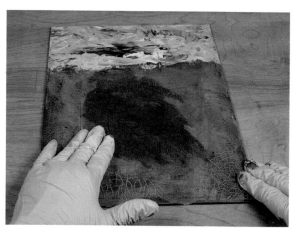

6 When the crackle is dry, rub Diarylide Yellow into the cracks along the periphery using your finger.

7 Use your finger to add some Quinacridone Burnt Orange into the cracks in the center area. Note how the crackle glaze was thicker and the cracks larger in this area. Let the paint dry and if you want to remove some, gently rub it with a damp paper towel.

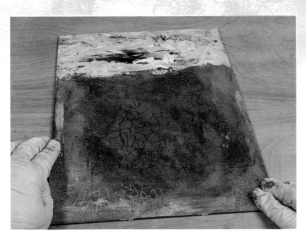

8 Add a little Cobalt Teal to the outer edges to create a frame effect.

9 Cut or tear some interesting papers into strips and use decoupage and a brush to adhere them to the panel. When dry, trim the papers to the panel sides. I added a few dark lines on the horizon and put some more Titanium White in the upper blue section. My road map is ready to go.

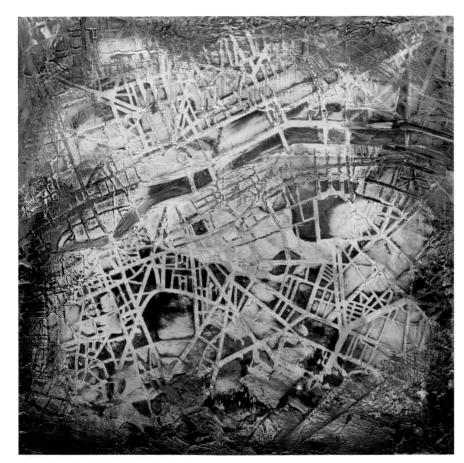

Another road map perspective.

AERIAL VIEW
Sandra Duran Wilson
Mixed media on panel
10" × 10" (25cm × 25cm)

The Western Gate

When we move around the circle of the seasons, we reach autumn, where the rapid growth of summer has ended and the time is ripe for the harvest. The time of day in relation to this place on the circle is twilight, that magical time between light and dark where contemplation moves inward. This is the time to give back; these are the middle years where we are ready to give back to the younger ones and share our wisdom. You have pursued many paths and now you look deep within to find the calling of your heart and soul. Listen to its whispers. You gain great strength in this knowing even as your body ages. This is the season to look within, learn your strengths and weaknesses. Use your power wisely. The seeds are formed, the harvest is brought in. Learn how to be self-sufficient and trust in your intuition and transformation. This is the time to share your vision. This is the wonderful place of balance between looking within and acting with courage and grace.

The season of the west is manifested in the physical body. In this season, we shift from the exuberant and rapid growth of the south to discovering balance between our external energy (knowing when to act) and our internal energy (knowing when to rest).

In the following exercises we will learn to embrace our physical strength and energies with movement and meditation. We will learn when to wield our power shields and when to sit in quiet contemplation. Prepare yourself to manifest change, sit in peaceful stillness and embrace balance.

AUTUMN SONG
Sandra Duran Wilson
Mixed media on paper
15" × 11" (38cm × 28cm)

Power Shield

Embody your super powers and shape your destiny.

MATERIALS

Wood embroidery hoop, 18" (46cm) in diameter

Heavy muslin or unprimed canvas

Scissors

Glue gun

Fan brush or toothbrush

Acrylic paints—red, blue, yellow, orange, white, black, Red Iron Oxide, Cobalt Teal, Interference Blue and Interference Violet

Gesso, black

Plastic mask

Marbelizing spray, gold

Paint pens

Mat board

Acrylic gel medium

Moldable foam stamps

Hair dryer

Stencil

Foam rollers and dabbers

Spray bottle of water

Brushes

Paper

SHE'S GOT STARS IN HER EYES
Sandra Duran Wilson
Mixed-media on fabric and wood
26" × 18" (66cm × 46cm)

Superheroes have remained popular subjects throughout the ages. Mythologist Joseph Campbell explored archetypal heroes and origin stories in his 1949 work *The Hero with a Thousand Faces*. He talked about how the hero battles powerful forces and returns home from mysterious adventures with supernatural powers that may be used to benefit humanity. I think superheroes today are a symbol of hope,

and their origin stories inspire us and provide models of coping with adversity, finding meaning in loss and trauma, discovering our strengths and using them for good purpose. They teach us to be better people and to bring goodness into everyday life.

Wonder Woman's superpowers lie in her Amazonian bracelets, golden lasso and shield. Who says you can't have your own power shield?

In this exercise we will make a power shield that will stimulate creativity and allow empowering qualities to come to the surface. You will create your shield using colors, textures, words and designs that represent your personal superpowers. To discover what your superpowers are, grab your journal and begin with this simple writing exercise:

Is there a superhero story, character or movie that you identify with most?

What are its qualities?

What are its vulnerabilities?

How do these stories inspire or mirror your journey?

What colors and patterns represent your strength and power?

For my power shield I have incorporated the symbol of a mask to represent all the roles I take on. The wandering lines represent the journey of life, and the stars in the eyes of the mask represent spirituality. As you work through the project, reflect on your superpowers and incorporate your colors, symbols and images.

Follow the basics of how to make your shield and add your personal symbols.

1 Put your fabric or unprimed canvas into the embroidery hoop. Pull tight and cut around the fabric in a circle, leaving enough extra fabric to glue down on the inside of the hoop—at least 1" (25mm), maybe a little more.

2 Remove the fabric from the hoop and apply the first coat of paint—Cobalt Teal and white on one half and yellow on the other. Now you have the outline of the area you will be painting. Adjust the paint colors as desired. I added some more white on the yellow area. While the paint was still damp, I blended some of the yellow and teal together with a brush to get a nice soft green. Let it dry.

3 While you wait for the fabric to dry, paint the mask. Remove the elastic band from the mask then paint it with red. When dry, spray the mask with gold marbelizing spray. Be sure to protect your surface from overspray.

4 Create a painted paper that looks like a starry universe. Paint your paper with black gesso or black paint and let it dry. Use Interference Blue diluted with water and paint loosely over the black. When dry, repeat the process with the Interference Violet. Let it dry. Dilute some white paint with water and load the paint onto a fan brush. Tap the brush handle to splatter on the stars. Let it dry.

5 Use scissors to cut notches and waves around the outer edge of the mask. When the galactic paper is dry, cut out a rectangle and attach it to the back side of the mask with a glue gun.

6 Using a hair dryer, heat up blue moldable foam stamps and press them into textures while hot so the impression remains. I pressed these into a fiber weaving, but you can use rubber bands or paper clips or any other interesting texture. Paint the stamps with orange and blue acrylic paints and stamp onto your canvas. Be sure to rinse the paint off the stamps before it dries.

7 Place a stencil on your canvas and trace the pattern with a white paint pen. Remove the stencil and add a blue line next to the white line.

8 Paint the outside of the hoop with Red Iron Oxide and let it dry. (Acrylic paint would also work.) Mist a ridged foam roller with some water and work it into the foam so it won't absorb too much paint. Loosely press the roller into a mixture of Cobalt Teal and white and apply it to the hoop. You could also paint by hand for more precise lines.

9 Use two different sized foam dabbers and two different colors to decorate around the hoop. Go around the hoop with the first color (yellow) and then repeat with the smaller dabber (orange).

10 When everything is dry, put the canvas back into the hoop. Pull it tight. You may need to mist the back with some water to stretch it back into place. Tighten the hoop and use the glue gun to secure the fabric in the back.

11 Paint a piece of mat board and cut it to cover the wood fastener of the hoop. Use gel medium to adhere it to the wood (a glue gun also works). Let it dry. I used the gel to glue the mask in place, too.

12 Hang your shield and evaluate. Listen to what it says to you about your power. I decided to add a few more elements to my power shield: some more dots within dots of color, lines to my maze pattern and some yarn to the bottom triangle.

Here are two power shields I made years ago at different times in my life. The power that I was working with was very different then. The first shield embodies my inner creativity that was trying to break free. The second shield represents healing, using the bear as the symbol for nurturing and being a natural healer. The symbols you work with will change just as the issues of your life change. The constant is that there is always help and guidance when you tap into your inner superpowers.

The Seven Chakras

The wheels of light and color reveal ancient wisdom.

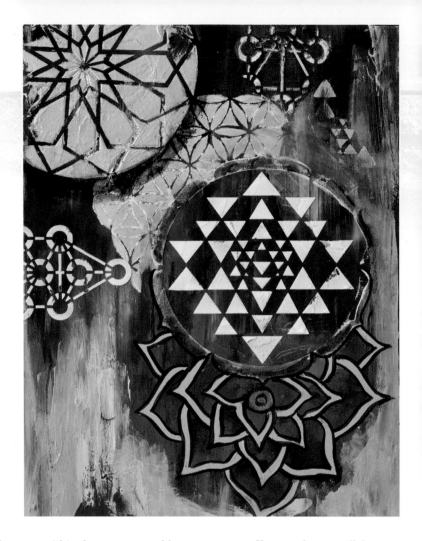

SACRED ROTATIONS
Sandra Duran Wilson
Mixed media on panel
14½" × 11½" (37cm × 29cm)

In this finished painting I used all the chakra colors in the background, covering the ROYGBIV spectrum of the rainbow. I used sacred geometry stencils and incorporated more of the chakra colors into my piece. I then painted a lotus petal in shades of indigo and violet.

When you incorporate different elements of the chakras into your painting and put it in a place where you see it daily, it will act as a reminder of the chakras' meanings and how we can maintain a healthy rotation and vibration of this other system that we operate from.

MATERIALS

Chakra and geometry stencils

Panel, paper or canvas

DecoArt Metallic Lustre cream
wax—gold, copper, silver, bronze, orange and green

Acrylic paints

Acrylic soft gel medium

Brushes

The chakra is a center of energy within the human body that helps to regulate all its processes. Originating from Sanskrit, it literally means *wheel*, and is experienced as a vortex of spinning energy interacting with various physiological and neurological systems in the body. The chakra system is comprised of seven chakras running from the base of the spine to the top of the head. Imagine that your spine is like a vertical power current where energy runs up and down the spine. This is your main source of energy. The chakras regulate the flow of energy throughout the electrical network that runs through your physical body. The chakras are like rechargeable batteries. They also influence your energetic perceptions and feelings.

Sometimes chakras become blocked due to stress, either emotional or physical issues, and if the body's energy system can't flow freely,

problems may occur. You may become ill, have low energy, discomfort or feel out of balance. By learning about the seven chakras, you can become more in tune with the natural energy cycles of your body, and you can use this information to connect physical, emotional and spiritual energy and the chakras that empower them.

The Seven Chakras Exercise

This exercise will help you to activate and become aware of your chakras. Paint a canvas or panel for each of the seven chakra colors. While painting, focus on the attributes of each chakra. Place the corresponding chakra stencil over its color and apply a clear soft gel over each stencil. Let this dry and then use various metallic cream waxes rubbed over the symbols. The waxes are water soluble so you can wipe off any extra that goes outside the symbols.

Chakra	Description	Practice

Chakra

1 RED
Base chakra
Instinct
"I am"

2 ORANGE
Sacral chakra
Emotion
"I feel"

3 YELLOW
Solar Plexus
chakra
Energy
"I do"

4 GREEN
Heart chakra
Love
"I love"

5 BLUE
Throat chakra
Truth
"I speak"

6 INDIGO
Third Eye
chakra
Intuition
"I see"

7 VIOLET
Crown chakra
Connection
"I understand"

Description

The red chakra is associated with survival. Located at the base of the spine, this center relates to Mother Earth. This is where we need to feel grounded and secure. The issues around this energy center may have to do with physical health, work, shelter, food and money.

The orange chakra is our connection and ability to accept others and new experiences. It is located about 2" (5cm) below the navel. The associations with this energy center are emotional: dreams, inner visions, hopes and memories. This is our creative center and our sense of abundance.

The yellow chakra is the power center. It is in the upper abdomen or stomach and it holds the element of fire, self-esteem and self-confidence. Have you ever noticed when you are afraid or nervous you may feel it in this area of your body? This chakra is where you experience your identity and personal power.

The green chakra relates to the heart and soul. It's the place of union between the upper and lower sections of our energetic being. There are three chakras above and below the heart chakra. When the heart center is open, you can move from ego to a more conscious approach to life.

The blue chakra deals with communication and self-expression. It also vibrates to creativity. It's like a radio transmitter and receiver, bringing information and guidance to our intuitive self. What are the affirmations or denials that we tell ourselves?

The indigo chakra is located on the forehead between the eyebrows. This is our psychic center, the place where we perceive reality or the pictures we hold in our mind. When our third eye chakra is balanced, we are as in touch with our intuition as we are with our other senses.

The violet chakra is our spiritual center. It is located at the top of your head, and it expands down into your body and upward connecting you with universal energy. This chakra is pure spiritual energy. It is the place where the soul comes into the body. Think of it like the spiritual intention enters your body here and flows down into your life.

Practice

Stomp your feet to ground yourself with the earth. If you are feeling ungrounded, take care of your physical needs and then spend some time in meditation, repeating a word or phrase that connects you to the earth and your body.

Spend time nurturing your creative passions and take time to enjoy the pleasures of life. Make some art, cook a fabulous meal or find other simple pleasures. Maintain balance in your pleasures by asking yourself these simple questions before each action: Is what I am about to do good for me? Is it healthy and nourishing?

Make a list of the things you are good at. Learn to feel your own power and self-worth. The first three chakras make up the energetic areas of the personality—red (base) is body, orange (sacral) is emotions and yellow (solar plexus) is the ego. Together these chakras root you in your body and the physical world.

Develop healthy boundaries yet be open to letting love penetrate the walls you may have built around your heart to protect yourself. This is where love, compassion and kindness emanate from, for both you and others.

Speak your truth. Begin by saying it to yourself and then practice saying it to others. A turquoise stone is beneficial for balancing the heart to throat chakra connection. Wear it as a necklace so the stone rests at your throat and touch it during the day to remind you to speak your truth with love.

Spend time in meditation and paying attention to your psychic senses and intuition. Listen to the whispers of your muse. This chakra is the window to your soul.

Focus on balancing and being in tune with your other chakras and your crown chakra will keep you connected to universal energy. Spend time in meditation and breathing to balance all your energetic wheels.

Doorway to Stillness

Simplify a busy painting by removing texture and adding new elements.

Contributed by Nancy Reyner

MATERIALS

A painting or canvas that you feel is too busy in areas

Electric sander

Waterproof sandpaper

Gold leaf

Acrylic paints

Paintbrushes

Painting knife

Each of my paintings is different, some busier than others, some more abstract than others, but my intent is always the same. I work the paintings until they emanate some type of spiritual quality or meditative stillness for the viewer. The canvas is like a doorway, and with the image I paint on it, the painting can become an entry or portal for the viewer with the potential to offer a transformative experience. Encouraging a stillness, a time away from the normal reality viewing of our physical world, can propel the viewer into an alternate reality.

While painting and evaluating my work in progress, I make a point of identifying qualities of stillness in the work to ensure these get enhanced and not neglected. My process involves two main aspects: putting paint on the surface and then taking some off. This may seem counterproductive, but it is in fact a way for me to get an equilibrium in the image between what is considered too much and what is not enough. Here is an example of my evaluation process. In this exercise try reworking a painting to reduce some busy areas to help focus on the parts that work.

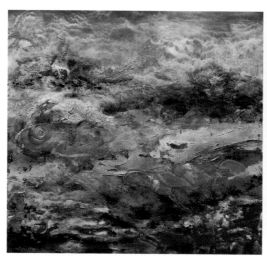

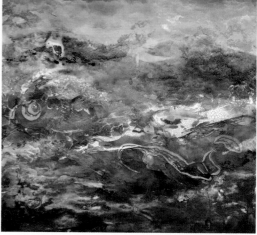

1 When I begin a painting, my goal is to get as much variety as I can onto the painting surface. This sometimes results in an overcrowded, busy image as pictured here. This painting may have some interesting details or areas, but lacks focus and the overall stillness or restful areas I aim for in my work. It has everything but the kitchen sink, including gold leaf, acrylic paint, acrylic textural gels such as glass bead gel, crackle paste, pouring mediums and black mica flakes.

2 I like using an electric sander with waterproof sandpaper to wet-sand off some of the detail and texture. Since this painting has thick underlying texture, I was able to sand off only a small amount with ease. It is somewhat improved but still needs more simplification overall.

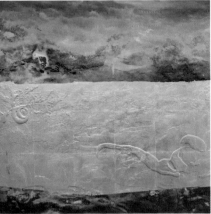

3 The painting at this point still feels too busy and could use more simplification. The painting started with a gold leaf background, so I decided to simplify the middle portion of the image by bringing back some of that gold leaf. Since I was unable to sand through the many layers of paint in the previous step to reveal the underlying leaf, I can overlay the gold leaf over the paint.

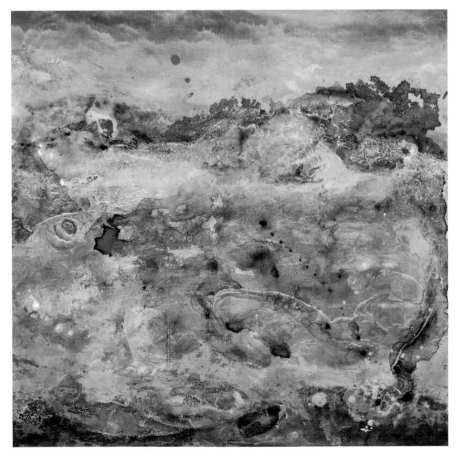

4 I added paint using a brush and knife on top of the stark band of gold leaf running across the middle to integrate it with the upper and lower areas remaining from the original painting. I overpainted the hard edges of the new leafed area so it would blend more. The finished painting maintains an active quality, but now has enough quiet areas to allow a stillness in the work.

RED SQUARE
Nancy Reyner
Acrylic and gold metal leaf on wood panel
30" × 30" (76cm × 76cm)

30

Labyrinth

A walking meditation to contemplate the answers to your questions.

LISTENING TO MY JOURNEY
Sandra Duran Wilson
Mixed media and acrylic on paper
11" × 16" (28cm × 40cm)

I added some splatters of white paint to look like stars on my finished labyrinth. To achieve this texture, dilute paint with water until it is the consistency of milk and then splatter using a fan brush or toothbrush.

When dry, use your hand to travel the circuit, just as if you were walking the labyrinth. The raised edge of the lines will keep your hand in place.

MATERIALS

Mixed-media paper or watercolor paper

Gesso

Acrylic paints

DecoArt Americana writer, white

Deli sheet or freezer paper

Carbon paper

Painter's tape

Brayer

Fan brush or toothbrush

Photocopy of labyrinth

Spray bottle of water

In 1995 I helped build a labyrinth in the desert mountains near Santa Fe using rocks pulled from the hillsides and transported to a flat space. It took a community of people doing backbreaking work to make the labyrinth a reality. After our arduous labor, hundreds of people were able to use it for contemplation and walking meditation. The labyrinth was a gift to myself and to others.

Walking a labyrinth is a way to gain insight using moving meditation. It represents the spiritual journey one undertakes to discover one's own center and then return to the world again. It is a microcosm, a moment that can represent a life journey. It is an ancient symbol that relates to wholeness. It brings together the imagery of the circle and the spiral into a meandering but purposeful path.

The labyrinth has an ancient history dating back over 4,000 years. The classical, or seven-circuit, labyrinth is the design we will use in this exercise. It is a single pathway that loops back and forth to form seven circuits. Most of the early labyrinths were of this type. Here in the Southwest, you will sometimes see the seven-circuit labyrinth depicted on pottery and cave walls in both a circular and a square form. Labyrinths may evoke a spiritual pilgrimage, a journey to develop mindfulness, environmental art and community building. You can find various forms of labyrinths at schools, hospitals, churches,

museums and other sites. See the labyrinth worldwide locator online at labyrinthlocator.com.

When I walk a labyrinth, I first center myself in my body by taking several deep breaths and then formulating a question in my mind. I walk the labyrinth slowly, mindfully placing one foot in front of the other. I repeat the question in my mind as I follow the path to the center. When I reach the center, I touch the earth with my hands and I feel for the answer within myself and the earth. I give thanks and I place my question into the earth. As I slowly and mindfully reverse course and journey back out, I listen for the answer to my question. I have always gotten results. I find this a very powerful tool for gaining insight, grounding myself and connecting with spirituality. You may also walk the labyrinth with blessings or prayers. Whatever your spiritual question or search is, the labyrinth is an ancient and powerful symbol and a tool of discovery.

In this exercise we are going to make a hand labyrinth. This is a small portable example that can even be used with your eyes closed. There are digital labyrinths that you can find and use online, but personally, I like to be away from electronics when I am tapping into my internal spiritual guides.

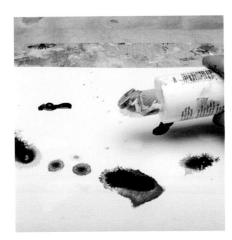

1 Prepare your paper with gesso on both sides. I am using an 11" × 16" (28cm × 41cm) sheet of Canson 138-lb. (224gsm) paper. You can also choose to back your labyrinth with a decorative paper using double-sided adhesive film, though this is optional. Place two or three drops of each of your paint colors and several of white around the paper.

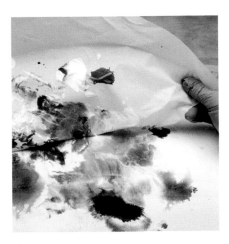

2 Mist with water and use a deli sheet or freezer paper to move the paint. Spray more water as needed. Pick up the paper and rotate it to move paint to other areas. Be careful not to overmix or your colors will become muddy. Let the paint dry thoroughly.

3 Place the printout of your labyrinth pattern on top of the carbon paper and put this on top of your painted background. I selected a photo of a seven-circuit labyrinth. Search online for other inspiring patterns.

4 Tape the layers in place and use the handle of your brush to trace the pattern onto the background.

5 Remove the copy and the carbon paper and use a dimensional paint to create the white lines. The dimensional paint adds a raised texture to the lines. Be careful not to smudge, and let them dry completely.

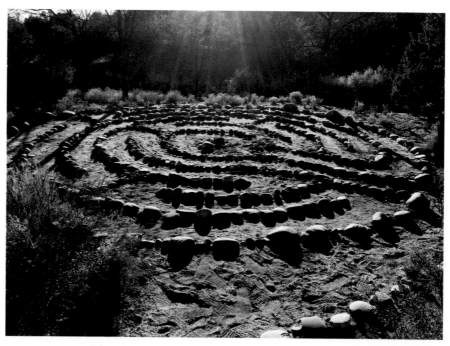

6 I decided to back my labyrinth with decorative paper to make it more durable. I used a wood grain sheet of paper cut to the size of the labyrinth and double-sided adhesive to attach it. A brayer is handy for getting out air bubbles.

A stone labyrinth in the desert mountains of Santa Fe, New Mexico. Photo by Jane Rosemont

31

Double Decker

Discover inspirational guidance and get new painting prompts all in one.

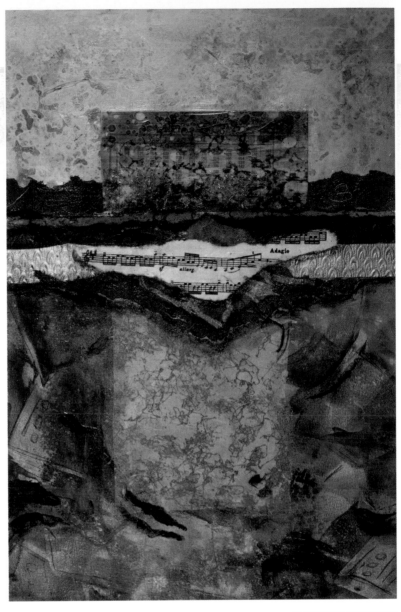

GAINING ALTITUDE
Sandra Duran Wilson
Mixed media and acrylic on paper
18" × 12" (46cm × 30cm)

In this exercise we will make a deck of cards with a creativity prompt on one side and an inspirational word or phrase on the other. Keep them in a bowl and pull out a card when you need a boost. You can make a deck for all sorts of different creative endeavors, including painting, writing, journaling, cooking, acting, music, improv and comedy . . . they are even a great tool for creative problem-solving in business.

I love the beauty of having both an inspirational word to contemplate and a prompt to follow through. If I pull a word that says "Trust" on one side and "Go with first thought" on the other, then I am reinforcing the message for both. When you are putting your two lists together, try to match them in this way. "Be Open" may pair with "Rub off some paint" and "Joy" might fit well with "Bright colors." So many possibilities.

1 Print your inspirational words on decorative paper; you can also handwrite them if you prefer. I used a photograph of one of my paintings and opened it on my computer to use as a background. Then I typed the words for painting prompts onto that. I printed it on double-sided adhesive film. You could also print your words on clear mailing labels.

2 Cut the adhesive film so each word or phrase matches in size. Peel the backing from the adhesive and put it on the back of one of the words that have been printed on decorative paper.

If you printed your words on clear mailing labels, simply affix them to decorative or hand-painted paper. Your words of inspiration will be on one side and the painting prompts on the other.

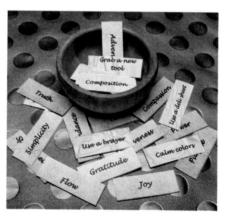

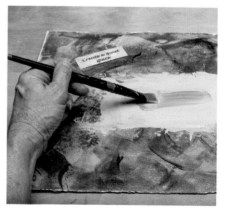

3 Use a bone folder or craft stick to burnish the two pieces together.

4 Complete matching your words of inspiration with the painting prompts. I like to keep them in a bowl where it is handy to pull them out and follow them.

5 Select a painted background that is rather busy and uniform. Mine reminds me of wallpaper. Draw a card from the bowl. My first pick says "Rest" on the inspiration side and "Create a quiet space" on the painting prompt side.

I first used a mixture of Bright Green and white to cover an area in the middle, but it didn't feel restful, so I painted over it with a mixture of Quinacridone Gold mixed with white.

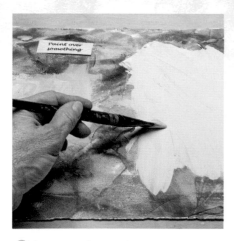

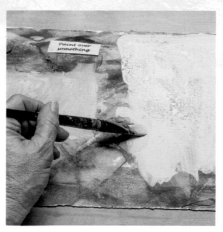

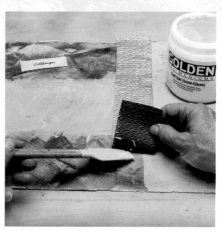

6 Select another card. My card's combo reads "Transformation/Paint over something." I decided to add more white to my Quinacridone mixture and paint over the top section of the piece.

7 While the paint was still wet, I sprayed some alcohol on the surface to create an implied texture. The alcohol creates a resist and the paint moves away from the drops exposing the underlying color.

8 My next card says "Freedom/Collage." I found a textured piece of paper and painted it with gold paint. When it was dry, I applied soft gel semi-gloss to the paper to act as a glue and pressed the gold paper down. I recommend putting a piece of plastic wrap on top of the paper and using your hand or brayer to get good adhesion. Remove the plastic wrap for easy cleanup.

9 My next card was "Synthesis/Fuse." I had to think about this one and I came up with using fusible web. I cut it to the size I wanted and left it on the backing paper. I mixed some Cobalt Teal with my white mixture, diluted it with water and brushed it onto the fusible web. I let it dry and then I sprayed it with gold marbelizing spray.

10 I removed the fusible web from the backing paper and placed it on the painting in the location I wanted. I adhered the web with a heated iron set on synthetic and no steam. To do this, put the painting on a towel on top of a heat-resistant surface. Place a piece of cooking parchment paper on top of the fusible web and fuse it using the iron. It should take about 10 to 15 seconds. Check to make sure it is fusing. Turn off your iron. I added some more collage elements to finish the painting.

The Verb

Embody a verb to set yourself free.

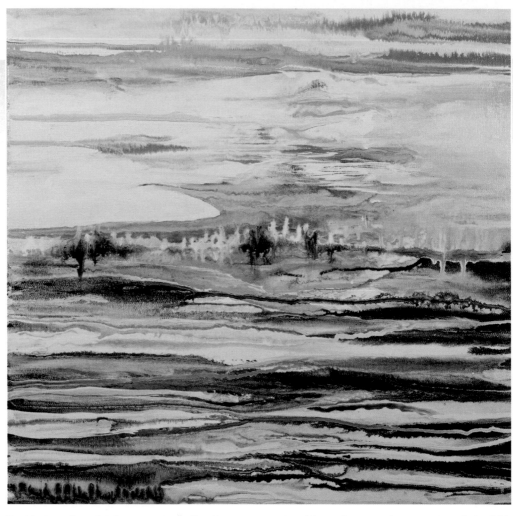

FLOW
Sandra Duran Wilson
Acrylic on canvas
18" × 18"
(46cm × 46cm)

For this piece, the verb I chose was *flow*. I diluted some paints so I could pour them onto the canvas. I recalled a childhood memory of how I would float in an inner tube on the river. My grandmother would tie a rope around the tube so I wouldn't be swept downriver in the current. I was free to float and flow. A total freedom of childhood.

After working with this technique and experimenting, I decided that *flow* would be my word for the year. I wanted to experience the freedom of floating again, so I focused on my memories of long ago. *Flow* represented the ease and lack of resistance I felt as a child floating on the river. Throughout the year when I felt resistance in my work, I focused on flow. It all began with a verb and ended up manifesting in my life.

You can do almost anything for sixty seconds, even hold your breath. So whatever you want to do or be, you should try it for sixty seconds. I learned of this exercise when I was in art school and taking a mixed-media class. The class was made up of students from the art department, writing, photography and even culinary arts. I loved this class because we got to eat the culinary students' creations after presentations. This exercise always stuck with me and I have used it to jump-start many projects from art to exercise.

Here's how it works. Cut small pieces of paper to about 1" × 3" (3cm × 8cm) rectangles and write a verb on each piece. You want action words like *dance, fly, sing, think, create* . . . you get the idea.

When you have a good selection, fold them in half and put them into a bowl. If you are working with a group, pass the bowl around and have each person pull out a verb. If you're working solo, pull out a verb when you're ready to begin your next creative endeavor. Allow the verb to inspire you and apply it to your project. Say you are looking

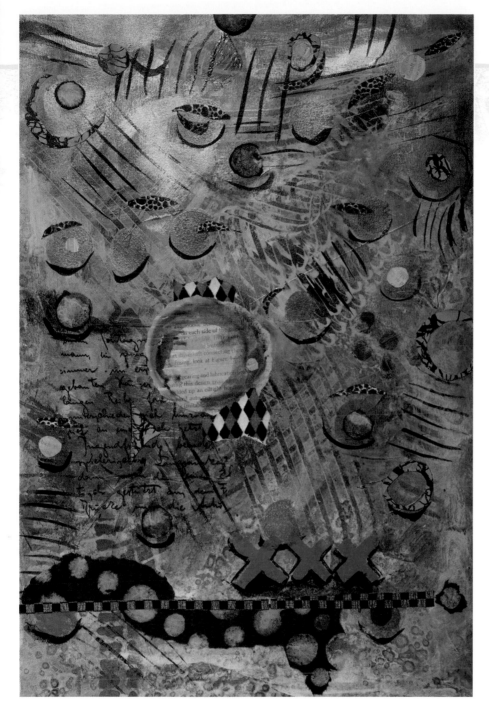

For this piece, the verb I chose was *flight*. I thought about all the different modes of flight and animals and how they fly. I moved and pretended to fly like a child running around with my arms out and a cape flowing behind me. What wonderful feelings I was able to capture with this imaginative play activity. This painting is what I created by combining all my explorations.

FLIGHT
Sandra Duran Wilson
Mixed media and acrylic on paper
22" × 15" (56cm × 38cm)

to write a new story and your verb is *give*? Well, you have a jumping-off idea at the ready. Let's say your verb is *apply* and you are cooking. Apply a new ingredient.

When you pick a verb, you want to go beyond the obvious. Embody the verb. Like an actor, become the verb. What is it? How do you feel about the verb? Write about it, move, make sound and use your many senses to explore the verb. Let it simmer and then do it. Back in my college mixed-media class I picked the verb *create*. I created a clay cave that held eggs inside. The eggs were ideas waiting to hatch.

Here are two painting examples that resulted from this exercise. See how a verb can really get you moving? Try one! You may just rediscover some long-forgotten passions.

33

Healing

The transformative art of healing through creative painting.

Contributed by Ardith Goodwin

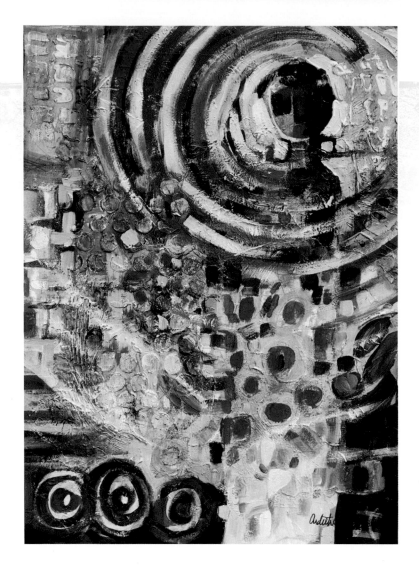

**THROUGH THE WINDOW
OF YESTERDAY**
Ardith Goodwin
Mixed media and
acrylic on canvas
14" × 11" (36cm × 28cm)

MATERIALS

Mixed-media
paper or watercolor
paper, 140-lb.
(300gsm)

Heavy-body gesso

Old credit cards or
mark-making tools

Stencils

Graphite pencils

Acrylic paints

Fluid acrylics

Water-soluble
colored pencils

Synthetic flat
brushes

I never started out with the intention of becoming a painter I was born to be a teacher. What I didn't see coming was the unexpected path that led me into years of medical struggles, having to give up my teaching career and going on total disability. I was at a pivotal point in my human experience, and art and my faith showed up to transform my path.

Now the gift of creativity, that was something I was always familiar with. From my first experience of licking Play-Doh as a child to looking for different ways to approach eating without utensils, I was always looking past the ordinary. This practice would come to serve me well as I moved from being a nonpainter to one who slings paint for a living.

What I quickly came to understand after months of simply sketching and tinkering with watercolors was that in those moments, my soul was finding its way to becoming healed. Despite the physical challenges, the medication fog and the overwhelming feeling that things would never change, creating artwork gave me a respite and my spirit began to lift. I am now a full-time working artist, off disability and living an incredible, transformative journey.

The key for me was to move the line while I healed. That simply meant to engage in the act of creating and giving myself permission to see the outcome as restorative, never about perfection, but about transforming my heart from A to B. You don't have to have medical challenges like I did to find the impact in the act of painting. You just need to move the line yourself and experience the power of engaging in what you were created for.

This exercise is all about embracing the imperfections of a textured surface, choosing a few key framework elements that resonate with you as important, and visually creating a painting that ties those in with an abstract figure. It can be a visual record of your own journey.

1 Apply gesso over the entire paper. Put it on thick enough to mark into it with an old credit card, the end of your paintbrush or any other marking tools you love. Let it dry completely.

2 Apply a thin coat of fluid acrylic to your paper. This glaze of color will serve as your basecoat. I chose Holbein Pyrrole Orange Transparent. Let it dry.

3 Choose a stencil you love and scrape a layer of gesso over the stencil using the credit card. You don't have to use the entire stencil. Trust your instincts to use parts of it in the areas where you would like to create a raised texture.

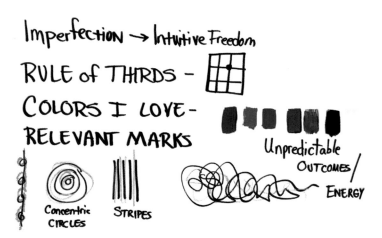

4 It's time to choose a framework. This is the most important step in the process. Working within a set of parameters helps create a connection to purpose and a focus for your path.
 1) Choose a concept that matters to you—I chose Imperfection.
 2) Choose a few types of marks that you connect with—I chose organic scribbles (energy), concentric circles, stripes and a spinal structure.
 3) Choose a basic composition—I chose the Rule of Thirds.
 4) Choose three to four colors you love.

5 Creating visual interest through mark-making is important. It represents the juicy tidbits of a beautiful, imperfect life for me. Use your graphite and water-soluble pencils to create organic, random marks.

6 This part of the process is all about intuition. I know my composition will have a focal point in the upper-right quadrant, so the layers and marks I place now will be used to serve that final outcome. Use shapes, marks and the symbols from your framework to begin filling the page and let them dry between layers.

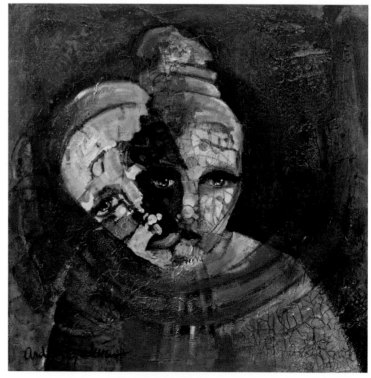

7 Since I plan to place a face shape for the upper-right focal point of the painting, I want to layer and plan ahead to bring that figurative shape into form. A key to focal point impact is to make your figure a lighter value and the background a darker value.

A PAGE FROM THE BOOK OF MUSTS
Ardith Goodwin
Mixed media and acrylic on canvas
20" × 20" (51cm × 51cm)

By moving the line, I gave myself permission to heal, grow, change and become a full-time working artist. Here is another example of my work.

Habits

**Develop your
curiosity muscle.**

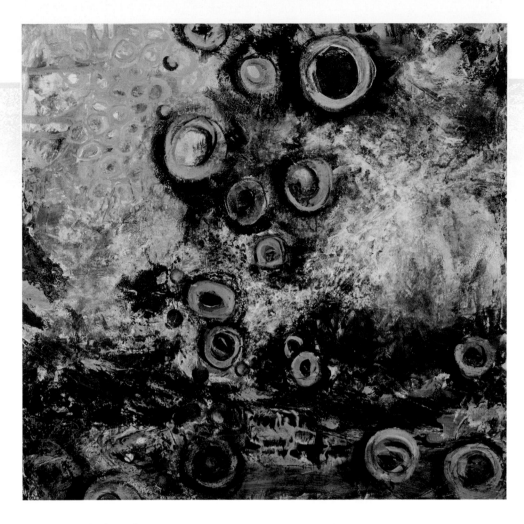

WINDS OF CHANGE
Sandra Duran Wilson
Mixed media on canvas
20" × 20" (51cm × 51cm)

"Between the head and feet of any given person is a billion miles of unexplored wilderness. The question I ask myself and everyone else is, 'Do you have the discipline to be a free spirit?' Can we be free of all that binds and bends us into a shape of consciousness that has nothing to do with who we are from moment to moment, from breath to breath?" — *Gabrielle Roth*

False beliefs that are repeated over and over create a pathway, and they are reinforced in our neural pathways. Behaviors release certain chemicals in our brain. Our body knows this, and it becomes used to receiving those chemicals, making it difficult to change patterns. You can, however, cancel and clear these negative thought patterns. For example, some people live by the belief that if it wasn't for bad luck, they would have no luck at all. This type of thinking only serves to reinforce our noticing when things go wrong. Your experience may not be that different from anyone else's, but because you believe that you always have bad luck, you notice it more.

On the other hand, those who tell themselves that they are very lucky will make note of all the little wins and miracles throughout the day. The lucky thinker pays attention and reinforces the positive.

Old patterns of thinking can and will arise, and you have a choice whether to engage them or not. When a negative thought comes up, say "cancel," clear the thought and replace it with a positive one. Here's an example: Say you are at the store and you get into a checkout lane and the thought comes into your head that you always pick the wrong lane. Hit cancel and clear the thought. Replace it with, "I am in the best lane I need to be in right now." Whether it is the fastest lane or not, look for the positive. Adjust your internal critic to become your personal cheerleader. You can choose to live in serenity and release some of the old beliefs.

Find Your Routine

The silence before creation can be deafening. To be creative, we must be brave and strong. To begin with nothing—the

blank page, the empty canvas, the silence before the music— is intimidating and can frighten the best of us away. Stay, sit in the silence for a moment. Do not run away or procrastinate. Exercise your creative muscle. This is where routine is a lifesaver. When you have established certain creative warmup exercises, you can stay in shape and be ready when the challenge is presented. Discipline turns into habit and habits lead to meeting your creative muse on a regular basis.

What is the best way to find your routine, develop good habits and unlearn bad ones? First, let go of the notion of some mystical and natural ability to create. With practice, hard work and showing up, you will get to a place where creativity flows easier. An animal can paint a picture if someone puts paint on its paws or tail, but it can't do it intentionally. Practice inspires creativity. Try this exercise: First find your muscle, your curiosity. Then stretch and flex this muscle. Learn association and flexibility. "If this is possible, then what would happen if ____?" Fill in the blank. This is one of the most important exercises, like stretching before a race. Skill invites creativity in for a cup of tea. It takes skill to bring your vision to life. Habit, practice and repetition give your soul more space to let creativity emerge. Your muscles are ready, and you don't have to think about the paint, the words or the notes. You have the "hows" under control, so the magic may flow.

Preparation, skills and showing up allow you to be receptive to seeing creativity everywhere. The most important practice to develop is simply *to begin*. This is what the accidental masterpiece exercise is all about. It tricks you into beginning. Set up a simple exercise that you can implement every day. Start with something easy but meaningful enough that you want to do it. For example, take physical exercise and think of how difficult it can be to maintain. Start small. Begin by walking just ten minutes a day. Start each day, every day doing only ten minutes. I find it is best to do it at the start of the day. No procrastinating. Once you have done this for three weeks, it is becoming a habit and you will miss it if you don't do it. You can increase your time, but maintain the habit.

Grab your journal and pen.

What are you curious about? Just begin writing anything. Do not pay attention to sentence structure or grammar, just freely associate words. This is how I begin my books, a new painting series or even an adventure. What do you want to find out about? This is another great morning habit to develop. Give yourself ten minutes to do this.

Follow your stream of consciousness. How can you turn an idea upside down? How can you be flexible with an idea? Pick one idea from your writing and through the course of your day pay attention to how it fits in with what you are doing. It is like priming the pump. Once you have put this idea in your mind, you will notice things that refer to it. Say the idea I am curious about is robots and programming. While going through my day I see an article on a country giving citizenship to a robot. I see an art installation that combines farming with music and color. My mind has been primed to notice these connections. Follow the stream of consciousness and it will eventually lead you to the ocean.

My friends and I used to make up free association games. You would pick an object, and everyone would go around and come up with an alternative function or existence for the object. A beret was not merely a hat to put on your head, it could be a flying saucer, a shoe, a swimming pool for tiny fish, a flying disk, a purse, a flower pot . . . you get the idea.

Play this game with yourself or with others. Try sketching or writing about some of these free associations for ten minutes a day. What would it look like if you combined some of the objects' alternative functions? Stretch your imagination like a rubber band and then let it fly. Look for a theme or common element.

I have seen in my paintings a recurring theme of circles. Several years back I was talking with a fellow artist and he said he had been painting a lot of circles also. Neither of us consciously knew why, so we began to explore this idea. For me, time is nonlinear, and I was looking at the circular and repetitive nature of time. He is a Native American artist, and he too identified with this concept. We live in different parts of the country, but we had both tapped into a similar reason for our symbols. When I am painting or sculpting, I am in the moment, and later I identify some of the reasons why I made what I did.

Going forward, practice and develop your habits. Follow your ideas to create without judgment, purely for pleasure, and creativity will be your faithful companion.

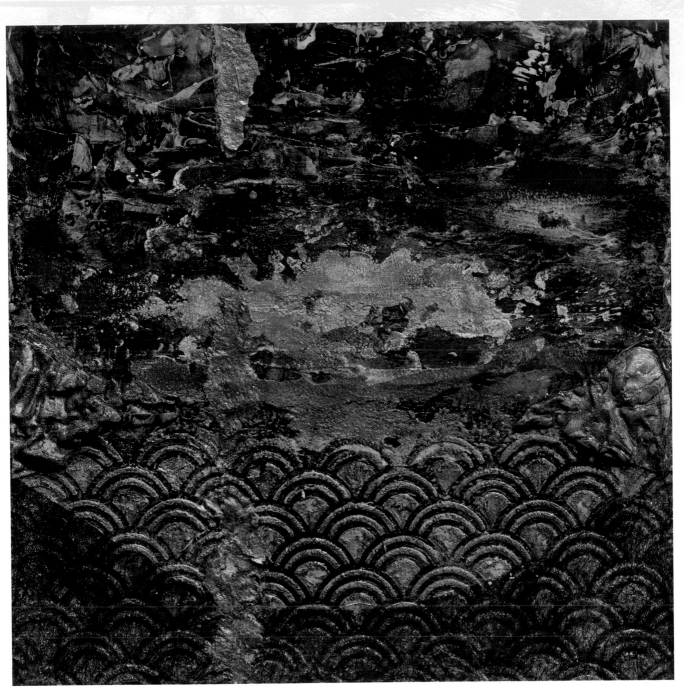

IN THE VALLEY
Sandra Duran Wilson
Mixed media on canvas
10" × 10" (25cm × 25cm)

I incorporated some unusual materials into this painting, like dryer sheets and grout. Stretch your imagination when it comes to materials to use in your creations.

Rhythm
Uncover your truth through
meditative dancing.

"Dance is the fastest, most direct route to the truth—not some big truth
that belongs to everybody, but the get down and personal kind,
the what's-happening-in-me-right-now kind of truth."
—*Gabrielle Roth* —

MATERIALS

Yupo paper, 5"× 7"
(18cm × 13cm)

Markers

Water-soluble
crayons

Graphite pencils

Fluid acrylics or
watery paints

Skewer, plastic
forks and other
mark-making tools

Spray bottle of water

Stamps and stencils

Sponge

Alcohol

Music by
Gabrielle Roth

Color shaper

Gloves

I was fortunate to have studied movement medi-
tation with Gabrielle Roth and her son, Jonathan
Horan. She was an amazing woman who could
really see into your soul and coax you out of
your paralysis. Gabrielle and Jonathan showed
me how to embody the sounds, rhythms and
movements that were hidden deep inside me.
Meditative dancing is like a trance where you let
go and connect in the moment. Find your sound,
move to your own rhythm and connect spirit
with the sound. I have synesthesia, which is a
crossing of the senses. When I listen to music
I see colors, and numbers create melodies in
my mind. Connecting rhythms and sounds with
movement is a similar sensation.

The *5Rhythms* is a practice of five fundamen-
tal energies that Roth termed Flowing, Staccato,
Chaos, Lyrical and Stillness. She called them the
five rhythms of the soul. Roth saw these patterns
in nature and life experiences, and she guided
thousands to find their own rhythms. By practic-
ing the rhythms, you can awaken a deep part of
your creative soul. You begin a nonverbal conver-
sation with your muse and you find yourself mov-
ing through lifetimes in a matter of thirty minutes.

I use her albums often in meditation groups
and people sometimes will say, "I am not going to

dance." I tell them, "You don't have to, just stand
there with your eyes closed." As the music of the
drums fills the room, the skeptics begin to slowly
move, tapping a foot or swaying to the sound. As
the rhythm changes, so do their movements.

This exercise is a moving meditation where
the spirit gets embodied and we sweat our
prayers, which is the title of one of her albums.
We will use the music and rhythms to exercise
mark-making through the *5Rhythms*. As a visual
artist, it is important to understand the rhythms
of your marks. If you do not understand their
nature, you will not know how to infuse emotion
into your art. This moving meditation will exer-
cise your creative muscles and open your soul to
embrace creativity.

You may wish to explore your mark-making
more and think about what archetypes you might
assign each rhythm. To move into your creative
self, let go of judgment and the idea of right or
wrong. Each mark is just that, a mark, and as you
feel it you will be able to impart that feeling onto
the canvas, the page, the sound—whatever cre-
ative exploration you are dancing with. It is good
to expand your creative vocabulary, so let the
poet dance and the actor paint. It will free your
inhibitions because you are just playing.

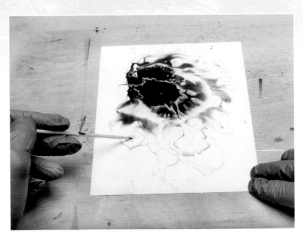

1 Seek out the songs by Gabrielle Roth that represent the five rhythms: Flowing, Staccato, Chaos, Lyrical and Stillness. You can download or listen online, use a streaming service like Spotify, or purchase the album called *Endless Wave Volume 1*. I usually listen to three to five minutes of each rhythm.

Gather your other supplies. Yupo is a great choice for this exercise because paint moves easily on this surface, which also holds graphite and acrylic pens.

2 Listen to the first of the rhythms, Flowing, and begin painting. Dilute some acrylic paints and apply to your paper with a skewer. Spray the paper with water and tilt it to move the paint around.

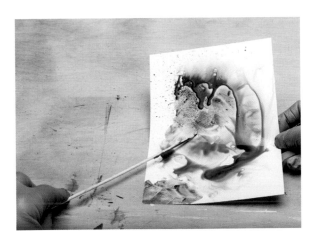

Flowing—Listen to the rhythm and feel yourself floating and flowing on the water. With flowing I feel free, almost detached, as I watch and allow the paint to simply move.

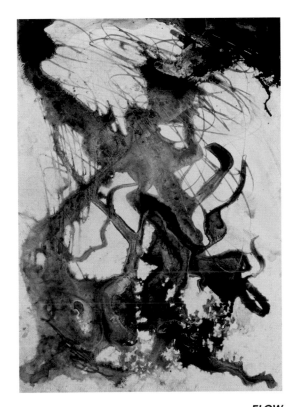

FLOW
Sandra Duran Wilson
Mixed media on Yupo
7" × 5" (18cm × 13cm)

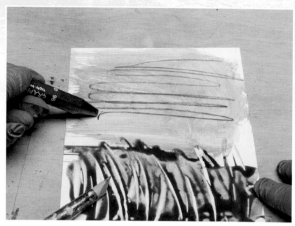

Staccato—This rhythm promotes angular, graphic, hard-edged movements. I feel the mark-making is strong, almost like jabbing the paper.

Chaos—Comes on quickly and gets your heart pumping. I use a color shaper to move the paint and a graphite pencil to add marks. I also grab a foam stamp in the moment.

STACCATO
Sandra Duran Wilson
Mixed media on Yupo
7" × 5" (18cm × 13cm)

CHAOS
Sandra Duran Wilson
Mixed media on Yupo
7" × 5" (18cm × 13cm)

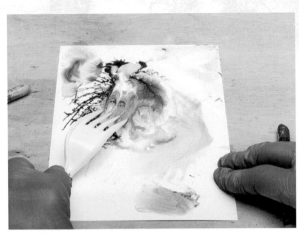

Lyrical—Take some time to embody the rhythm and use it as inspiration to create. The Lyrical rhythm moves me to be more interactive than I was with Flowing.

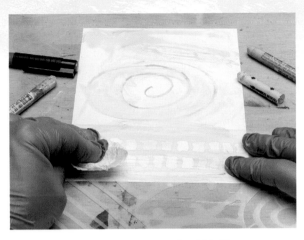

Stillness—Return to your center point. Go within. The water-soluble crayons are light in saturation. They feel serene. I sense that it is about removing parts of the painting. I use a stencil and a sponge with alcohol to act like an eraser.

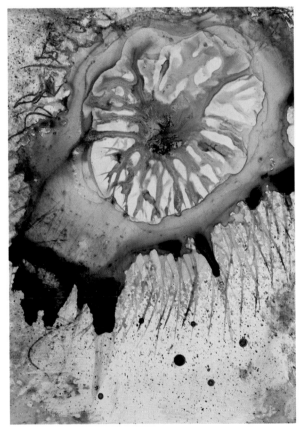

LYRICAL
Sandra Duran Wilson
Mixed media on Yupo
7" × 5" (18cm × 13cm)

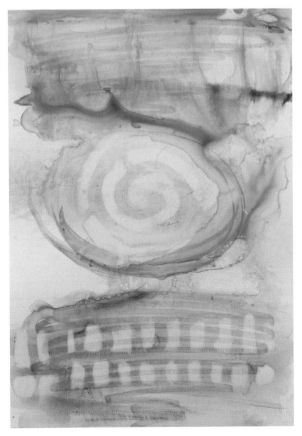

STILLNESS
Sandra Duran Wilson
Mixed media on Yupo
7" × 5" (18cm × 13cm)

Shadow Play

Search the shadows of your mind to find new inspiration.

WINTER MOON
Sandra Duran Wilson
Mixed media on paper
22" × 15" (56cm × 38cm)

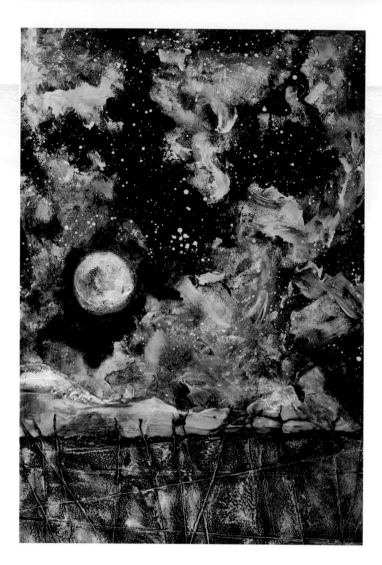

I worked on my composition by painting some areas black to make the night sky. I used a round foam stamp to make the moon, and I splattered white paint for the stars.

The bottom of the piece was treated to collage. First I tore and cut another piece of the paper that had blue and white paint then arranged it to look like mountains. I painted a handmade piece of paper black and let it dry. I added Interference Violet on top using a dry-brush technique. I used soft gel to attach the papers and a brayer to roll them flat. The handmade paper, as seen in the bottom of the piece, came with linear threads attached. I added some highlights to the piece with Quinacridone Gold.

MATERIALS

Mixed-media paper

White and black gesso or paint

Foam rollers

Brush

Key cards

Rubber bands

Scissors

Brayer

Gloves

Acrylic paints— Quinacridone Gold, black, white, Interference Blue, Interference Violet

Soft gel

Foam stamp

Collage elements

Handmade paper

The direction of the west is where we meet our shadow. Psychologist Carl Jung theorized that our shadow is an ancient aspect of ourselves that we drag behind us like a tail. We must think of our shadow as an ally, not something to be feared and hidden. Society uses morality to mold us to fit into the expected norms, but sometimes we internalize the effects of this. It is as if we each carry a bag around with us through life, and every negative, unpleasant or perhaps even evil idea, act or experience gets stuffed into the bag. As we age, we find we are pulling a long heavy bag behind us. We have baggage.

To become a fully actualized person—to wake up—we must task ourselves to pull these shadows out of the bag and examine them in the light of day. Once we can see them, acknowledge them, modify them and release them, they can

no longer control us. We are never completely free of our shadows due to the good vs. evil duality of our world. We must have the darkness to appreciate the light.

Chiaroscuro is a visual treatment contrasting light and shadow that was developed during the Renaissance. It helps define and emphasize depth. To experience depth visually we must see both shadow and light. They coexist to create perception and depth of field. Without light a drawing would only be black, and without dark we would have only a blank page.

In this exercise we are going to work with shadow play. Recall something negative that you may have been told as a child. Perhaps it was "don't ruin your crayons" or "don't waste paper." Or "share with your sibling, don't be selfish." You

stuffed these admonishments into your bag. Your shadow says that you are greedy and wasteful. That you don't deserve all the fine art materials out there, you will only ruin them. Eventually this can translate into "You are not creative." What a crazy world our minds create! You see, you are creative. Practice working with your shadow, rather than against it, to create from this dark place. Examine it, restructure and reframe it, and put it on the shelf for inspiration.

1 Prepare the paper with white gesso and let it dry. Next, wrap rubber bands around a foam roller and roll it into black paint. Freely roll it around on the paper. I also used a foam roller that had a stripe pattern. There are no rules here. You could even use your hands or brushes.

2 Do the same with another roller using white paint or gesso. You do not have to wait for the first layer to dry. As you roll the white over the black, you will create different values. You are creating depth with the chiaroscuro effect. The only caution is not to overmix and end up with all the same gray value. Strive for lights, darks and grays.

3 My piece was beginning to look a little muddy, so I used old hotel key cards loaded with paint to bring in more lights and darks. I used one card for black and another for white. Work with these to vary the areas of solid and pattern. Let it dry.

4 Use a brush to apply interference paints over both light and dark areas. The unique quality of these paints is that they need to go over a dark background to bring out their light and color, much like our shadow play.

5 Use the key cards or a knife to move more paint. I decided to go back in with white and black to build my composition and then added more interference paint on top.

No Comparison

Let go of comparisons and embrace your uniqueness.

Claybord panel,
6" × 6" (15cm × 15cm)

Finished background painting, 12" × 12" (30cm × 30cm)

Acrylic paints—
Hansa Yellow Medium, Quinacridone Nickel Azo Gold, Dioxazine Purple, Interference Blue and white

Paintbrush

Polymer medium gloss, soft gel gloss or semigloss

Palette knife

Brayer

Plastic wrap

Wood pieces about ¼" (6mm) thick

T-square or ruler

E6000 craft glue

Laser copy image sized to fit your 6" × 6" (15cm × 15cm) panel

Spray bottle of water

Paper towel

Scissors

Kraft paper

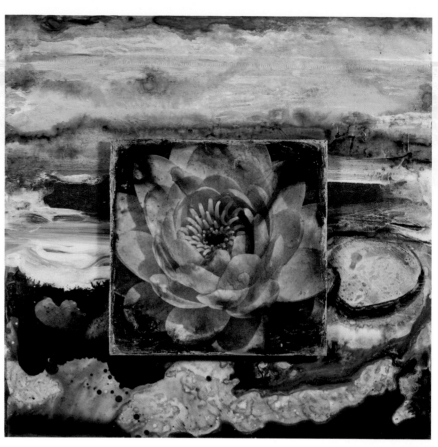

WATER LILIES
Sandra Duran Wilson
Mixed media on panel
12" × 12" × 3" (30cm × 30cm × 8cm)

To awaken your creative muse, you must go out of your mind and into your heart. We creatives are the leaders of the soul revolution; kindness is our implement and cooperation is our goal. Our ego loves to compare and compete, but our soul just wants peace. Ego shares space with soul in our bodies and minds, so how can we get these two roommates to coexist peacefully?

German artist Paul Klee said artists should break down the artworks of their peers and predecessors into the most elementary components—line, form and color—to determine what makes an image successful or problematic. "We do not analyze works of art because we want to imitate them or because we distrust them," he once said. Instead, we do so "to begin to walk ourselves."

In today's world of social media, comparison is tough to avoid. Remember what you see on social media is a person's highlight reel that has been heavily edited. It doesn't serve you well to compare yourself to someone who is likely posting only their great successes. You are not them and this is your journey.

I have changed my life dramatically many times. I aim to reinvent myself every decade or so. I remember the day when I turned the corner and sought the path I am on now. I was working at a job that I had loved for several years and it brought me satisfaction, but it wasn't the artistic life I'd envisioned. I was feeling disconnected. I had been trying to get my boss to let me change my hours so I could fit in more studio time, but he wasn't going for it. I decided to take a few days off and try to cheer up. It was autumn and a friend and I were having a lovely lunch outdoors near the art district. We walked over to see the gallery across the street, and the gallerist began to tell us about the exhibit and the artist. As

he told us of her recent travels and commissions in Europe and her upcoming shows and sales, I thought *This is what I want.*

Rather than allowing the comparison to make me feel bad about my position, I used it as my vision. Right then I said to my friend that this is the life I am going to create. It didn't happen overnight. It took several years, but it gave me time to practice my skills and get my work ready. I showed up every day with a vision in my mind. Some days I wasn't sure what it was going to look like; I just kept showing up and saying yes.

This exercise is a fun way to use comparison as motivation. I started with a background painting I already had, but it didn't have focus or a story. It needed something to create balance and harmony. I analyzed the lines, color, shapes and form to see where I wanted to take it next. I came up with the image of a water lily to complement the background. We are going to transfer a realistic lily image onto an abstract background and fuse the two together so they complement each other rather than do battle in contrast.

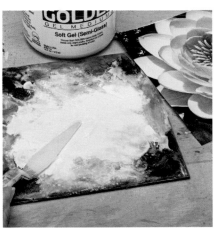

1 Create a background for your image transfer. Mist your panel with water and while you wait for it to soak into the Claybord, dilute yellow, white, Quinacridone Nickel Azo Gold and purple with a small amount of water. If you are using heavy body paints, you will need to add more water. If you are using fluid paints, you do not need to add water. Apply the wet paints to the surface with your brush and do not overmix. Use a paper towel to blot off some paint. Let it dry.

Note: You want to use light colors or your image may not show up very well in the transfer.

2 To make a successful laser copy, use an image that has some light areas so the background colors will show up. Make sure to use a laser copier for this. It will not work with an inkjet.

3 Trim your transfer to the same size as your Claybord panel. Mine is 6" × 6" (15cm × 15cm). Use a palette knife to spread a layer of soft gel across the surface. It should be thick enough so there are no empty spots, but not so thick that it will all squish out when you transfer the image. Your success of image transfers is dependent on this step. The image will only transfer where there is wet gel, so you must be quick.

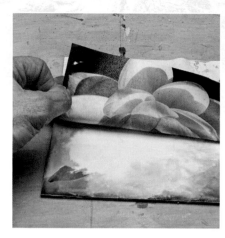 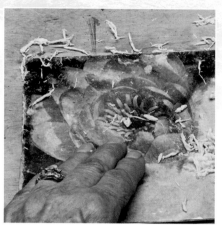

4 Quickly, while the gel is still wet, place the laser copy image-side down. Be careful not to get the gel on the back side of the paper.

5 Put a piece of plastic wrap over the back and carefully press the image down. Begin from the middle and work your way out to the edges. Again, be careful not to get the gel on the top. If you do, wipe it off with a damp cloth.

6 Remove the plastic and wipe off the edges if any gel has seeped out. Let the piece dry overnight. It may be tempting to remove the paper sooner, but to ensure a successful outcome, it is best to wait. When the paper is dry, mist the surface with water and begin to roll the paper off. The paper will come off in several layers like an onion skin.

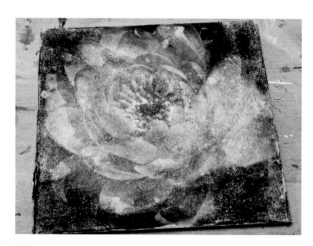 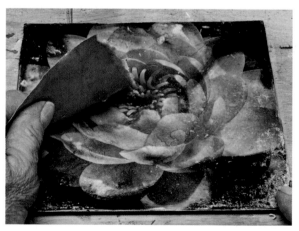

7 When the surface is wet, it will look like all the paper is off, but when it dries it may still be hazy.

8 Here is a trick for removing the last bit of paper haze. Use a piece of kraft paper or brown paper bag. Mist the painting surface lightly with water and then use the paper to remove this last bit of paper.

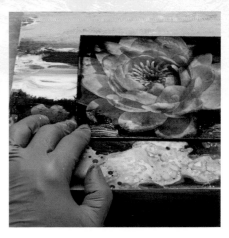

9 I like to seal the surface with a thin coat of polymer medium gloss. Brush on a thin layer and let it dry. It will also help make any paper remnants more transparent. You can see the colors of the background painting coming through the water lily petals.

10 Paint the edges of your wood pieces and let it dry.

11 While waiting for the wood pieces to dry, place the small painting on top of your 12" × 12" (30cm × 30cm) panel to see if any improvements can be made. I decided to add some Interference Blue at the bottom over the dark areas to help integrate it with the background panel.

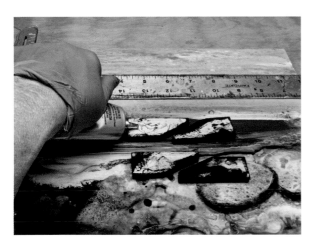

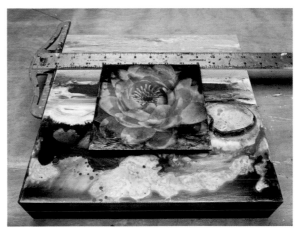

12 Use a high-performance craft adhesive to glue your wood pieces down, then add glue on the top, and center your smaller panel on top. Use a ruler to ensure proper placement.

13 Weight the pieces with a book to dry overnight. I used a T-square to make sure the pieces remained parallel. After about 15 minutes into the drying process, check that your alignment hasn't shifted, and carefully put the book back in place.

When dry, add a few finishing touches. I added a bit of gold paint around the edges of the small panel and some dark blue at the top of the larger panel.

38

Resistance

Find strength in that which you resist.

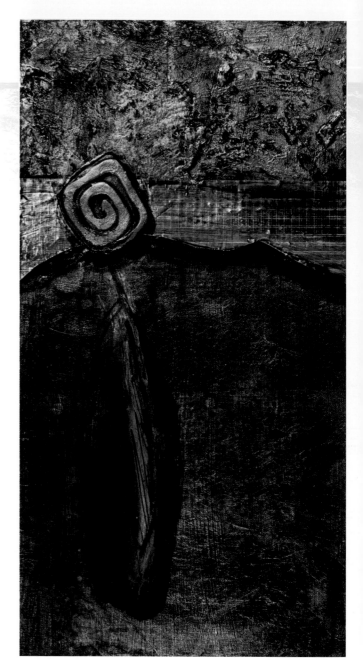

MACAW
Sandra Duran Wilson
Mixed media on panel
12" × 6" (30cm × 15cm)

That which you resist the most usually holds the greatest lesson for you. Every challenge is a beautiful gift, it just arrives in a strange package. I didn't use to think this, but after many tough lessons, I have come to realize that what I desire now may not be for my highest good. Some of my biggest heartbreaks, losses and struggles have yielded the most amazing gifts in the long run. The key is to look beyond the immediate situation.

The other thing that I have learned, and it still serves me well, is to pay attention to my resistance. When it is the strongest, it usually means there is a big lesson ahead. Once I muddle through the excuses, rationalizations and poo-pooing, I come to realize that this is indeed the direction I need to go. Now I am not saying to dismiss your gut instincts or intuition, but pay attention to your resistance. This lesson is your strength.

Letting go allows for magic to happen. Having navigated difficult challenges is like placing a star in the sky. Filmmaker Trent Jaklitsch says, "Each star in the sky was born from that beauty. And later we used those stars to navigate. We steer our ships by them. We discover new ground and return to the harbor by their light. So, the challenges that we overcome give us direction." These challenges are your foundation. When you are faced with a daunting challenge, look back at the storms

I created this painting on top of gold leaf. I began by using gel on the upper portion to create texture while keeping it smooth on the lower section. I then applied Mona Lisa Simple Leaf, an easy-to-use gold leaf by Speedball, over the entire surface. To complete this layer, I sprayed it with MSA varnish and let it sit for several hours. You will find that the paint will bead up depending on its viscosity (i.e., the thickness or thinness of the paint).

Experiment with this quality of resistance. Let each layer dry completely before proceeding with another. If you don't want the paint to resist, add some polymer medium. I finished the painting using interference paints for the feather and aluminum tape across the middle. The spiral is made from paper clay, which I painted and adhered with acrylic gel.

you have weathered and take strength in knowing that you have survived.

Pull out your journal or sketchbook and make notes. Ask yourself the following: What is a statement that is sure to get a rise out of you? Why don't you try this or do that? If you only did this, then you could _____? (Fill in the blank.) How does it make you feel? Where in your body do you feel it?

Address these feelings and ask what they have to teach you. Continue this dialogue when you are feeling resistant. Perhaps someone is suggesting you enter a show or take a certain class and you think, *I don't need that.* Or your mind automatically goes to excuses why you can't do it. Pay attention. Notice where you tend to feel your resistance and is there a pattern? You will benefit greatly from this practice.

You did the challenging work so now let's play with resistance in our art. This is fun and a good reward for doing the challenging work. I have a few of my favorite resist techniques. These two paintings use very different resist techniques, but the reasons why they work are the same. I use resists in creating most of my backgrounds.

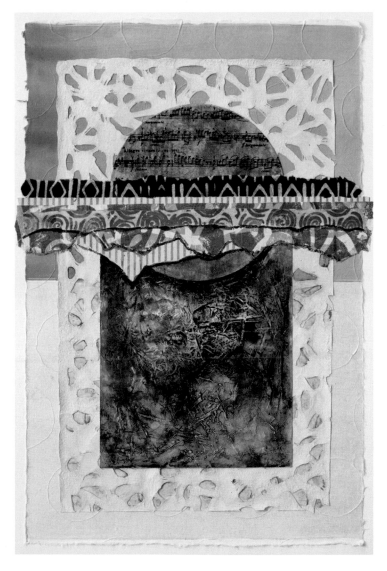

MOON SONG
Sandra Duran Wilson
Mixed media on paper
30" × 22" (76cm × 56cm)

This painting was created using many different papers. The circle is a metallic paper lid that had a similar quality to gold leaf. I used viscosity and layers to create the background colors. The background papers are mulberry bark and rice papers that I painted.

Alcohol resist is a fun technique that I use a lot. When your paint is still wet, drop some rubbing alcohol onto the paint. The wet paint will move away from the alcohol drops and create an opening, revealing the underlying colors. Let it dry and then repeat the resist using assorted colors as I did on the circular lid.

The rectangular paper below the circle was made using tar gel or string gel dribbled on to the paper. When dry, apply colors and wipe some off. The string gel resists the paint and makes it easy to rub off. Mix some color into the gel and use a knife to dribble and draw the strings over the paper. Let it dry and try some more resists. I hope you learn to love resists like I do. They add incredible depth to the surface.

Be Bigger Than Your Fears

Live large, dream big and break out of limiting constraints.

SUN MOUNTAIN
Sandra Duran Wilson
Mixed media on panel
16¼" × 13¼" (41cm × 34cm)

Pull out your mat board and take a spin around the painting, looking for those little masterpieces hidden in plain sight. When you have found the section you would like to enlarge, make a copy of it. From this copy enlarge it on a copy machine, play with the format and use it as the starting point for your new painting.

MATERIALS

Existing painting

Mat board

Craft knife

Fear: You can perceive it one of two ways. Both ways are appropriate in different situations. If you are in danger, forget everything and run. Under different circumstances this may be a better interpretation: Face everything and rise. Fear has a way of escalating itself quickly. The imagination can take you from hearing a branch scraping against the window on a dark night to some big scary monster crawling in through the window in just a few seconds. We do love to scare ourselves with spooky stories, but don't let your fears control your creative soul. Be bigger than them. Stand up to them and see how reacting in a different manner than your usual way can set you on a new path to greater freedom.

Spiritual author Marianne Williamson said, "Our deepest fear is not that we are inadequate. Our deepest fear is that we are powerful beyond measure. It is our light, not our darkness, that most frightens us." Empower yourself by being accountable for your actions and choices. Be brave! Face your fears of failure or of not being enough. Face the fear of knowing that you are good.

Do you ever feel discouraged when viewing others' work and their successes? Social media can be a bit overwhelming and we spend more and more time there. It can feel like everyone is at the party but you. Take care of yourself and do what makes you happy. What makes you happy and successful is not going to be the same for the person next to you.

I see this happen a lot in workshops. We get neighbor envy. Everyone else's work looks so much better than yours.

Well, they are saying the same thing to themselves, so whose reality is real? When this happens, hit pause and mute. Step back and reassess with fresh eyes. Walk away and come back. You will see with fresh eyes what makes your work unique and what may need to be fixed.

Here is an exercise that will help you be bigger than your fears. This is a way to move from a small painting to painting larger.

1 This is a small 8" × 10" (20cm × 25cm) painting that I made in a painting demonstration. I want to crop a portion of it, change the format from horizontal to vertical, and expand it into a larger painting. Challenge yourself to replicate the colors and textures. This will help you remember the steps you took to successfully complete the painting the first time. The more you practice, the easier it gets.

2 Cut two pieces of mat board into L shapes using a craft knife. Slide the boards around to create a window. Play around with the dimensions and view to come up with a new painting. Here I have cropped an area of the painting that I wish to replicate in an enlarged and vertical format.

3 The original painting was in a horizontal format, 8" × 10" (20cm × 25cm). My new piece is a 14" × 11" (36cm × 28cm) panel in a vertical format. It changes the feel of the painting even though I stayed true to the original piece. I was able to match the colors and textures, but then added a few new marks. At this stage I can choose to continue to develop this painting in a slightly new direction or keep it as is.

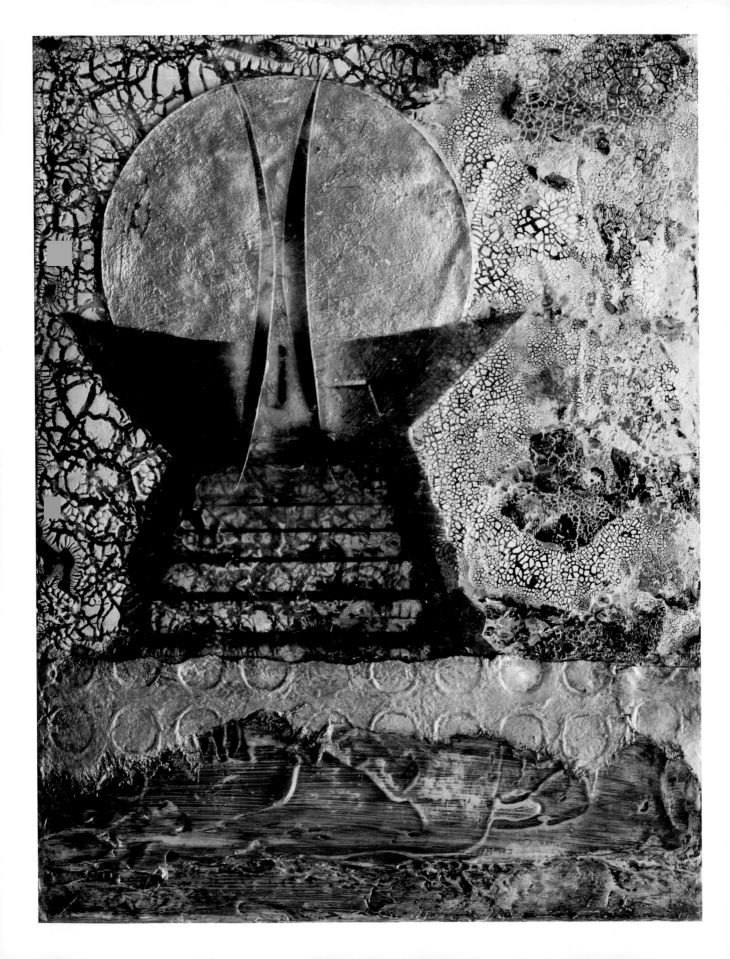

The Northern Gate

We come around to the winter season. A season of peace, compassion, patience and joy. This is the season when all seems to be sleeping. The plants are dormant, the air is cold and snow may cover the ground, yet there is great activity below. The seeds are storing their energy in anticipation of spring.

There is a paradox in this direction. We are both at the end of the year and the beginning. Old age to newborn, the cycle of Mother Earth continues. This is the direction of wisdom and renewal. While this is a time of external rest on the surface, it is a time of internal growth and moving closer to your spirit. We come to understand that the more we give away, the more we gain. We move into the joy of completing the circle and accept our path as we travel around the seasons to be reborn into the spring.

The mind is represented in this season and direction. As we complete the circle, we also complete the mind. Knowledge answers the questions of What? When? Where? Who? How? When knowledge expands into wisdom by filtering it through the soul, it provides answers as to the why.

In this direction we will push our boundaries by testing what we perceive as reality. We will let go of knowing. You may feel a bit untethered and uncomfortable during some of the exercises, but to be free we must let go of control and learn to trust. We will create a shrine to honor this process, and use both art and writing to open our mind to the unlimited possibilities that present themselves when we let go. Embrace the paradox of the season; the more you let go, the more you receive.

HOLDING THE LIGHT
Sandra Duran Wilson
Mixed media on panel
12" × 9" (30cm × 23cm)

Ancestors

Connect with the creative muse that walks beside you.

MOON SHADOWS
Sandra Duran Wilson
Mixed media on panel
12" × 9" (30cm × 23cm)

MATERIALS

Kroma crackle paste	Spray bottle of water
White glue	Plastic wrap
Creative Paperclay	Brush
Rubbing plate	Scissors
Muslin or canvas	Texture or rubbing plate
Simplefix premixed adhesive grout	Acrylic paints— Payne's Gray, Quinacridone Nickel Azo Gold, Titanium White, Light Green, Red Iron Oxide, Cobalt Teal, Copper Metallic, Maroon Red
Mixed-media paper	
Gessobord panel, 9" × 12" (23cm × 30cm)	
Marbleizing spray, gold and black	
Acrylic soft gel, semi-gloss	DecoArt Metallic Lustre cream wax
Polymer medium	Plastic sheeting
Palette knife	Paper plates
Deli sheet	Brayer
Heat gun	Gloves

Where does your inspiration come from? Are you attracted to certain shapes, marks or symbols? You may feel that you have a benevolent angel watching over you, or perhaps you even know who it is. I sometimes get the feeling that there is a whole group of spirits guiding me. I always joked that I needed an army of guardian angels. So who are these guides? Are they ancient ancestors or a relative from the other side who is reaching out energetically to you?

With your journal at hand, set aside some dedicated time to meditate and talk with your ancestors. Sit quietly for a few minutes. You may even

want to set your meditation timer on your smartphone like the Insight Timer app. Follow your breath and gently expand your awareness beyond your body. Sense the guides you have around you. Welcome them and gently sit in silence. Listen for any guidance you may receive. After a few minutes, thank them for being present in your life. Open your eyes gently and use your journal to record any words, feelings or directions that you sense.

Now begin to doodle. Let go of thinking about anything and breathe and doodle. With practice, you will find that you begin to develop a visual vocabulary that is unique to you. I call this my ancestor language.

In this exercise incorporate the symbols, shapes or colors that you have experienced during your conversations with the ancestor into a work of art. Here I share how I made mine. Feel free to adapt the techniques to fit your personal vocabulary.

1 Cover your work area with plastic. Cut the fabric so it is slightly smaller than your 9" × 12" (23cm × 30cm) panel. Mist your fabric with water and then use a palette knife to spread adhesive grout onto the muslin or canvas fabric. Apply a thin layer and really press it into the fabric. Add some more so your layer has varying depth. Let it dry.

2 When the grout on the fabric is dry, bend, roll and curl the fabric to create cracks in the adhesive grout.

3 Place your paints on a plate and dilute with water to the consistency of cream. I used Cobalt Teal, Payne's Gray, Quinacridone Nickel Azo Gold and Titanium White. Brush onto the fabric. Spray the surface with water and direct the paint with your brush. Hold the fabric over the plate and let the paints flow and mix together. Let the extra flow off onto the plate. Let it dry completely.

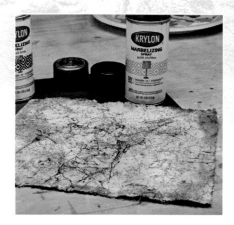

4 Paint your Gessobord panel with Red Iron Oxide and let it dry. Next spray gold and black marbleizing paint onto the dry canvas painting from step 3.

5 Use a palette knife to spread a generous layer of soft gel onto the Gessobord. Place the canvas piece on top and use a brayer to adhere the canvas to the panel by rolling lightly from the center of the canvas out to the edge. Gradually increase the pressure. When the air pockets have been removed and the fabric is securely pressed down, place a piece of plastic wrap over it and weight it down with a board or books. Let it dry completely.

6 Make some embellishments with Creative Paperclay. Squeeze and work the clay to slightly soften it, then press it onto a rubbing plate to emboss a texture. Pull it off the plate and add any other textures or carvings that embody your personal symbols. Use a knife or the side of your palette knife to trim the sides or cut out clay shapes.

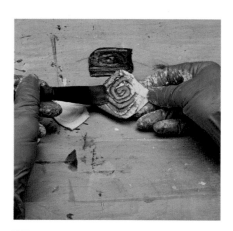

7 Let the paper clay dry completely. This could take overnight depending on the temperature and humidity. When dry, paint with Copper Metallic.

8 Begin the crackle papers. Place drops of paint onto a sheet of mixed-media paper—I used Cobalt Teal, Quinacridone Nickel Azo Gold, Payne's Gray and Titanium White. Spray with water and press a deli sheet on the paper. Drag, pull and twist the deli sheet to blend and move your paint. Mist with more water if needed. Save the deli sheet for another project. Let it dry completely.

9 When the paper is dry, use your palette knife to spread a thin to medium layer of glue over the entire sheet and let it dry. Don't worry if the layer is not perfectly uniform; it will add to the effect.

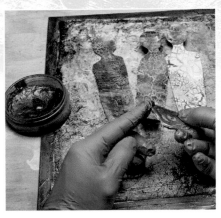

10 When the glue layer is dry, mix the Kroma crackle paste with a small amount of Light Green paint and spread it over the surface. You don't have to cover the entire surface with the same color. Try spreading plain crackle paste, which will dry a translucent white.

11 Kroma is the only crackle product that can be heat dried. Use a heat gun and keep the gun moving so as not to burn the paper.

12 Draw the shapes of your ancestors on the back side of the paper and cut out the figures. Follow your vision. I am adding some metallic cream wax to the side of the paper clay shapes.

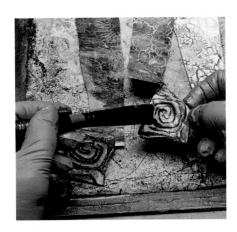

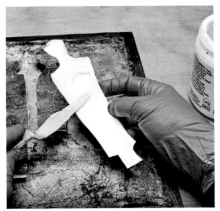

13 Mix some Maroon Red with polymer medium to make a glaze. Paint this over the copper embellishments and then partially wipe it off so it stays only in the recesses.

14 Spread the gel medium on the back of your paper cutouts and adhere them to the panel. Press down and, because of the textured background surface, you may need to add more gel.

15 Do the same with the paper clay shapes. Place plastic on top and weight it all down with books overnight. Add some finishing touches with a glaze of Payne's Gray and polymer medium on the outside edge. Add shadows with a dark glaze between the figures for depth. Use a dry-brush technique to add some Light Green to the ridges of the paper clay elements.

133

Living in the Question

Find magic in letting go of knowing the answers.

Contributed by John P. Weiss

It takes courage to live in the place of not knowing, but this is where miracles happen. This story says it beautifully. This week tell your own story, either visually or write about living in the question. You may use this story as inspiration for a painting.

The Morning Fox

A story of loss and love by John P. Weiss

The fox started coming every day after Carole died. It was the strangest thing. One minute we were making buttermilk pancakes in the morning and then, in an instant, Carole was gone.

She woke me at 3:00 AM and said she was having trouble breathing. I fumbled for my cell phone and called. People came and in a blur I was at the hospital. Bright lights. Noise. Confusion. No one could tell me anything. Finally they let me in to see her.

"How're you doing, babe?" I held her hand.

"Oh, John. I'm so sorry. I thought we'd have more time. Now, you promise me. Water the flowers in the patio garden. Keep up with your art. It'll keep you sane. And make sure you feed her."

"Feed who?" I asked my beautiful wife. My love. My everything, who was slipping away before my eyes.

"You know who. I named her Eloise, after my grandmother." She leaned back on her pillow, fighting to breathe.

God, I loved her. No one ever prepared me for this. How do you say goodbye to the love of your life?

"Babe, who are you talking about?" I caressed her face.

"The fox, honey. I named her Eloise. Don't you remember? She used to play with Troy." Troy was our German shepherd. He passed away last year. The most gentle dog you'd ever meet. He'd play with all the wildlife. It's like they knew he was harmless. A gentle soul.

"Oh yeah, I'd forgotten. You named her 'Eloise?' That's perfect. She's a beautiful fox. Very elegant and athletic." I looked deeply into Carole's eyes. "This is so hard. I love you so much."

She closed her eyes and grabbed my hand. "Oh John, this is life. We've had so much. We've been blessed. I'm so sorry we don't have more time. Promise me you'll stick with your art. You do beautiful work. Promise me you'll keep moving people with your creativity. And remember to feed Eloise."

And then she looked at me and said, "Feed her, John. I don't know why, but she's special to me. Feed my little fox."

I told her I would, even though I didn't understand.

Carole fell asleep after that and never woke up. She seemed fine but then cancer can be deceiving. We had a beautiful service and at the reception there were many people who talked about my Carole. So many nice things were said. I did my best to be gracious, but I was dying inside.

Death takes a part of us when it steals the ones we love.

I awoke the next day, early. My sleep was fitful and I felt tired.

Brewed and poured a cup of coffee. Made my way onto the back deck and settled into one of the Adirondacks. The air was crisp and a breeze washed over my face. It was peaceful.

There was a light dusting of snow on the ground. Everything was pristine and crisp and fresh. And that's when I saw her. She crept out of the brush like a Kabuki theatre actor. Stealthily, silently and with an elegant grace in each footstep. Her tail was full and her eyes were bright. She was absolutely beautiful.

Just like my Carole.

I remember asking Carole why the fox was so important to her. I mean, there had been other wildlife that visited our home over the years. Rabbits, coyotes, birds, deer. But for some reason the fox touched Carole.

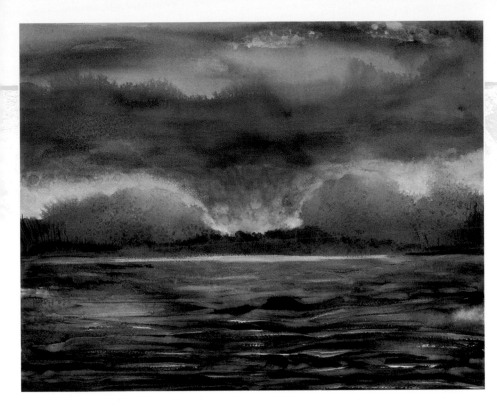

SPIRIT LAKE
Sandra Duran Wilson
Mixed media on paper
22" × 30" (56cm × 76cm)

She told me: "I read once about a fox cub that was trapped in a snare for two weeks. He should have died, but he didn't. Do you know why? Because his mother brought him food every day. When he was rescued, he was injured and in pain. But he was also chubby."

I held her hand. "Wow, that's amazing." I smiled at her. She reached out with her other hand and said, "John, when you go to bed at night you're going to dream. You're going to be sad and lonely and maybe scared. Just like that fox cub in the trap. But here's the deal. I'm going to come visit you. In your dreams. I'm going to be there for you. Just like that mother fox. I'll take care of you, honey. In your dreams. Don't ever forget that."

I never did forget that. In fact, the morning after Carole's fox came by to visit, I started leaving little treats in the backyard. I dragged the Adirondack chair out to the rear yard. I'd make coffee in the morning and get up early. I'd cook sausage and bacon and take it out with me.

Soon Carole's fox started coming every morning. Over time, the fox became more comfortable with me. She'd come closer and closer. Sometimes I could hold the bacon in my hand and she'd eat it.

Yesterday was Carole's birthday. I got up early and cooked some bacon and sausage for our little fox. But then I fell asleep in the backyard. I was feeling sorry for myself the night before and drank too much wine. So I was a bit hung over and fell asleep in the Adirondack chair.

I've never been a superstitious man or given to religion. But I always sensed that maybe, just maybe, there was more to life than met the eyes. Still, I never dwelled on it.

That early morning of my wife's birthday, as I lay asleep in the rear yard Adirondack, something amazing happened. I was dreaming and Carole was facing me. She held my face in her hands, and she told me that everything would be okay. And then she leaned in to kiss me. I felt her soft kiss on my lips.

When I awoke there she was. Eloise. The little red fox. Licking my face. She had eaten the bacon and sausage I left. I guess she wanted to thank me.

Or maybe it was Carole. Maybe she found a way. Through the fox. To reach out and reassure me.

Just like that mother fox who took care of her pup when he was trapped.

Because I was trapped, too. Trapped in an ocean of grief. Until I awoke with that fox licking my face.

And I knew. I knew that everything would be all right.

Now, whenever Eloise visits, I feed her and we hang out. She's as beautiful as my wife. She brings me peace.

She taught me to be thankful. She helps me understand that Carole will always be with me, and that love is the most powerful thing in the universe.

Embrace the Unknown

Let the messy parts lead you to a fresh approach.

Contributed by Connie Solera

GUARDIAN
Connie Solera
Acrylic, oil pastel and
graphite on paper
12" × 9" (30cm × 23cm)

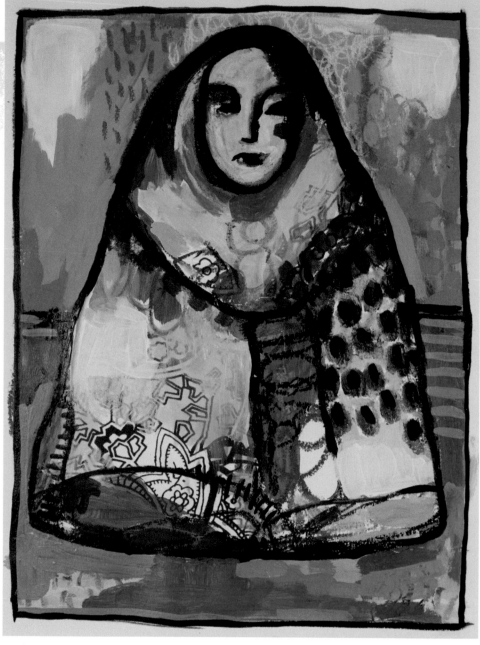

MATERIALS

Art journal or
mixed-media
sketchbook

Water-resistant marker

Water-soluble graphite
or pencil

Acrylic paints

Collage papers

Glue stick

Oil pastels

Synthetic paintbrushes

Painting is always an adventure. I rarely know where I am headed, but I can feel it in my bones when I finally arrive. To get there it takes listening to what the painting wants—one mark, one color and one glorious brushstroke at a time.

I never come to the blank page with a set idea or a specific image I wish to convey. Instead I muster up my curiosity and strap on a willing-ness to explore the unknown. Though I must tell you, this uncharted path isn't always easy. There are many unexpected bumps in the road that can show up and spook you. One simple line or a swatch of color can turn a piece that you adore into a raging mess. But please don't panic. Trust.

I find it's the messy parts that lead me to a new expression or a fresh approach. That's why

I always welcome in a little uncertainty when I paint. As you'll notice in the following lesson, my random scribbles and finger-painted smears add character and a sense of electricity to the piece. Without them things would appear and feel flatter.

My rule of thumb is that once the painting process starts to feel comfortable and cozy, that's the cue to shake things up. It doesn't have to be drastic. (For me it rarely is.) Scribble here or glue down a piece of found paper there or choose a color that feels wild—but get the energy moving in the painting and follow where it takes you. We humans love to stay in our comfort zone, so inviting in creative detours, no matter how messy they might get, helps us stray from our usual routine and discover new lands!

Finally I know a painting is complete when I feel a sense of wholeness to it. Though because adventures can be unpredictable, sometimes the painting ends up less attractive than I prefer. Other times it leaves me all warm and tingly inside. Either way I find it best not to get too attached to the final outcome. The beauty of painting is that there is always another adventure ahead.

In this exercise, follow along as I embrace the messy and honor what feels right in the moment.

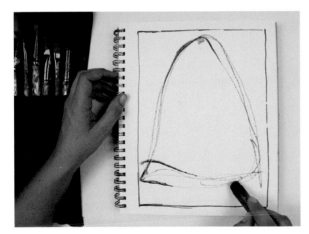

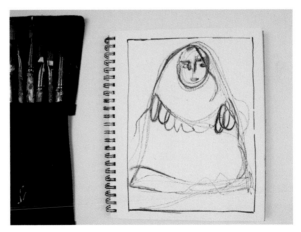

1 The first thing I do when approaching the blank page is create a frame around the edge with a water-resistant marker. Don't pull out the ruler or worry about making it perfect. This line is simply a ritual I like to do that symbolizes setting a boundary, making the first mark and ultimately welcoming in the unknown.

Once the frame is set I pick up my water-soluble graphite stick, dip it into water and get moving. Depending on my mood, my line might dance, saunter, gallop or move at a snail's pace. The intention here is to keep it fluid.

2 After moving the line around the page for a while, an image might start to form or possibly a relationship of shapes sparks my interest. Most of the time, what appears for me is the hint of a figure. I have a slight obsession with painting robed women who are robust like mountains and grounded on the page. This is why taking creative detours is so important. Even though I tend to paint the same subject matter, inviting in a little adventure makes each one look unique.

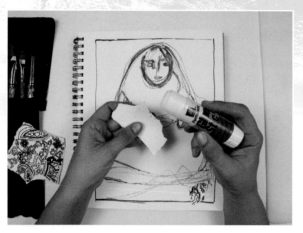

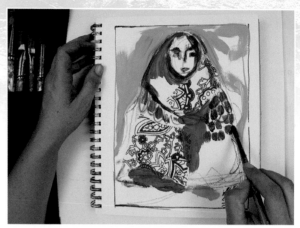

3 In the corner of my studio is a stack of scrapbook papers and old magazines that I purposely collect and use for collaging. It's quite cathartic to rip and tear the paper and then discover interesting ways to place the organic shapes into the image so that the patterns create something fun for the eye to explore and rest upon. It's also a great way to break up the energy. Many times I'll glue a pattern down and it will shift the whole painting and lead me somewhere completely unexpected.

4 Keep your paints close by and grab the colors that call to you in the moment. This will help you both slow down and choose colors more intuitively. Vary your brushstrokes and the way you apply the paint as well. Sometimes I use long, large strokes. Other times I might dab, dab, dab.

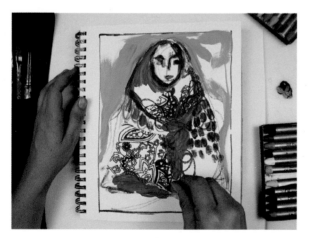

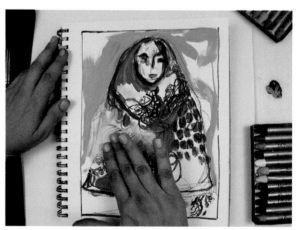

5 I typically feel the urge to shake things up when things are going smoothly. That's when I pull out my oil pastels and start clustering lines together and tangling them across the page in scribbly fashion. Yes, it can feel both exhilarating and scary to let loose like this, but it's in these bursts of creative rapture that the painting starts to take on personality.

6 If scribbling isn't enough to break up a good thing, I also like to squeeze some paint directly onto my page and feel my way around using my fingers instead of the brush. Make sure all the previous paint is dry to avoid a total muddy mess.

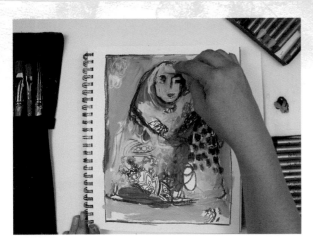 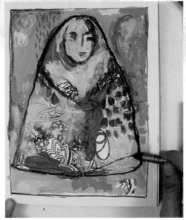

7 Once the color, line and pattern create a sense of harmony, instead of breaking up the energy again, fine-tune aspects of the image or abstract shapes. For this painting I defined the face by applying a layer of oil pastel. You may want to accentuate a figure, an image or a shape that is calling to be the focal point of your entire piece.

8 The last thing I always do in my paintings is pull out the black. Here I used a black oil pastel to create a soft border that helps define the edge of the woman figure. Next I used black fluid acrylic paint to add tiny details such as the pattern of dots on her robe and a more defined edge around the eyes and face.

9 Finally I use the same fluid acrylic black paint to go over the frame on the perimeter of the painting. At the beginning of my painting this simple line was a ritual of stepping into the unknown. At the end of my painting this same line marks a moment of coming full circle. I end the adventure in the same way I began, but now possess a greater sense of wisdom and fulfillment for having taken the journey.

Buried Treasure

Mining your past to tell new tales.

Here is my completed necklace of found treasures. Find your buried treasure and set your imagination free. You could string garlands of treasure and hang them on your gratitude tree, or wrap them around a wreath. One of the most creative displays I've seen is thousands of little plastic pieces and other found "trash" attached to a chain-link fence. These guys had the most imaginative front yard and the fence was so colorful as the thousands of pieces moved in the wind. Everything from little plastic toys to sidewalk finds. After a while folks started leaving things for them and even attaching some newfound treasures.

MATERIALS

Needle-nose pliers, two pairs

Chain with links wide enough to attach your treasures

Clasp

Jump rings

Towel

Stray pieces of jewelry, earrings, pendants, etc.

We are made up of so many experiences, connections, thoughts, things and beliefs. Buried treasure exists all around us. You can dig deep into your beliefs, your dreams, fears and hopes, and you can dig deep into your closet and your pile of memories. Keep digging until you reveal the buried treasure, the nuggets of gold that you have tucked away. It is amazing how a tiny piece of something can tell an entire story in memories. Harness these forgotten treasures and create a new narrative for them. Find the treasure right in front of you and repurpose it with new meaning.

The treasure in this case is my container full of all my orphaned earrings, broken pendants, stray pieces of jewelry and other assorted finds. In this exercise let's make treasure necklaces from my buried and lost artifacts. You may even incorporate ribbons from a favorite article of clothing, pieces of stone or shell—whatever your treasure is.

To begin, gather your orphaned earrings, ones you no longer wear, pendants or other found treasures and lay them on a towel to keep the tiny pieces from straying. Determine the length of necklace you want and note the center point. Set out the pieces and design the order in which you would like to attach them.

1 To attach a jump ring, grasp each side between the split with needle-nose pliers and twist in opposite directions. Move one side toward you and the other side away. Do not pull apart.

2 If needed put several jump rings together.

3 Use the same technique to attach the earring to the chain.

4 Attach all the pieces to the necklace chain. You may add the pieces in other ways, too. Use the wire that may already be on the earring, tie with ribbon or yarn, wrap the piece in wire and attach, or use any other ingenious method you come up with. Finally use jump rings to attach the clasp for the back. I attached an extra jump ring hanging at the back of the chain to shorten my necklace as desired.

Sacred Shrine

Make space in your everyday life to allow miracles to happen.

MATERIALS

Apoxie Sculpt
by Aves

Stencil

Brayer

Plastic wrap

Found box

Window from dollhouse
furniture

Mixed-media paper

Scissors

White glue

Objects that have
meaning for you

Wood pieces

E6000 craft glue

Brush

Skewer

Acrylic paints—Phthalo
Turquoise, Permanent
Violet Dark, Bright Gold,
silver, black, white,
bronze, Interference
Blue, Interference
Violet, Colbalt Teal

Gesso, gold

DecoArt Metallic
Lustre cream wax

Gloves

Palette knife

Spray bottle
of alcohol

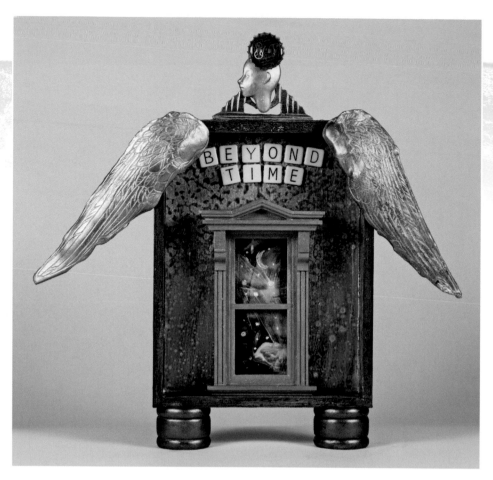

BEYOND TIME
Sandra Duran Wilson
Mixed-media shrine
14" × 14" × 2" (36cm × 36cm × 5cm)

Our intentions, actions and creativity separate sacred space from everyday ordinary space. Symbols and rituals play a big part in indicating the transition from sacred space to ordinary. I always found my spirituality in nature, but as a child growing up on the Mexican border, the rituals of the Catholic church always designated sacred space. The dance—stand up, kneel, sit down, cross yourself, bow your head, be silent and sing—combined with the incense, robes and language, transported me to a different place. As I got older and was able to roam the hills and rivers on my own, I found a much more profound peace in nature. The sounds of water flowing, wind blowing and insects and birds singing. The visits from the animals and the beauty of the

plants, the colors and the dance of light grabbed me and held me. To this day I practice a daily walk in nature to ground me, center me and inspire me.

Sometimes we create altars or designate areas with mementos, candles or photos to remind us to connect with sacred spaces. I feel a profound connection when I create an artistic shrine. It is a visual reminder to connect with my spirit. I may create an art piece in nature and take a photograph of it, then display it on my mirror as a daily reminder, or I may gather objects and make a space on my tabletop. In this exercise we will build a shrine that encompasses and holds the ideas and intentions we wish to focus on.

To get started, grab your journal and pen and find a quiet spot where you can reflect. Here are a few prompts to get you started thinking about your shrine: What aspect of life do you wish to focus on? What would you like to manifest in your life? Where do you find peace? Keep the questions and answers in the positive. For example, I wanted to explore the concept of time. One of my questions was, how do I feel about time? Is it finite or infinite, can it be changed, can it go in reverse? How do we create time for ourselves? Where does it go, how can I find more, where am I when I am not here?

There are no strange questions when you are journaling. Write whatever it feels like you need to, no judgments.

After writing and exploring what your shrine will be, begin to gather your objects. Your focus will narrow and you will begin to see the things you want. Things will find you. Sometimes I am strongly drawn to an object. I don't have a plan in mind for it, I just know I need to have it. It may even be years down the road before I find its purpose. This was the case with the dollhouse furniture. I've always loved boxes and collected them. And the dollhouse furniture came along with some boxes.

1 The first step is to make some wings. Aves Apoxie Sculpt is great stuff. You can sculpt with it and it dries hard, like stone without heat. It is also an adhesive. Take two equal amounts from parts A and B. I wear gloves when handling. Mix the two parts together until they are completely mixed and all one color.

2 Lay a portion of the mixture between plastic wrap and use a brayer to roll it out to a ¼" (6mm) thickness, approximately the size of the wing stencil. Remove the clay from the plastic and place it on top of the stencil. Place the plastic back over the clay and apply enough pressure to create an impression, but not so much that it is difficult to get the clay off.

3 Peel the clay off the stencil. If it doesn't come off easily, turn the clay over and peel the stencil off.

4 Use a palette knife or a craft knife to trim the shape to the design of the wing. Let the wings dry overnight. I used the plastic to prop up the wing in the middle so it would have a slight bow.

5 The dollhouse furniture window even has a piece of plastic for the glass. I removed this while painting the wood. I used gold gesso, but paint will work just as well.

6 Paint the outside of the box with the gold and let dry. When the gold is dry, paint the outside with Permanent Violet Dark.

7 While the paint is still wet, spritz alcohol onto the surface to create a speckled resist.

8 Repeat the technique from step 7 on the inside of the box using silver for the first color and Phthalo Turquoise for the second color and alcohol resist.

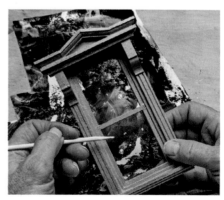

9 Create a galactic paper like we did in the Power Shield exercise in Part 3. Paint a piece of mixed-media paper black, leaving some areas unpainted. Let it dry. Use a brush to apply Interference Blue in some areas and Interference Violet in others. The interference colors only show up over the black paint. Cut out a shape to fit behind the window. Put the plastic back into the window frame and use a fine brush or skewer to paint white stars and a moon on both sides of the plastic.

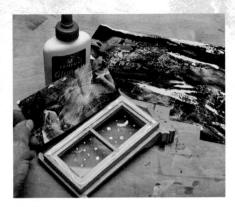

10 Put white glue on the back side of the window and press the paper into place. Weight it down with a book and let it dry.

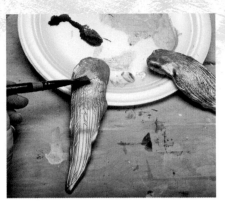

11 Back to our wings. Use Cobalt Teal and Bright Gold paint to layer color onto the wings. Let it dry, then paint a layer of gold, wait a few minutes and then wipe some off. Repeat with the Cobalt Teal.

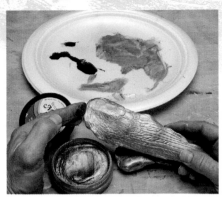

12 Apply a layer of fuchsia metallic cream wax to the wing.

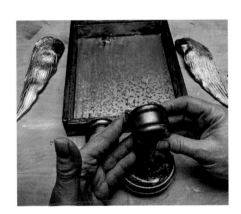

13 Paint the wood napkin rings a bronze, let them dry and add purple metallic cream wax.

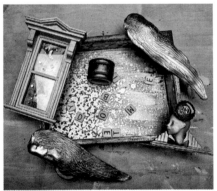

14 Gather together all the pieces for your shrine. I assembled a top piece made from a clay face I made, a part of dollhouse furniture and a little bottle-cap art piece. I adhered them together using Apoxie Sculpt. I also found some letter tiles to spell out words.

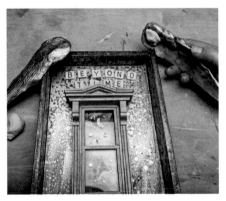

15 Use a high-performance craft adhesive to glue the letter tiles. Then mix together two equal parts of Apoxie Sculpt and place a ball of it on the back side of the wings. Press them into place on the box. You may want to prop the wings while they dry. I used craft glue to adhere the feet and the top ornament onto the sculpture.

45

Trust and Synchronicity

Connect the dots and trust the journey.

The term *synchronicity* was coined in the 1950s by psychologist Carl Jung to describe uncanny coincidences that seem to be meaningful. How does synchronicity foster trust? Connect the dots and pay attention to the signs that are knocking on your door.

The knock on my door came in the form of graffiti on a bathroom wall. "Time is an illusion to keep everything from happening at once." I thought, *That is the answer to everything.* Soon after, I dropped out of college and began following the signs that led me from college to Mexico, to stone cutting, to making jewelry. My journey took me to Santa Fe, New Mexico, where I connected another dot. I ran into someone I knew from college and I worked for him for the summer selling jewelry in Santa Fe. I would sleep on the floor of the workroom and make jewelry and sell it during the day. At the end of the summer I sold all the gems I had mined in Mexico and went into business with my employer. I had to work two jobs to pay the rent and after a few years, I decided I was too young to be working so hard. I was twenty-one and I sold out my share and traveled the world for a year. I eventually ended back in Santa Fe. I thought it was as good as anywhere else.

I eventually went back to college and reinvented myself again. I had always been creating—making jewelry, sculpting, painting or writing—but I was also working for others. I was working as a bartender and when the opportunity came up I worked in a spiritual retreat center. There I was able to share and teach creativity with others, a wonderful experience I had for a decade.

Then another dot popped up. I quit being an employee and became a contractor. I was able to do what I loved both at the center and in my artwork. But synchronicity intervened. I was fired. The center was going to be sold to a corporation, and I was the first to be let go because I was a senior contractor. I simply had to trust. I had just gotten married and we had moved to a much larger, more expensive home. I thought,

How am I going to pull this off? I continued doing what I had already been doing: making art and selling it on weekends at outdoor shows in Santa Fe. Now I had more time to do just that. That year I made more money than I had the previous year when I was working both jobs.

Since then, I have continued to challenge myself, trust in the process and reinvent myself every decade. I figure this will help me keep up with the flow of change. That is the ultimate connection, and what allows the circle to be completed. My work is now represented in a gallery that is in the same space where I first started at age nineteen.

Trust that the universe is working in your favor. Pay attention to the signs. I am not special. The universe operates this way for everyone. You must pay attention, take action and trust. Let me share some steps you can take to launch you on your journey.

How can miracles happen if you aren't paying attention? Will you notice the dots when they pop up in front of you? Coincidences and synchronicities are your dots. The universe has an underlying web that connects everything. I am a science geek, so trust me on this one. These dots, as I call them, are calling attention to something important in your life, glimpses of what goes on beyond everyday distractions.

Grab your journal and begin with these prompts. Have you followed your heart? If you did, what does your journey look like? Write down times when you have encountered synchronicities. Did you pay attention to them and what happened? Examples for me are when I have paid attention to a feeling, a sense of direction, gone a different route and encountered a person who has led me on a new path.

Exercise your trust muscle. Think of the little things you can begin with, like finding a parking spot, your keys or the book you have been looking for. I have developed my own personal meanings for certain symbols, numbers, animals and songs. When I see a hawk, I am reminded of my first spiritual teacher. The number 11 is very spiritual to me, so is the number 3. Trust

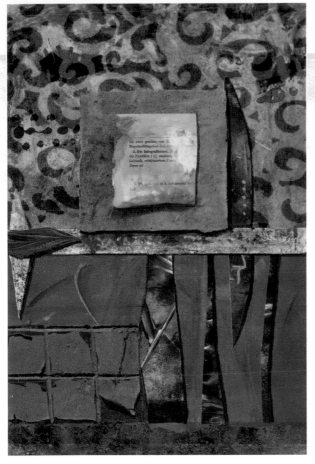

TRUST THE JOURNEY
Sandra Duran Wilson
Mixed media on paper
20" × 15" (51cm × 38cm)

TRUST
Sandra Duran Wilson
Mixed media on panel
12" × 10" (30cm × 25cm)

that the things you pay attention to, the dots that are in front of you, have meaning for you personally, because they do.

Try to elevate your synchronistic awareness. Begin to track your synchronistic moments. I find that I often look at the clock when it is 11:11 or 2:22 or 12:12, repeating patterns that have significance. Sure, I may look at the clock when it is 3:25, but I pay attention when I see my angel numbers. It reminds me that I am not alone on this journey. One day I was in a bookstore browsing when a book fell off the shelf and landed on my foot. Well, if that's not a sign, what is? I got the book and it had a profound effect on my life. The book was *Synchronicity* by F. David Peat.

Try this prompt in a different direction: How has a setback or "failure" affected your life? Getting fired was the best thing that ever happened for me.

Connect your dots. Look back over the seemingly unrelated events that have led you to where you are now and see how the dots are connected. Fine-tune your awareness and follow your path.

Now free your mind and trust. Create from this perspective. Whether you want to paint, write, play music, act or pursue your current passion, turn your mind off and your intuition on.

I created the painting *Trust the Journey* by connecting the dots. I began with paints that were on my table and used the first tools I grabbed. I tried things and combinations that were whispered to me. I followed one dot to the next and when the little voice said "Stop," I did.

So this is your next exercise. Create from a place of not knowing and trust the journey.

Gratitude Tree

Practice feeling grateful in order to manifest gratitude.

MATERIALS

Plastic sheeting

Tree branch or wire

Plaster gauze

Scissors

Tray or bowl
of water

Acrylic spray
paints—gold, blue

Acrylic paints—
blue, white, purple

Gloves

Apoxie Sculpt
or clay

Cardstock

Hole punch

Matte medium
decoupage

Thread or cord

Markers or
fine-tipped pens

Flowerpot or vase

Rocks or marbles

Rubbing alcohol

The gratitude tree is a creation for the soul. The idea is simple: to make a card every day to focus on what you are grateful for. I have been thinking about this idea for a long time. Years ago, I had wrapped a Y-shaped branch in colorful embroidery thread. It had feathers and beads and always made me smile when I saw it.

When I began to create a new tree for this exercise, I ran into problems. A branch broke when I was wrapping it, then when I took it outside to photograph it, the wind knocked it over and broke another branch. I was getting very frustrated. Reality wasn't matching what I saw in my vision. I told Cate Goedert, my photographer, that we would have to wait and do it another day. I took the tree back inside and attempted to repair the broken branch. It fell over and broke again. I left the studio in frustration. When I returned the next day, I was still filled with frustration. I sat down and looked at the cards that I had already made and then I had an idea. I wrote the lessons that I had learned with my darned gratitude tree. I took my frustration and turned it upside down. I wrote that I am grateful for the time that I am here. I am grateful for my persistence. I am grateful for my frustration because it helps me to release any perfectionism.

How to Use Your Tree

I like to put the tree out during the winter season and place daily gratitude cards on it. But different ceremonies may be created around the seasons. Whether you write your gratitudes on cards or infuse intention into other objects, it is the act of remembering and focusing on what you are grateful for. For the spring you might hang decorated eggshells along with intentions of what you would like to see born in the new season. For summer you can tie ribbons with intentions written on them. In the autumn you can add dried flowers or leaves. The practice and the intention of focusing on what you are grateful for will encourage you to focus on the things you already have. Rather than a feeling of lack, you will feel abundant with what you do have.

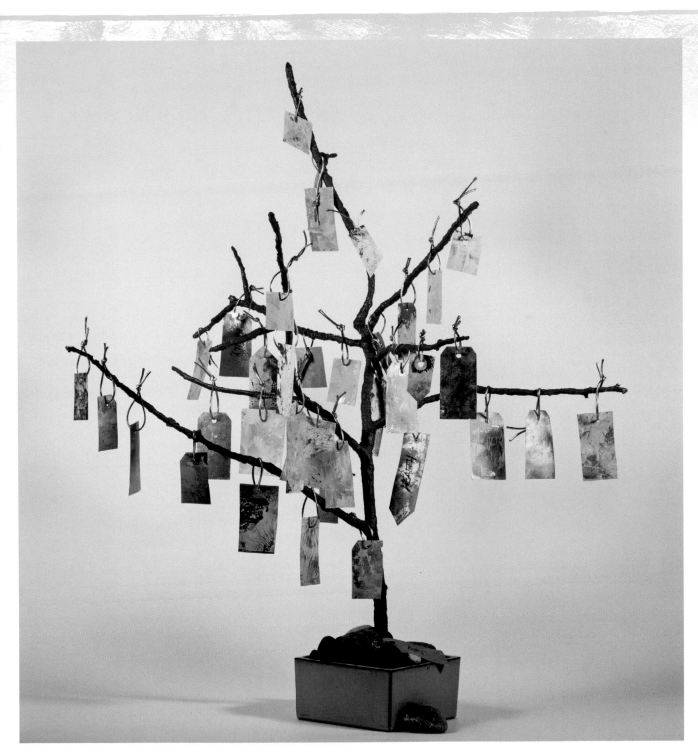

My gratitude tree and a variety of daily gratitude cards

1 Find your branch. Choose a sturdy branch, or you can even use wire as an alternative. Gather your materials and cover your work area with plastic. Fill water in a small bowl or tray. Cut pieces of plaster gauze about 4" (10cm) long and 1" (25mm) wide.

Dip a gauze strip into the water and pull it through your fingers to remove excess water. Wrap the gauze around your branch, overlapping as you go.

2 Continue wrapping the branch until it is completely covered. I wrapped two layers. Let it dry. This may take a day or two depending on how many layers of gauze you apply.

3 When dry, paint the branch with acrylic paint. I used spray paint, but you can brush on paint if desired. If you are using spray paint, it is best to use it outside.

4 Make a base for your tree branch. You can use clay or Apoxie Sculpt. If you use clay, work it around the branch so it will hold.

5 Place the tree in a flowerpot. The base helps to stabilize the tree. Fill the pot with marbles or rocks.

6 Make your gratitude cards. Begin by spray painting the cards gold. Let this layer dry and then put a few drops of blue, white and purple onto one card. I pressed a second card on the top, then twisted them around and pulled them apart to create a nice blend of colors.

7 While the paint is wet, drop rubbing alcohol onto the surface. The paint will move away (resist) from the alcohol and create openings in the paint layer. If desired, repeat on the other side, or decorate with stamps or whatever inspires you. Let it dry and then brush a coat of matte medium decoupage on top. This will make your surface easier to write on.

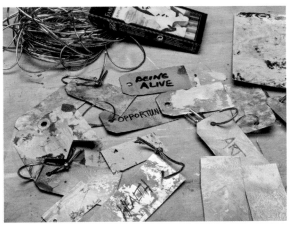

8 When your cards are dry, cut them to the desired size for your tree size and punch a hole in one end.

9 Cut thread or cord and put it through the hole. Tie a knot on the end to create a hanger. Write your gratitudes or intentions on the cards with markers or pens. I like to leave some blank ones in a bowl to write on and add to the tree later.

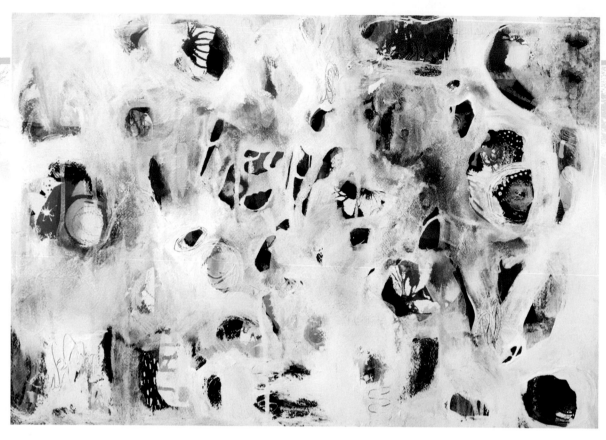

BEGIN AGAIN
Tracy Verdugo
Acrylic on watercolor paper
12" × 16" (30cm × 41cm)

MATERIALS

Watercolor paper

Acrylic Artists inks

Heavy bodied acrylics

Fluid acrylic paints

Tools from nature
such as twigs, leaves,
seedpods

Wide, flat wash brush

Various paintbrushes

Watercolor pencils

White oil pastel

Stencil

Share Your Light

Take a walk around the wheel to build a layered painting.

Contributed by Tracy Verdugo

In the paradoxical direction of north, we let go in order to become reborn. In this exercise we will create a painting based on our complete journey around the wheel and through the seasons. It is like a life review from beginning to end to beginning again. We are the sum of everything. Begin with innocence, learn from your first marks and add to them with your experiences. Gather your wisdom and trust that all remains even when it is hidden from view. You could not have achieved the depth and dimension of this life, or painting, without building upon your experiences. Trust yourself. You have embraced trust when you are willing to let go of the preciousness of the individual parts and embrace the whole of the painting.

1 We begin in the east, a place of curiosity, spontaneity and play. Collect tools from nature to create interesting marks like leaves, twigs, seedpods and flowers. We look at these tools with the wonder of a child, inventing ways to use them to lay down the first layers on our paper.

2 Using a red watercolor pencil, make an energetic, wandering design across the surface. Explore possibilities in straight and curvy lines, loops and scribbles, pressing hard and soft and in between. Then do the same with a white oil pastel. This is an invisible exploration that will only show up later when it resists through the inks. Bring in some inks and keep up the same playful spirit, using the ink droppers to draw and a wide flat brush with water to spread the color in some areas.

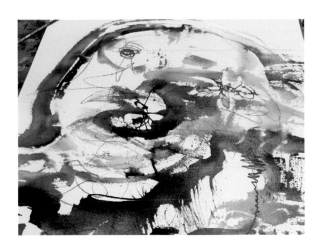

3 Add in more color and use your nature tools to scratch and pull and roll and twist, watching the colors merge with wonder while still being mindful to leave a little space in between.

4 For extra drama and contrast add in some Payne's Gray ink in several places, creating patterns and swirls and dark solid shapes for the colors to bounce off of.

5 We enter the south with some new tools—brushes and three heavy body acrylic paints (Light Ultramarine Blue, Light Phthalo Turquoise and Hansa Yellow Light). Embrace change. Trust that when we let go of the things that no longer serve us, we make space for new possibilities. Take your colors on a walk around the painting, releasing some aspects of the underlayers and creating some more solid opaque places for the eye to rest.

6 Add in some Titanium White to soften the colors and mix them with each other creating different tints in lemon, pistachio, mint and aqua.

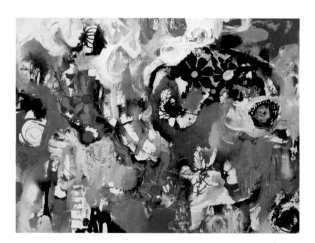

7 Be liberal enough with your colors in this step that the eye can easily move through the painting by gliding from one opaque area to the next. I chose to place a flower stencil in several areas to link one opaque area to the next.

8 Now enter the west, a place of richness, abundance and transformation. Use your acrylic inks to paint circles around the sweet spots that draw you in and make you feel good. Drag the pigment out with water and a wide brush to create a transparent glaze across the whole painting. I used Quinacridone Magenta, Flame Orange and Payne's Gray for this step, allowing them to mingle in some areas and stay separate in others.

9 At this point the work is rich and glowing with bright pops of color, like windows to honor what came before.

10 Just like that we arrive in the north, the place of knowing where we are ready to share our wisdom, acknowledge the beauty of all that has come before and step into our power. Harness this light in various potencies using white in all forms: ink, fluid acrylic and a heavier bodied version as well.

In the full and wondrous knowledge that all is cyclical, that nothing is lost, and that the more we give away the more we have, I chose to write the words *begin again* in white ink across the center of the painting.

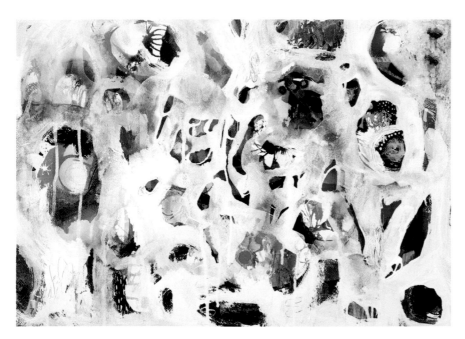

11 Use a wide flat wash brush dipped in water to spread white ink across the colorful surface creating a semitransparent veil and leaving new little "truth windows" to glimpse the various transformed layers.

Bring in some fluid and heavy body white paint to give some variation between the more transparent and opaque whites, blocking some areas out completely and leaving others mysterious and ethereal, the veil between worlds.

Finally, let go just a little bit more, knowing that all of our work and experience has meaning and purpose and that in every moment we can begin again, each beginning richer and fuller for our life journey.

What to Do When You Fall

Allow your struggles to guide you to discover a new perspective.

MATERIALS

Venetian plaster

Burlap

Gessobord panel,
8" × 10" (20cm × 25cm)

StazOn ink pad,
dark brown

Printed papers
for collage

Decoupage, matte
medium

Acrylic soft gel,
semi-gloss

Palette knife

Plastic sheeting
or paper to put under
burlap

Spray bottle
of water

Brush-tipped
marker, brown

DecoArt Metallic
Lustre cream wax

Acrylic paints—
Sepia, Cobalt Teal,
Payne's Gray

Scissors

Gloves

Stamps

Plastic wrap

Brayer

We all stumble at some point. The archetypal journey involves a climb to power, a struggle, a fall and finally a rise from the ashes. The fall is where we learn. What would you do if you were guaranteed not to fail? It is an interesting question to ask yourself. I find that if there is no challenge, half the fun is gone. It is the struggle that makes success sweeter. If there were no struggle, if you were guaranteed success, you might not get out of bed to bother with it. So embrace the struggle and when you fall, take a look around, learn from where you are, then get up and use what you have learned to rise up and create again. Accomplishment comes with progress in meaningful work.

Michelangelo said, "The greater danger for most of us lies not in setting our aim too high and falling short; but in setting our aim too low, and achieving our mark."

As a creative soul, you are going to fall. That is really the only given there is: the struggle. Oh, but what joyous floating happy dance feelings when success carries you back up out of the mud! Mud is where you began, and it is a good place to fall when you stumble because is a bit more forgiving than concrete. Remember the joy of childhood, playing in the mud. The critic wasn't standing over your shoulder saying, "No, no, no! That's not the right shape!" Take yourself back to the freedom of this place. Feel the mud between your fingers and try this exercise to help you restore that glorious freedom of childhood.

1 Cut a piece of burlap slightly smaller than your Gessobord panel. Place the burlap on top of the paper or plastic and spread a thin layer of Venetian plaster. Push it into the burlap so it binds with it. If your plaster starts to dry, mist it with a small amount of water. Then spread a thicker coat on the burlap and let it dry.

FLY LIKE YOU KNOW YOU CAN
Sandra Duran Wilson
Mixed media on panel
8" × 10" (20cm × 25cm)

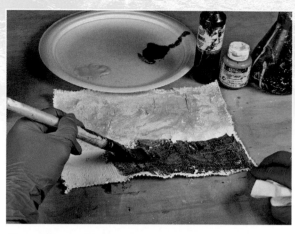

2 When the plaster is dry, crumble the fabric to create cracks in the plaster.

3 Dilute your paints with water and quickly brush onto the plaster. Do not overbrush or the plaster will rehydrate and become soft. I am using Cobalt Teal and Sepia. Let it dry. When dry, seal the surface with the matte medium decoupage. Let it dry.

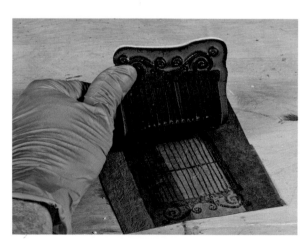

4 Make some collage papers incorporating stamps and other meaningful imagery. I am using a rubber stamp of a birdcage and dark brown ink. The paper I have is a two-toned paper that I found in my travels. Find images and paper that speak to you. Stamp onto the paper.

5 Add some depth to the lines in the birdcage using a brown brush-tipped marker.

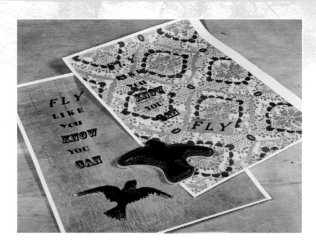

6 I printed the words *fly like you know you can* onto patterned paper using a laser printer. I stamped the bird image onto the paper as well. You could also stamp your words onto the paper instead of printing.

7 Paint the panel with Payne's Gray, let it dry and then spread a medium layer of soft gel on the panel with a palette knife. Place the burlap on top. Place plastic wrap over this and use a brayer to smooth it to the panel. Start in the middle and work your way out. Remove the plastic and let it dry.

8 Cut out your images and words and decide on your arrangement. Use either the decoupage or gel medium to adhere the birdcage to the surface and seal it.

9 I chose to add some metallic cream wax to the bottom section over the brown. Finish gluing your words down. For other finishing touches, I added some shadows below the words to create visual depth.

Success

Learn to define and appreciate your successes.

"Success is not final, failure is not fatal:
it is the courage to continue that counts."
—*Winston Churchill*—

Are you afraid of success? Once you become successful, then how do you remain there? The fall from grace can be scary, so some choose not to climb too high for fear of falling. When you fail you know why. When you succeed you may never be sure of what exactly caused the success, so how do you re-create it?

How do you look at success and what does it mean? How does that definition change and evolve over your life span? Most importantly, how does it make you feel? You have to go out of your mind and into your heart to create the revolutionary concept of success for the soul. Kindness will be the goal and creative cooperation can be the next definition of success.

Yes, we learn from our mistakes and then we try again. We practice, we try again and again. Is success ever really there? Is it attainable and sustainable? Sometimes the best intentions can have an unintended consequence. My father would always push me to do better, to be the best I could be. To me he never seemed satisfied with whatever I accomplished in school. If I had a 90%, he wanted better. When I came home with a 95, he would say, "You can do better." When I achieved 100, he said keep it up. He pushed me to be the best I could be, but I internalized the message that good was never good enough. It has taken me a long time to acknowledge that internalized message and find a balance that yes, I am happy and satisfied with what I have done. Yet I may never have got-

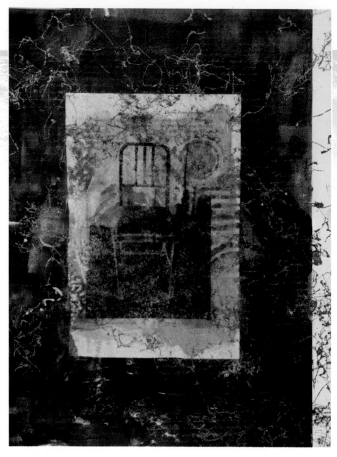

THE WISDOM CHAIR
Sandra Duran Wilson
Mixed media and
acrylic on paper
22" × 15" (56cm × 38cm)

My painting *The Wisdom Chair* reminds me of the passion I feel when I am creating completely from my heart. My muse becomes immersed in the unknown and I am willing to experiment without judgment. This is my current definition of success. It brings me joy and I think that feeling gets transmitted into the art.

ten to where I am today without that internalized mantra of "You can do better."

It is the fine line between learning, failing, getting up and trying again that pushes us to success. As we move through life the definition of success changes. Success for me in school was getting perfect grades. I learned later that wasn't the point of learning. I was so caught up in a narrow definition of success that I didn't learn for me. Now I appreciate learning new things just for the sake of learning. My successes are measured in connections with others. How can I be of service? I love to engage my curiosity. I still want to make the best art, so I push myself. As a creative soul, success and struggle commingle. One doesn't exist without the other. As a creative soul, you are always expanding your

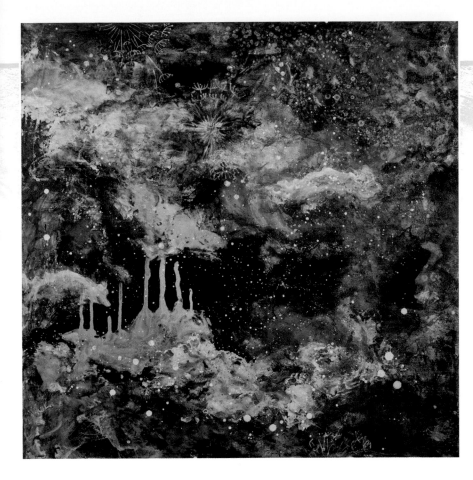

STARBURST
Sandra Duran Wilson
Mixed media and acrylic on canvas
24" × 24" (61cm × 61cm)

My painting *Starburst* represents success to me because I took a chance on following my passion for science, astrophysics and music. I combined them and came up with this painting. It led me down a different path than my purely abstract paintings, and it has been a successful journey.

vision and your spirit. Success isn't permanent, it is a state of evolution.

In this exercise, pull out your journal and draw four columns. Label the first column *Definition of Success*, the second *Action*, the third *Fear* and the fourth *How to Overcome the Fear*. Here's a fleshed-out example:

1) Definition of Success: Get art into a gallery
2) Action: Create the body of work and put it together in a format to approach galleries
3) Fear: Approaching galleries and fear of rejection
4) How to Overcome This Fear: Practice your approach, submit online, talk to others about your work, start a file of rejection emails (at least they took the time to let you know).

After you go through the process, let's say you do get into a gallery showing your work. Are you happy with your success or is it now changed? Would the bar for success mean to sell some work from the gallery? Selling is not a foregone conclusion when you are in a gallery. You see how the idea

of success changes. Nothing is static. Find the joy in the process.

Success for the creative soul may mean you have more time to pursue your vision. What happens when you have achieved the things you defined that would make you successful? You appear to have what others hope to achieve, yet you are not embracing this success. What is missing? How can you feel the success and connect with your passion? Step back and redefine what the success means. Here are some examples for your four columns:

1) Success means living every day to the fullest.
2) I should enjoy the world around me, love what I can do today.
3) I am afraid of losing what I have.
4) Be gentle with myself, use kind words, turn off my internal critic and embrace myself just as I am.

From there, you move to where you want to go. Cherish this moment. By acknowledging the temporary quality of success or existence you realize that you are already successful.

Find Your Song

Give a voice to your authentic self through song.

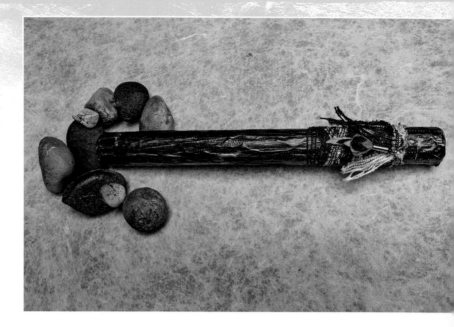

Here is my completed rainstick. I incorporated the stones into my ceremony because they are like holding the earth in your hand. When I am using sound to call to my muse, I will often use two stones and strike them together in a rhythm. Working with a group of people is a powerful way to give sound to your soul. Percussion instruments like rainsticks, stones, rattles and drums vibrate the entire body and spirit and unify a group through vibration.

MATERIALS

Cardboard tube

Box cutter

Hammer

Pencil

Small flat-head nails (shorter than the opening of your cardboard tube)

Metallic heating duct tape

Acrylic paints

Ink, violet

Texture tool

Dry peas, beans or rice and measuring cup

Brush and a palette knife

Yarn, feathers or ribbon for decoration

Towel or paper towel

Talking sticks have a rich spiritual tradition in First People cultures all over the world. They are used in council meetings to ensure that everyone is heard. The tradition has been adopted by other cultures and used in meetings and groups. The rainstick is believed to have originated in South America among the First People there. It is a musical instrument and used in ceremonies.

In this exercise we will make a contemporary rainstick and create a ceremony to discover and amplify your creative voice. This is the voice that whispers to your heart and soul. It is the voice that supports all people and does not judge. This is the voice that urges you to create. Learn to listen to the whispers that this rainstick will share. Hold this time as sacred. This voice is soft, it does not know time, it only knows creation. Make time to honor the voice. Play the rainstick and listen to the soft whispers of your soul.

Ways to Use Your Rainstick

Soothing sounds can add to the meditative experience. Where I live in the dry mountains of Santa Fe, New Mexico, rain is a blessed event. Because it is not so common, when it does occur it sets this time apart from ordinary time. Try using your rainstick to designate sacred time. Sit in a comfortable position, outside if possible, with your eyes closed. Turn the rainstick so that the seeds trickle down to the other side. When they have completed their journey, turn the rainstick over and repeat the process. You may play with the angle to achieve different rhythms. As you move the rainstick, imagine that the sounds are calling you into sacred time. Be aware of everything around you, the sun shining on you, the smell of the garden, the sounds of the animals or insects moving about. If you are inside, pay attention to how your body is interacting in the space. Be still, listen to the song and let it guide your imagination. After about five to ten minutes open your eyes and journal about your inspiration.

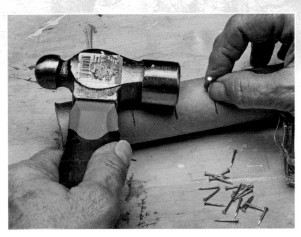

1 Cut the cardboard tube with a box cutter to the desired length. I made mine about 12" (30cm) long, though you will get more song if it is longer. Mark the tube at 1" (25mm) intervals with a pencil. Use a small hammer to push the nails into the tube along the 1" (25mm) intervals. There doesn't need to be an exact number of nails for each row; add a bit of variety. Work around the tube and cover the entire length.

2 This is what it looks like inside the tube with all the nails in place. Before you put the tape onto the tube, do a sound check. I put about ¼ cup (59ml) of lentils into a measuring cup. Put your hand over one end of the tube and pour the beans inside. Place your other hand over the other end and shake the tube back and forth to check the sound. Experiment with different size beans or grains. I decided to add some rice, too.

3 Aluminum tape is very sticky when you remove the backing. Cut the number of strips you will need to cover the size of the tube you are using. I am applying these lengthwise, so allow a bit of overlap and enough to cover the ends.

4 Cut three pieces of the metal tape about 2" (5cm) longer than the tube. Keep the backing paper on. Place on a towel or paper towel to provide some cushioning and then add texture to the tape. I am using a rotary tool, but you can use a skewer or even a textured plate to add texture.

5 Paint the tape with red paint. Let it dry.

6 Paint the tape with gold paint. My gold paint was thick, so I used a palette knife to rub it on and then wiped some off, keeping it only in the recesses. Let it dry completely.

7 Paint on the violet ink and gently rub off most of it. You are building layers of color. Let it dry.

8 When your tape is dry, remove the backing paper from one of the strips. Be careful because this stuff is super sticky. Place the tape, sticky side up, and then put the tube on top. Roll it around the tube. Repeat with the other two pieces of tape. Press it all into place, but do not cover the ends yet.

9 Cut a small piece of paper a little larger than the opening of the tube. Place it on one end of the tube and wrap the tape around the end, sealing it off. The paper keeps the rice/bean mixture from sticking to the tape. Pour your mixture into the tube and seal up the other end in the same manner. I wrapped yarn around the finished rainstick and decorated it with some feathers.

Joy Is a Circle

Listen to the circle of your breath and let it flow freely.

JOY IS IN THE CIRCLE
Sandra Duran Wilson
Mixed-media sculpture
16" × 12" × 5"
(41cm × 30cm × 13cm)

MATERIALS

Floral foam circle and rectangle

Floral foam cutting tools

Wooden dowels

Easy 3D Flex powder by Powertex

Textile hardener by Powertex

Gloves

Pencil or pen

Spatula or putty knife

Plastic container for mixing

2-part patina kit

Acrylic paints

Decoupage

Paintbrush

Lid or plate, circular

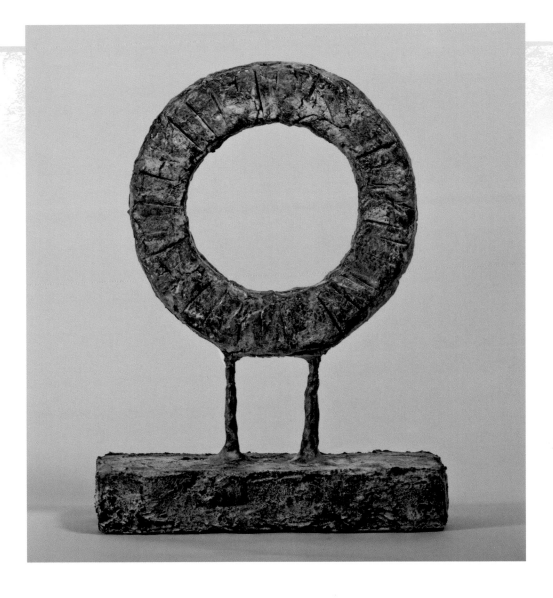

What you put out there comes back to you. What you give yourself, you give to others. What you give to others, you give yourself. It all goes around in the circle. Joy is the feeling you have when circulation is flowing freely, and pain is what you experience when there is blockage. Fear creates a blockage, so breathe and relax. Follow the circle of breathe in and out.

Ask yourself, would you rather be right, or would you rather be at peace. I choose peace now. Release your internal voice of judgment.

Release resentments and embrace your natural gifts and believe in your intuition and soul. To increase joy and abundance, increase your circulation. Find your joy in the circle. All points are connected within the circle. We live and die within the circle, just like the seasons.

Plato said, "The soul is a circle." To me, this means that the soul is the void within the circle. It is always unchanged and eternal. In this exercise we will create a sculpture to serve as a reminder to live in the circle.

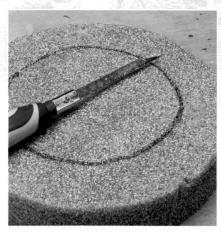

1 Use a lid or plate to draw a circle on a piece of circular floral foam. You can find this kind of craft foam and the tools for cutting it at a hobby store. They also sell wreath shapes that already have an opening.

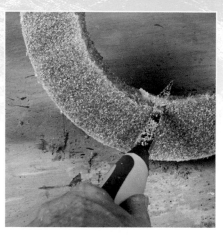

2 Cut out the inner circle using the floral foam blade.

3 Seal the foam with decoupage. I applied two coats, letting them dry between layers. Seal the rectangular base in decoupage as well and let it dry.

4 Put some of the Easy 3D Flex powder in a plastic dish. Slowly pour some of the Powertex textile hardener into the powder.

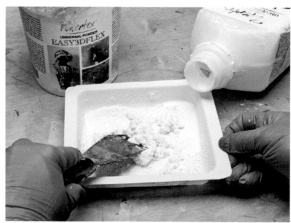

5 Use a putty knife to mix the two. Continue adding powder and fluid, mixing together.

"We are shaped by our thoughts; we become what we think. When the mind is pure, joy follows like a shadow that never leaves."
—*Buddha*—

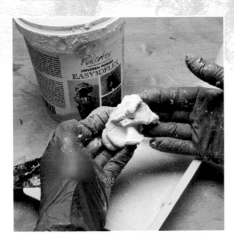

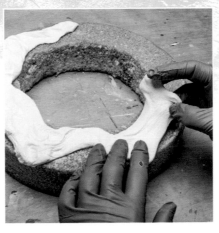

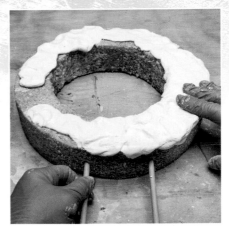

6 Mix until you have a claylike substance. If the mixture is too dry, add some more liquid, and if it is too wet, add some more powder.

7 Begin to spread the claylike material over the floral foam. If you want the finish to have natural cracks, make your clay mixture wetter than what you see here.

8 Cut the dowels to the size you wish to raise the circle from the base. Push two dowels into the circle and continue covering the circle and dowels with the clay mixture.

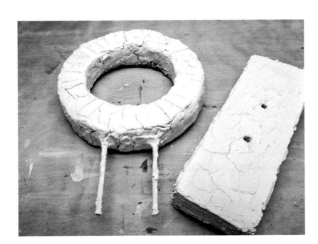

9 Press holes into the rectangular floral foam base before adding the clay mixture. Cover the base top and sides with the Powertex clay mixture as done with the circle. Place these near a heat source or outside in the sun to dry. Some nice cracking will occur on the surface as it dries. It may take a couple of days to become fully dry. Seal the surface with decoupage. One heavy coat should do it. When dry, put the two pieces together and use a small amount of the Powertex clay to hold them together. Secure the sculpture and let it dry.

10 Paint your sculpture using acrylic paints. I used Cobalt Teal, Titanium White, Phthalo Green and bronze. First apply the bronze paint and let it dry, then add thin layers of Cobalt Teal and Phthalo Green and wipe off so you have a glazed effect.

For additional texture I used a two-part patina kit by Modern Masters called Metal Effects that includes a bronze base, blue patina, primer and spritzer. Follow instructions on the package if using the patina kit. Seal the bottom of the base and add felt pads if you are going to place it on furniture.

Refill the Well

Allow the illusion of separation to dissolve.

"Knowledge speaks,
but wisdom listens."
—*Jimi Hendrix*—

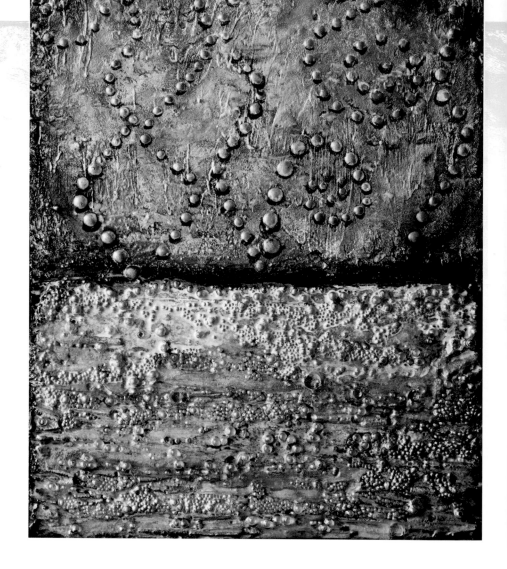

CONNECTED
Sandra Duran Wilson
Mixed media and acrylic on canvas
12" × 10" (30cm × 25cm)

When I began the process of writing this book, working on ideas and contributors that I wanted to include, Bebe was one of the first people I contacted. She had done a blog interview with me the year before, and we developed a soul connection. It was then that I began following her guided meditations.

Bebe was a very young forty-two when she moved on to the next level of being. She helped others as she journeyed through cancer, and her meditations continue to inspire and nourish my soul. Her voice is what kindness sounds like. She always found peace and connections, and she encouraged all to nurture themselves and their creativity. I would love to share her meditations with you, which are available online. You can find them by visiting YouTube.com and using the search function to find Bebe Butler's guided meditations by name. Four of my favorites are A Life of Meaning, Inner Power—Guided Meditation, A New Story and Allowing Light (for more on Bebe, see the Contributor section on the following page).

Here is what Bebe said about allowing: "I've been thinking a lot about 'allowing' and how we try so hard to do everything—our art, our life, our work—all on our own. We often don't make space to let in support by simply being. I believe there's an ocean of divine energy just waiting to wash over us and light us on fire with some magic."

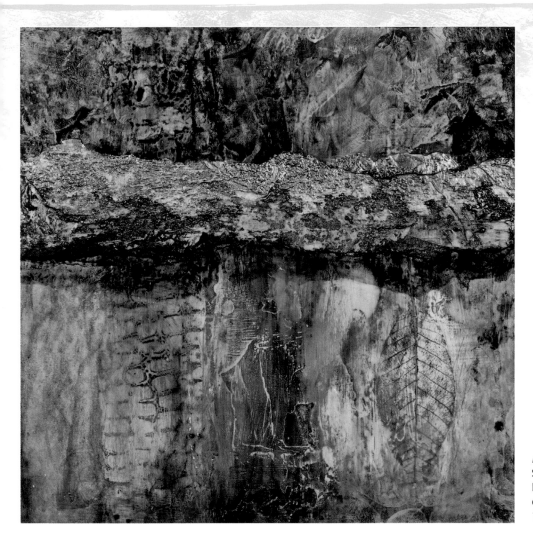

LOVE GROWS HERE
Sandra Duran Wilson
Mixed media and acrylic
on canvas
10" × 10" (25cm × 25cm)

The journey we travel around the circle continues endlessly. We always transition from winter to spring; we are like the seasons. I see this journey not just as a circle but as a spiral that moves endlessly. Each cycle around the wheel propels us to the next level. Growth and expansion is a part of this journey. The inner world is timeless and filled with love and peace. Travel into your inner world where the well is always full. The light always shines no matter what happens in the outside world. The illusion of separation disappears, and peace and love surround us all.

What is your new story? Change your story, change your life. You are filled with peace, joy and love. When the well is full, it is easy to give it all away because you know that the well is endless.

We are all here for our unique contribution. This is your story. No one else is exactly like you. You have relationships, you have lessons to learn and to teach, which only you can do. Know that the well is always full. We are like the ocean. When we are in our body and on the planet, we are like a cup of salt water removed from the ocean. But we are still a part of the ocean. We will always be part of the ocean. Become the light and expand yourself and your story. We are all connected.

CONTRIBUTORS

SETH APTER
sethapter.com

Seth Apter is a mixed-media artist, instructor, author and designer from New York City. He has published two books and eight workshop videos with North Light and has contributed to numerous other publications. He has designed product lines with Spellbinders Paper Arts, StencilGirl Products, Impression Obsession and PaperArtsy.

JILL K. BERRY
jillberrydesign.com

Jill K. Berry is a mixed-media artist and author who makes books, maps, paintings and other story-telling structures. She works in mixed-media with a bent towards classical art and teaches painting, lettering, journaling, mapmaking and various other mixed-media classes worldwide. Jill feels that art is necessary and accessible to everyone.

BEBE BUTLER
http://y2u.be/Y1I8VyCmNco

Bebe believed she had a moral and spiritual responsibility to help others reconnect with their deepest truth and inner beauty. Her love of God was seen and felt through her pure heart, speech and art. She continues to guide us into deep calm through her guided meditations that are used in meditation classes and workshops worldwide. Thank you, Bebe.

KIMBERLY CONRAD
kimberlyconradfineart.com

Kimberly Conrad is a contemporary abstract landscape artist located in Denver, CO. She is the cofounder, owner and CEO of Where Art Lives Gallery and magazine as well as an Art Marketing Coach, Life Coach and Licensed Heal Your Life Leader/Teacher.

AMY FLOWERS
shrewdarts.com

Amy Flowers is a self-taught artist whose work is energetic and vibrant. She uses multiple thin layers of acrylic to achieve the glow and depth that her pieces are known for. Flowers's work is inspired by natural color, form and the little details that surround us. She paints to express the energy and joy she finds in everyday adventures.

CATE GOEDERT
categoedert.com

Cate Goedert has been a fine art and professional pet photographer for many years. Her training includes study at the Rocky Mountain School of Photography, the Santa Fe Photographic Workshops, the Goodman School of Drama, and the Center for Creation Spirituality. She photographed all of the step-by-step images and more for this book.

ARDITH GOODWIN
ardithgoodwin.com

Ardith Goodwin has been a professional artist for the past 15 years. A colorist by nature, she uses acrylic and mixed media along with a framework of fractured line, dynamic movement and transparent layers to create imaginative figures and abstracts. She shares her love of art through teaching workshops nationally and online.

TONIA JENNY
toniajenny.com

Tonia Jenny supports creatives in the process of sharing their messages of inspiration with others. Prior to owning her own editorial, writing and life-coaching business, Tonia worked as a North Light editor for over a decade. Passionate seeker and "sacred maker," she never grows tired of learning from the talented artists with whom she adores working.

NANCY REYNER
nancyreyner.com

Painter, author and instructor Nancy Reyner works with a variety of mediums including oil, acrylic, watercolor, mixed media and, her first love, oil pastels. Nancy worked as a consultant for Golden paints and is the author of several books on painting including the best-selling *Acrylic Revolution* and her latest *Create Perfect Paintings.* She resides in Santa Fe, New Mexico.

CONNIE SOLERA
dirtyfootprints-studio.com

Connie Solera is an artist, teacher, adventurer and writer devoted to supporting women on their artistic journey of deepening their creative practice, awakening their innate wisdom and nurturing their dreams. You can peek into her life as a heart-guided artist, teacher and creative entrepreneur through her blog, workshops and retreats.

TRACY VERDUGO
tracyverdugo.com

Tracy Verdugo is a prolific painter, singer/songwriter and lover of the written word. She teaches her Paint Mojo and other creative workshops all over the globe and reminds her students of the wonder that already resides within them. She lives in Jervis Bay, Australia, with her daughters, Santana and Sienna, and husband of 30 years, Marco.

JOHN P. WEISS
johnpweiss.com

John P. Weiss is a writer, cartoonist and painter living in southern Nevada. He is a top writer on the website medium.com and he draws the weekly comic feature "The Life of Art" for faso.com.

INDEX

Other fine North Light Books are available from your favorite bookstore, art supply store or online supplier. Visit our website at fwmedia.com.

a content + ecommerce company

22 21 20 19 18 5 4 3 2 1

DISTRIBUTED IN THE U.K. AND EUROPE
BY F&W MEDIA INTERNATIONAL LTD
Pynes Hill Court, Pynes Hill, Rydon Lane, Exeter, EX2 5AZ, UK
Tel: (+44) 1626 323200, Fax: (+44) 1626 323319
Email: enquiries@fwmedia.com

ISBN 13: 978-1-4403-5307-9

Edited by *Sarah Laichas*

Production edited by *Jennifer Zellner* and *Amy Jones*

Cover design by *Charlene Tiedemann* and *Dean Abatemarco*

Interior designed by *Charlene Tiedemann*

Production coordinated by *Debbie Thomas*

About the Author

The senses become intertwined in the mind of the artist. Sounds appear as colors, numbers sing songs and frequencies dance in her head. Synesthesia is a crossing of the senses. The mixed-media work represents a beautiful blending of sounds, nature and science.

Sandra Duran Wilson comes from a family of artists and scientists. She grew up in a world where all things were possible in her imagination. It was a world where she could look through the microscope in her father's office and paint what she saw. Her early years were spent on the border of Mexico where the people, animals, landscape, music, culture and the stories of the *curanderos* shaped her reality. Years later she would return frequently to Mexico and South America to absorb the culture, traditions and art. Her spirituality combined with her scientific studies directed her work from realism to abstraction.

Her work is influenced by scientific concepts in physics, chemistry and biology. The pure fun of exploring what paint can do and her natural curiosity keep the work fresh and lively. She is continually exploring new surfaces, materials and techniques. Her work is represented in galleries in the U.S. and Australia and is found in corporate, civic and educational institutions and private collections globally.

She experiments, paints, writes and teaches at her studio in Santa Fe, New Mexico. She also teaches around the U.S., Europe and Australia. She is the author of six art technique books and several DVDs, and her work has been featured in numerous books and magazines. Visit her website at sandraduranwilson.com.

METRIC CONVERSION CHART

TO CONVERT	TO	MULTIPLY BY
Inches	Centimeters	2.54
Centimeters	Inches	0.4
Feet	Centimeters	30.5
Centimeters	Feet	0.03
Yards	Meters	0.9
Meters	Yards	1.1

Dedication

For Mark, my amazing soul companion. Walking the wheel with you puts the "whole" in my soul. I would like to dedicate this book to all the brave people I had the honor to be with over the course of a decade at The Life Healing Center. Your stories were heard, and I continue to carry them in my heart. I have been richly rewarded to witness all the amazing transformations and healing, and I dedicate this journey to all who are searching. I walk with you on this creative path. Thank you Joan and Louise for helping me to find my path. I would also like to dedicate this book to the late Marty McEvoy. Marty you always believed in the path I was on and helped me in ways that I didn't even understand at the time. I feel blessed to have known you and thank you for your support and for pushing me out of the nest.

Acknowledgments

There are many to acknowledge in the making of this book. I am so grateful to Tonia Jenny, who was the midwife for bringing this book to life. Thank you to Cate Goedert, my friend and photographer who stuck by me over the course of the year. This book would not have appeared if not for you. I also want to thank Christine Polomsky for helping us both in the learning process for book photography. Thank you to F+W Media for believing in me for a sixth book and, of course, a very big thank you to my fabulous editor, Sarah Laichas. Thank you to Clare Finney for designing the pages so they come to life. I would like to thank Elaine Salazar of Ampersand, Dana Brown of Ampersand, the talented team at Artisans Art Supply, Cheryl Hannah for always believing in my art, all my collectors, the many wonderful artists that I have been blessed to make art with, and as always, thank you to Mark for always being by my side.

FOREST LIGHT I
Sandra Duran Wilson
Mixed media on panel
30" × 10" × 2" (76cm × 25cm × 5cm)

IDEAS. INSTRUCTION. INSPIRATION.

Receive FREE downloadable bonus materials when you sign up for our free newsletter at artistsnetwork.com/Newsletter_Thanks.

Artistsnetwork
ARTISTSNETWORK.COM

These and other fine North Light products are available at your favorite art & craft retailer, bookstore or online supplier. Visit our website at artistsnetwork.com.

Find the latest issues of *Artists Magazine* on newsstands, or visit www.artistsnetwork.com.

Get your art in print!

Visit artistsnetwork.com/splashwatercolor for up-to-date information on Splash and other North Light competitions.

Follow North Light Books for the latest news, free wallpapers, free demos and chances to win FREE BOOKS!